Compositions Book 9

Original Music for Brass Quintet

by
Ken Langer

Compositions Book 9

Music for Brass Quintet

by
Ken Langer

Compositions Book 9
Music for Brass Quintet
by Ken Langer

Klangermuzik
http://www.klangermuzik.com

First Edition (Softcover)

Copyright © 2013, Ken Langer

ISBN: 978-1-300-79719-7

All rights reserved. No Part of this book may be reproduced or transmitted in any form or by any means, electronic or mechanical, including photocopying, recording or by any information storage and retrieval system, without written permission from the author, except for the inclusion of brief quotations with proper annotation.

Produced in the United States of America

The author may be contacted at ken@kenlanger.com.

Table of Contents

1	The 1812 OverDone	9
2	By Folly Comes Delight	19
3	Concert Fanfare	37
4	The Insulting Quintet	39
5	Moose River Suite	43
6	Six By Satie*	67
7	Six Chorales*	83
8	Snapshots	91
9	Two Chromatic Madrigals	101
10	Wedding Music	107
11	Christmas Bells For Brass	129
12	Three For Christmas	135

Note: works marked with an asterisk (*) are published. Individual copies should be purchased from the publisher.

Introduction

This book is a collection of original compositions for brass quintet: 2 Bb trumpets, F horn, trombone, and tuba.

The 1812 OverDone is a comical piece for quintet and kitchen appliances that pokes some fun at Tchaikovsky's masterpiece. By Folly Comes Delight is a seven movement work based on a four note motive: Bb, F, C, and D. The Insulting Quintet is another comical piece. Moose River Suite is a collection of four movements based on scenes in Vermont. Snapshots is a collection of works inspired by photos of my mother. Wedding Music is music that I wrote and used for my own wedding. The collection also includes original arrangements of works by Satie and several other composers and also concludes with two works for Christmas.

Works marked with a small number in the Table of Contents are published. Individual scores and parts should be ordered through the publisher. All other scores and parts can be obtained through me.

All scores in this book are transposed.

Recordings of all the works can be found on my website: http://kenlanger.com. Some of the recordings are live while others are MIDI transcriptions which may help you become familiar with each work.

The 1812 OverDone
for brass quintet and kitchen appliances

Ken Langer

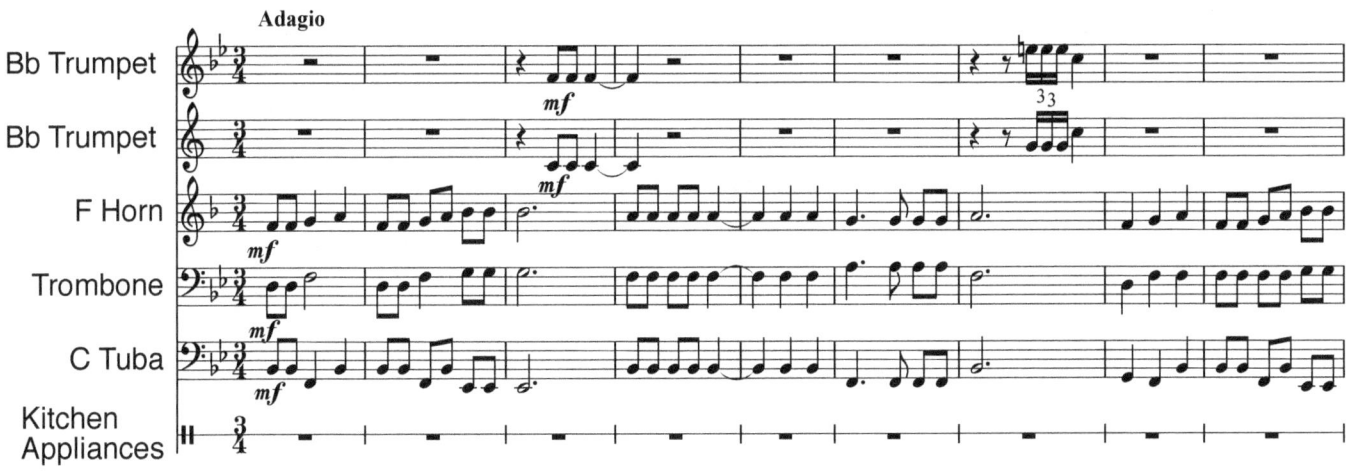
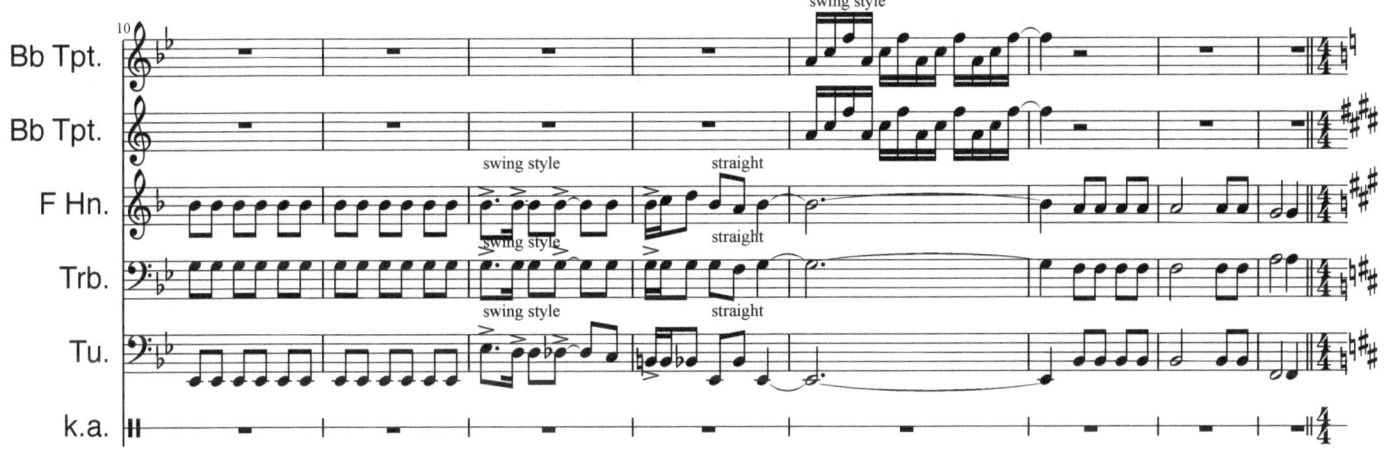
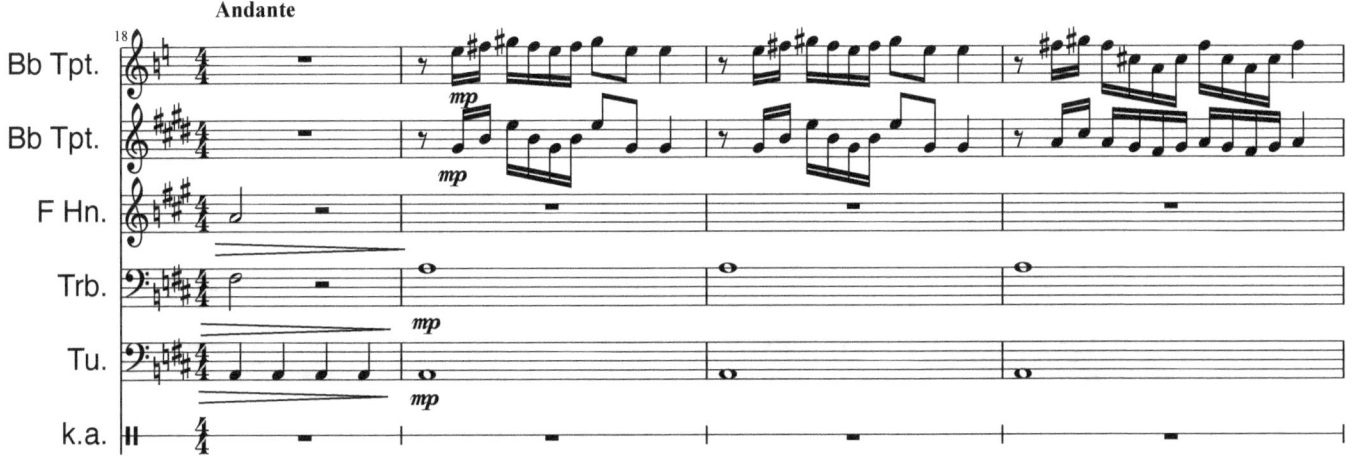

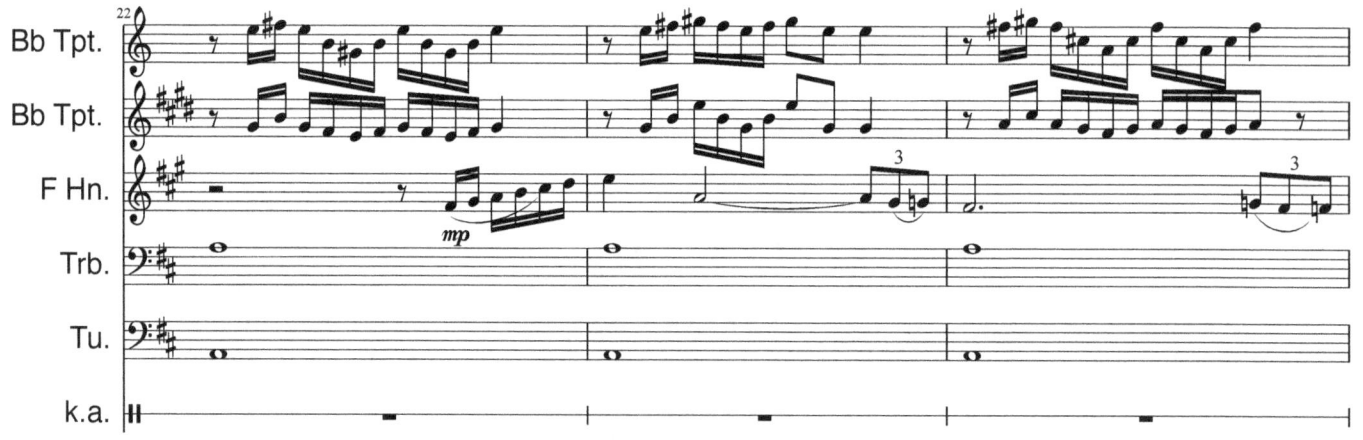
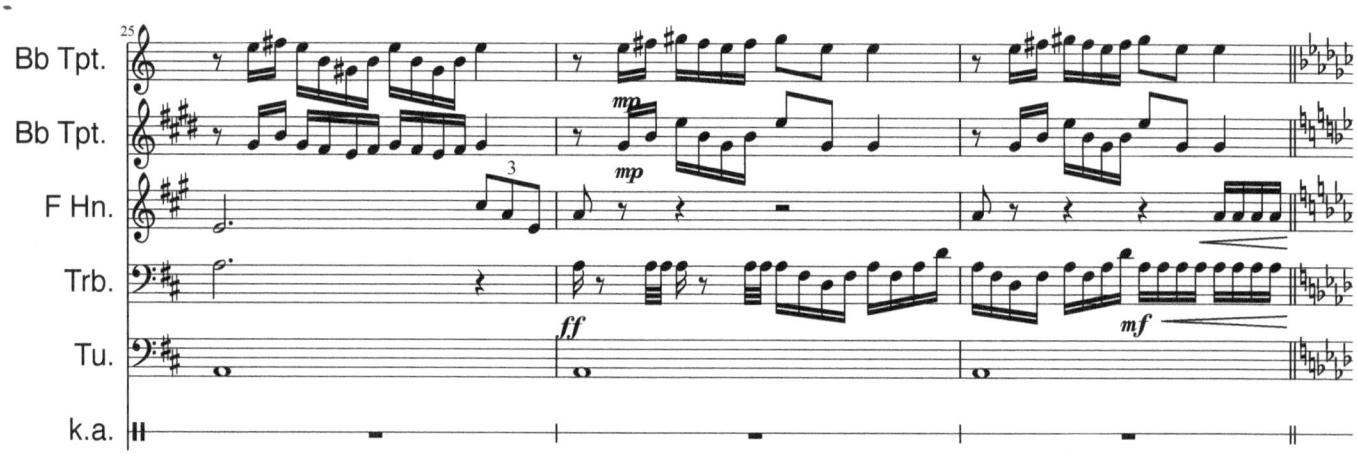
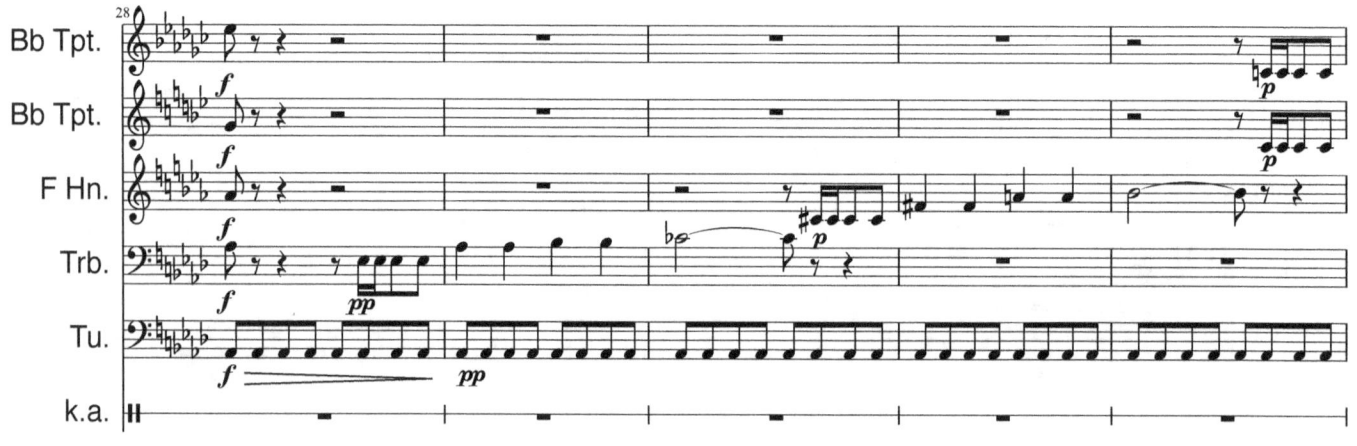

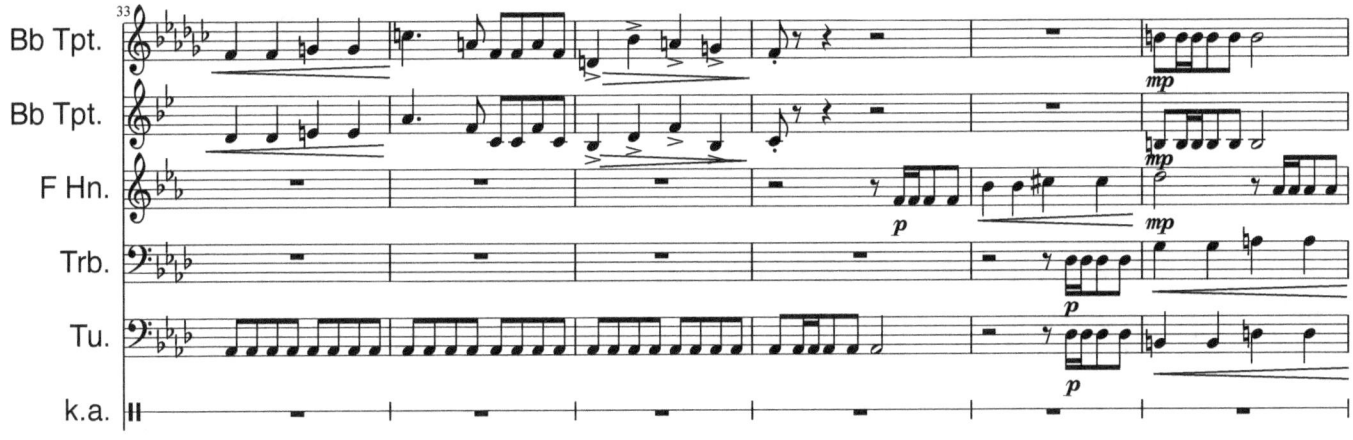
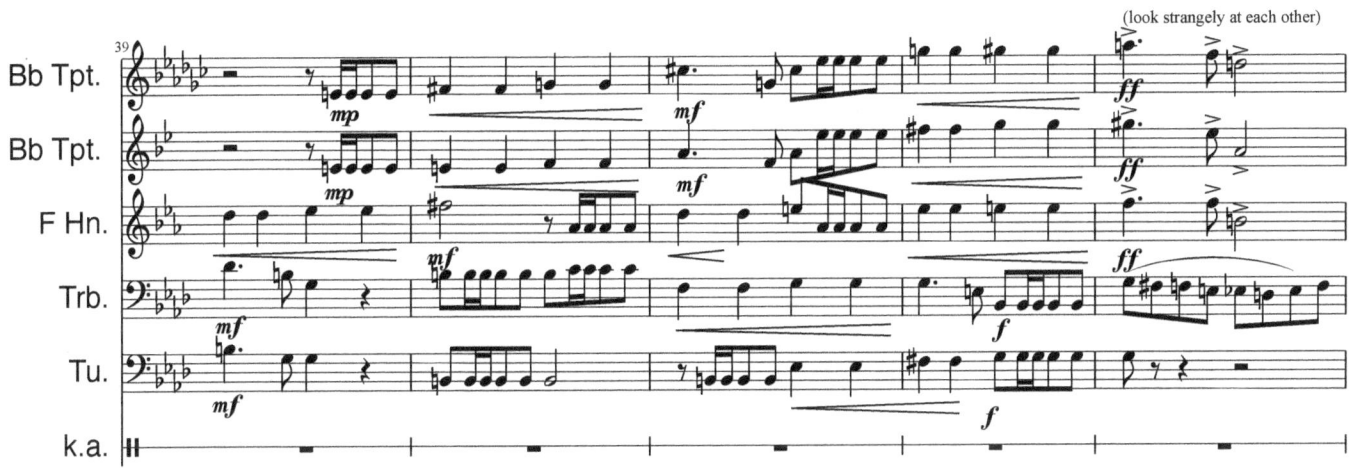
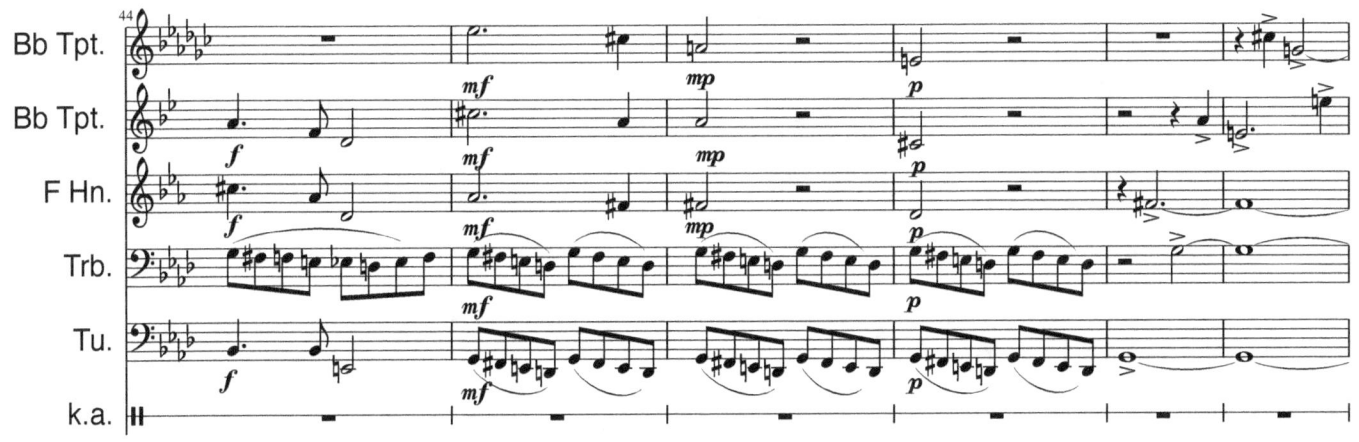

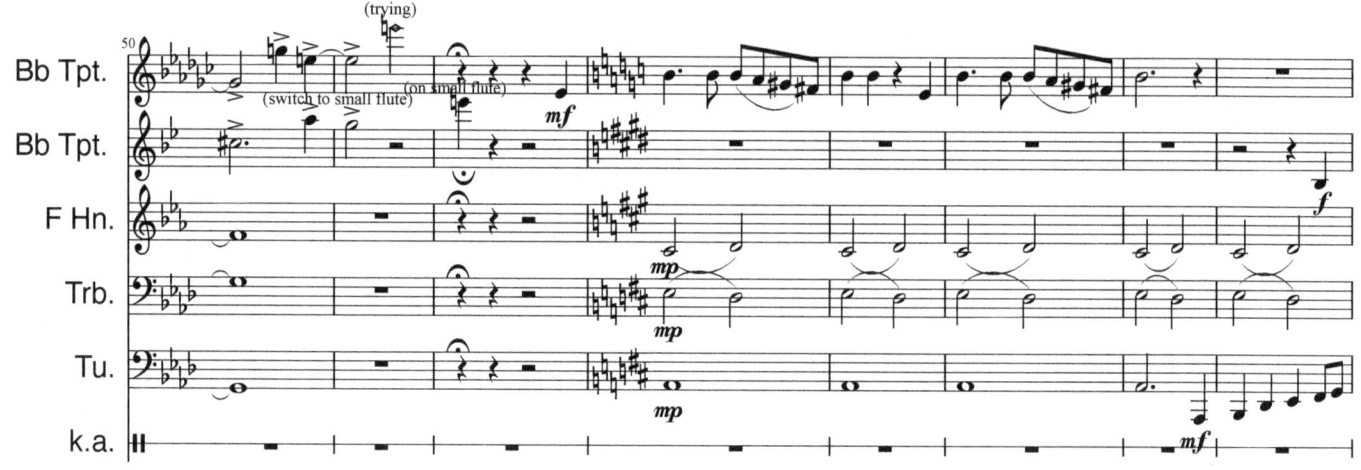
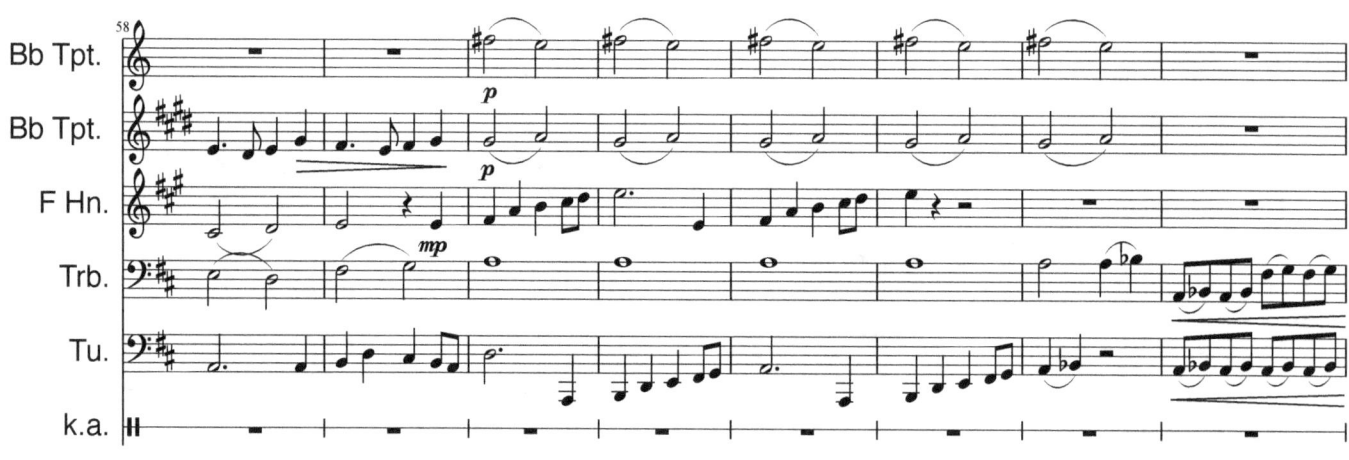
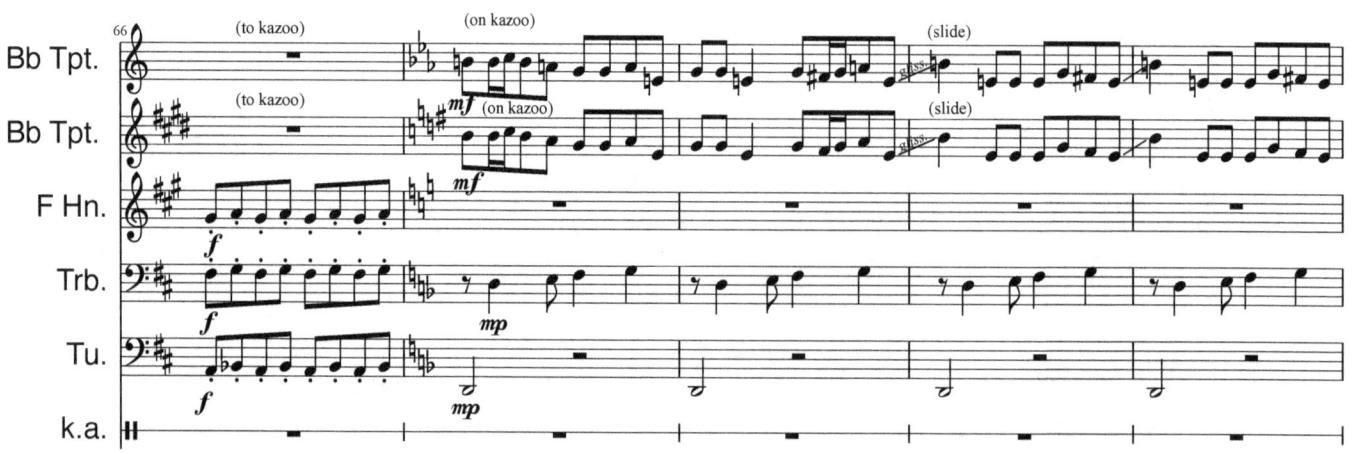

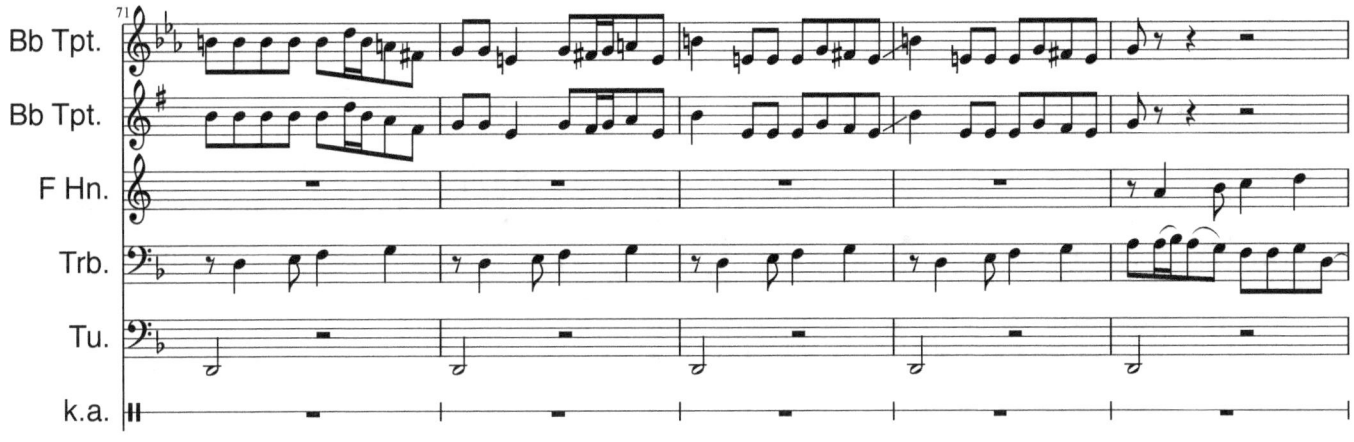
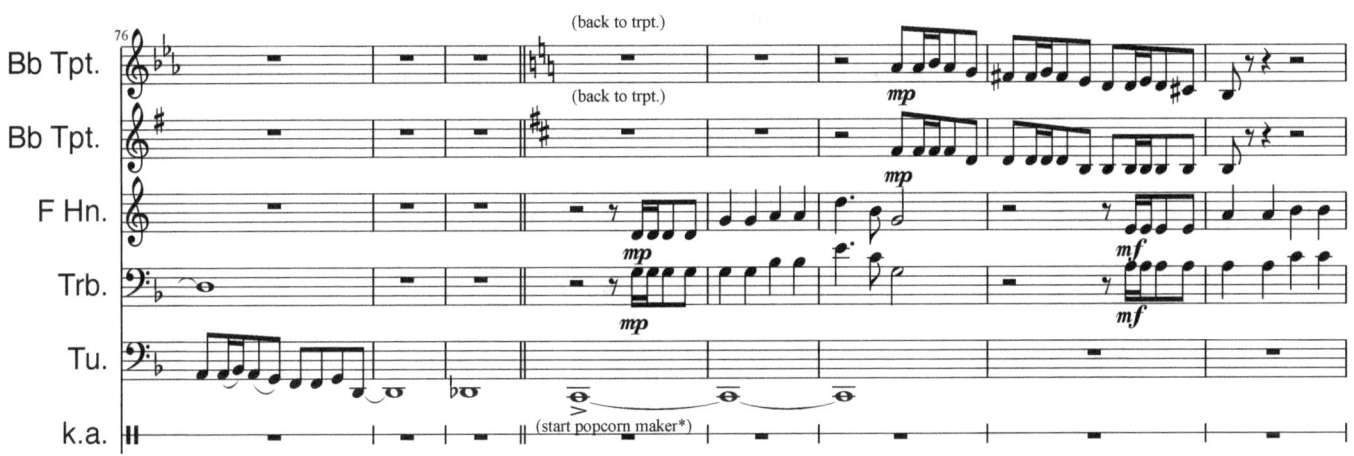
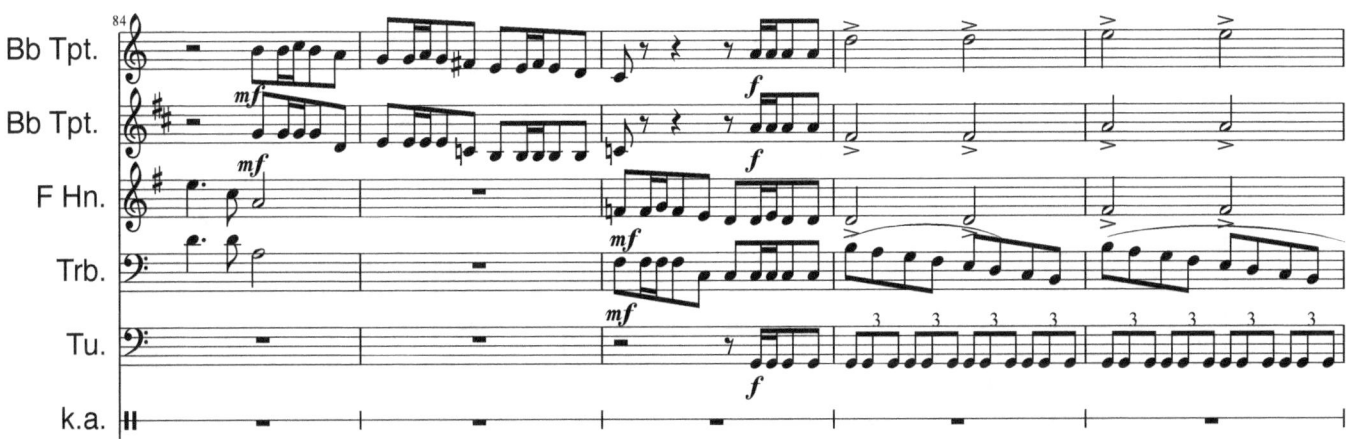

13

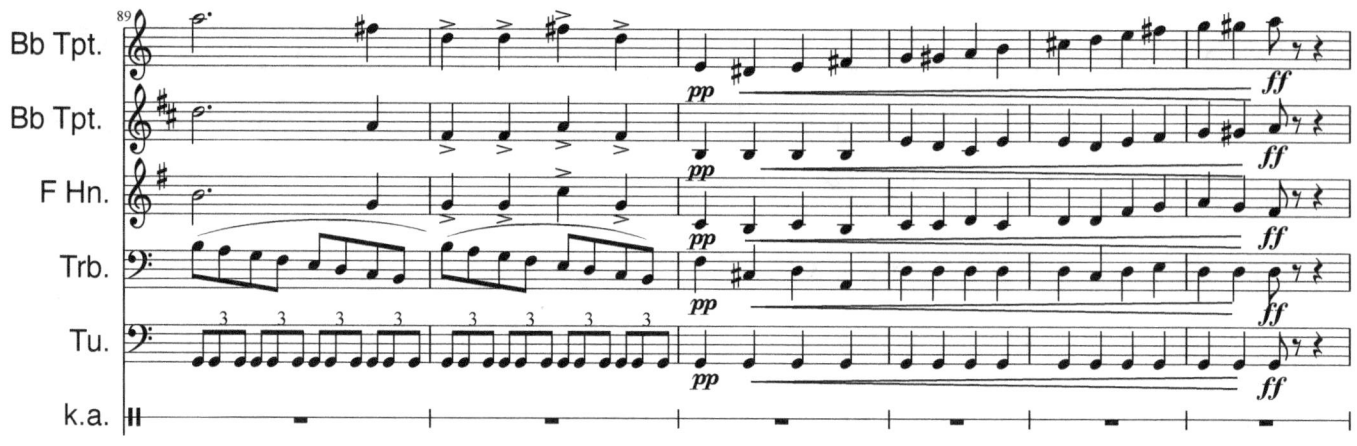
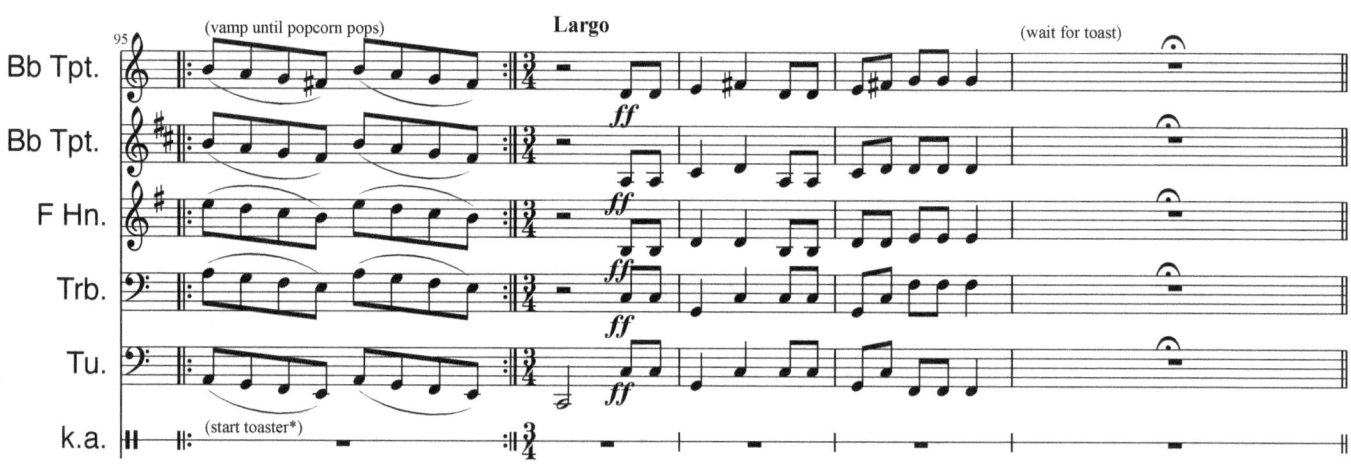
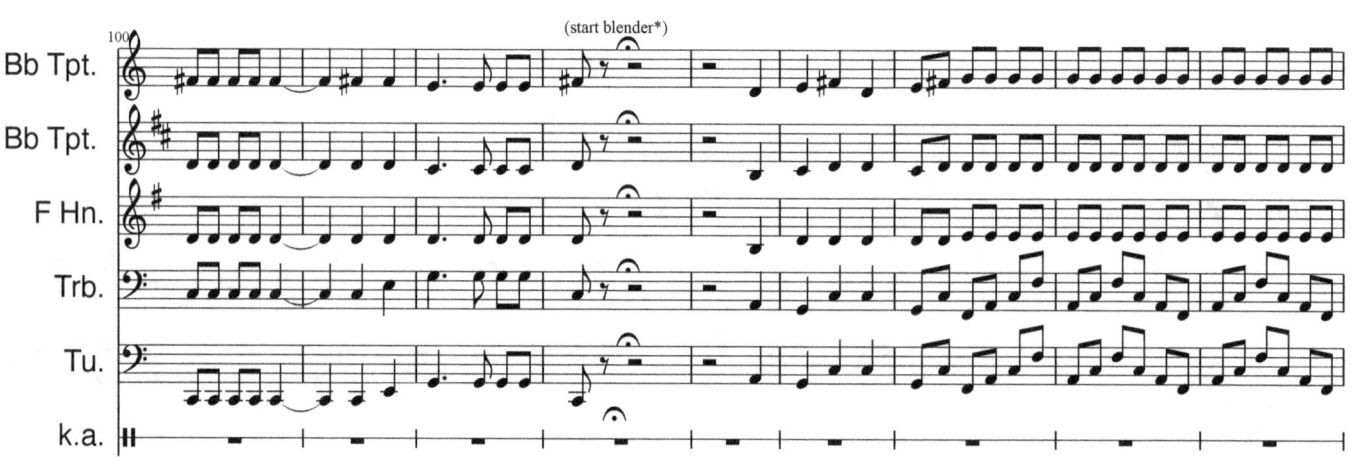

14

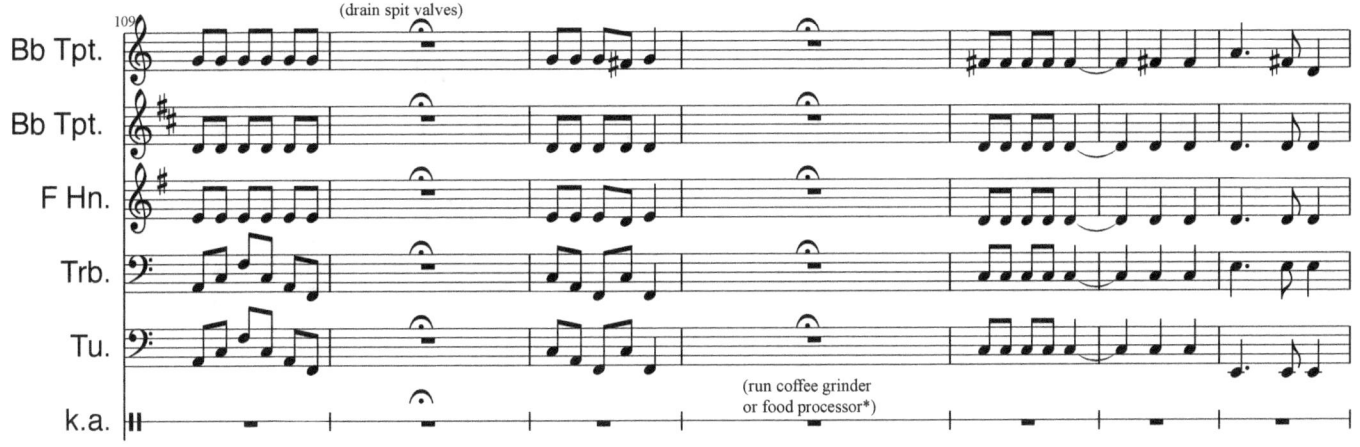
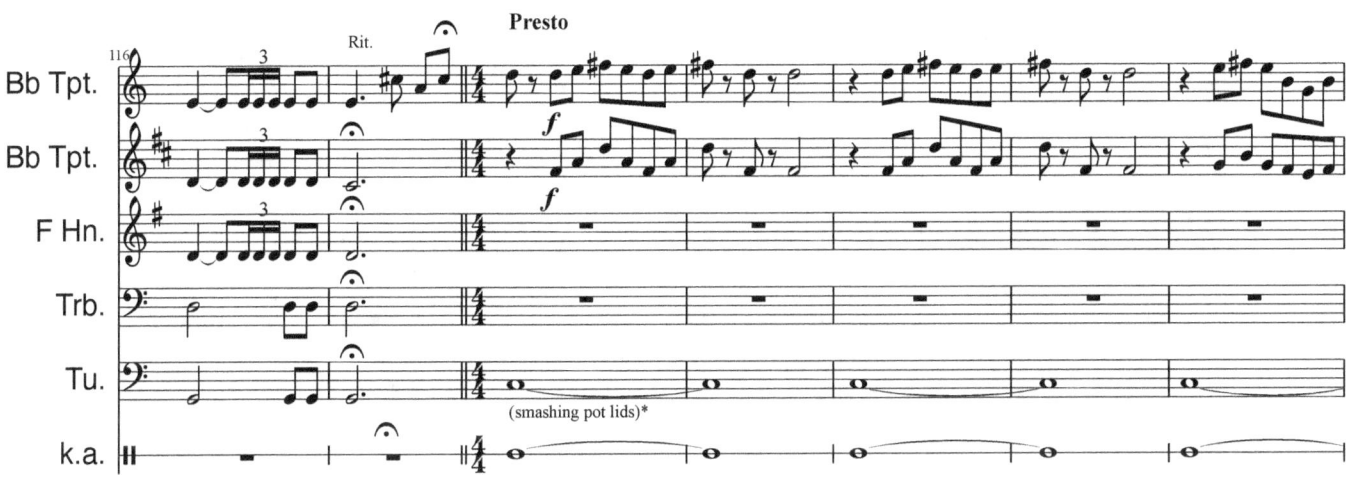
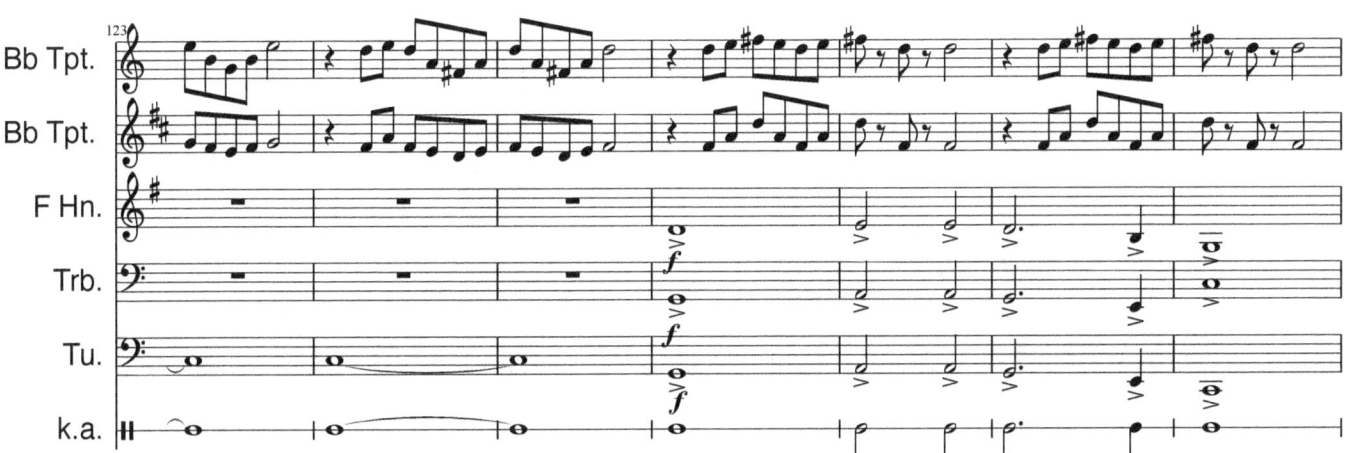

15

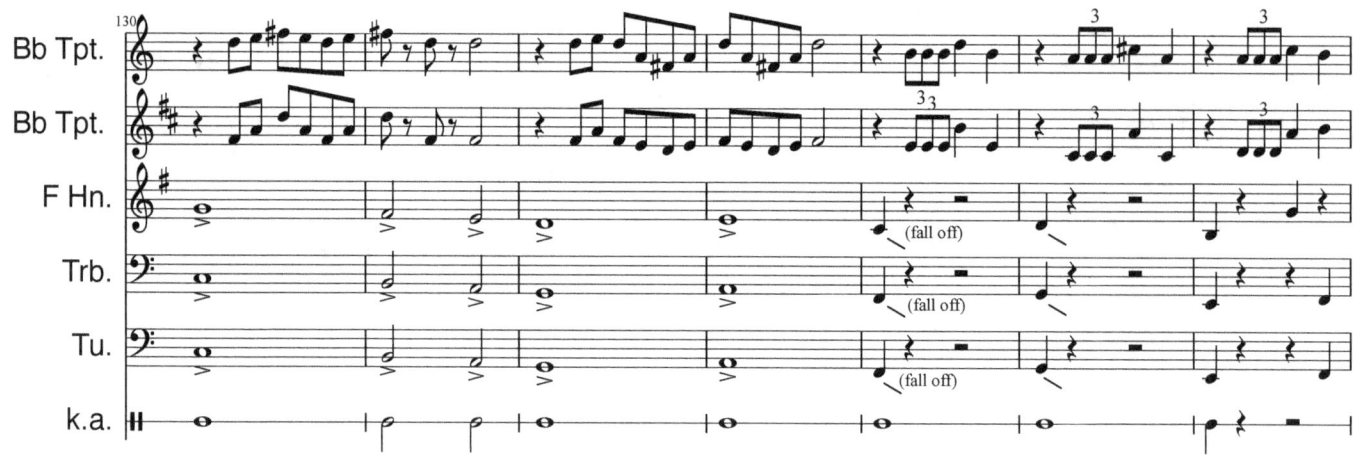
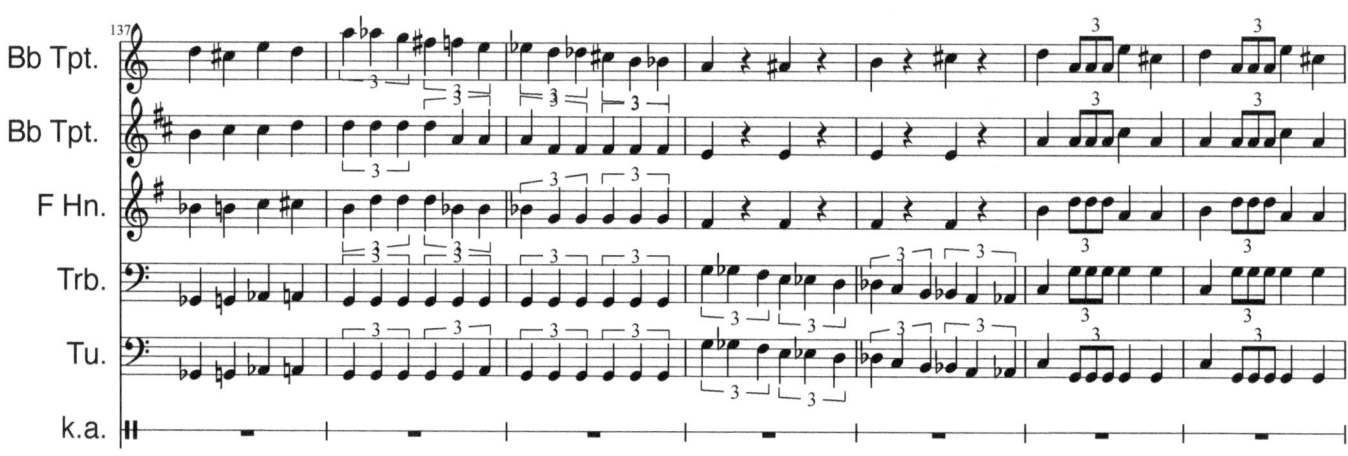
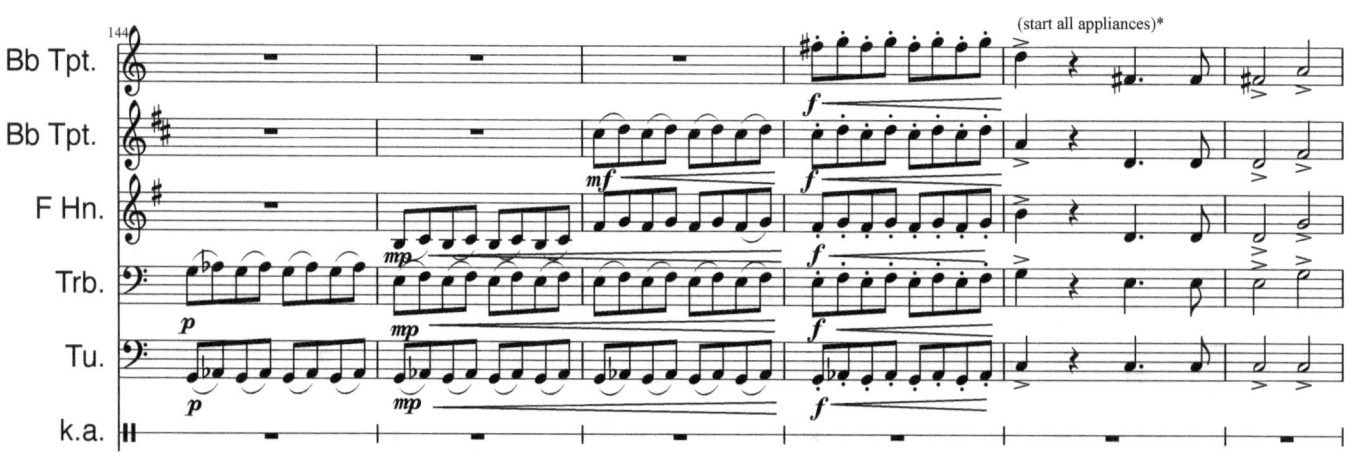

16

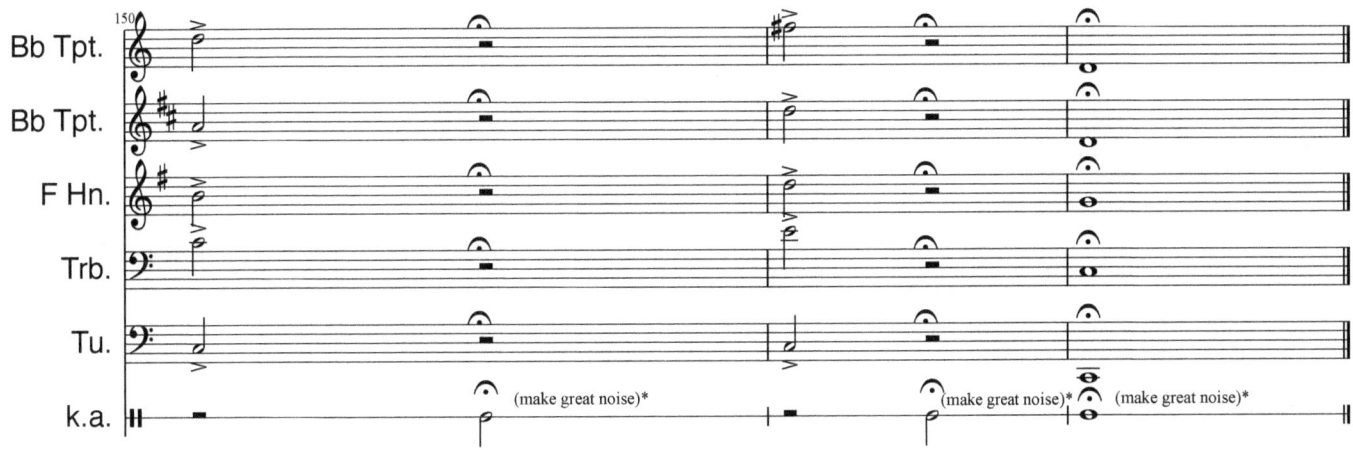

By Folly Comes Delight

Ken Langer

I. Fanfare

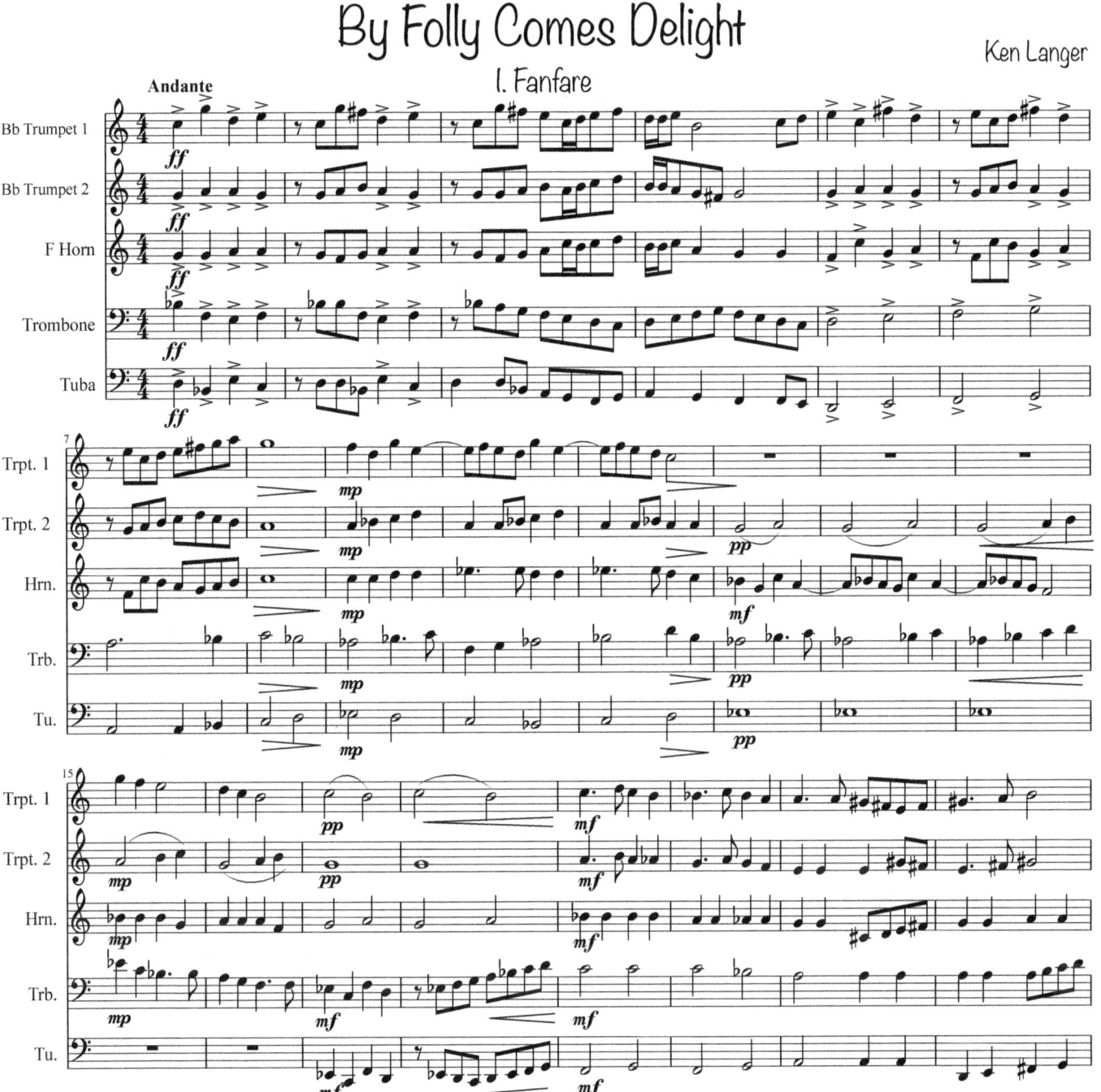

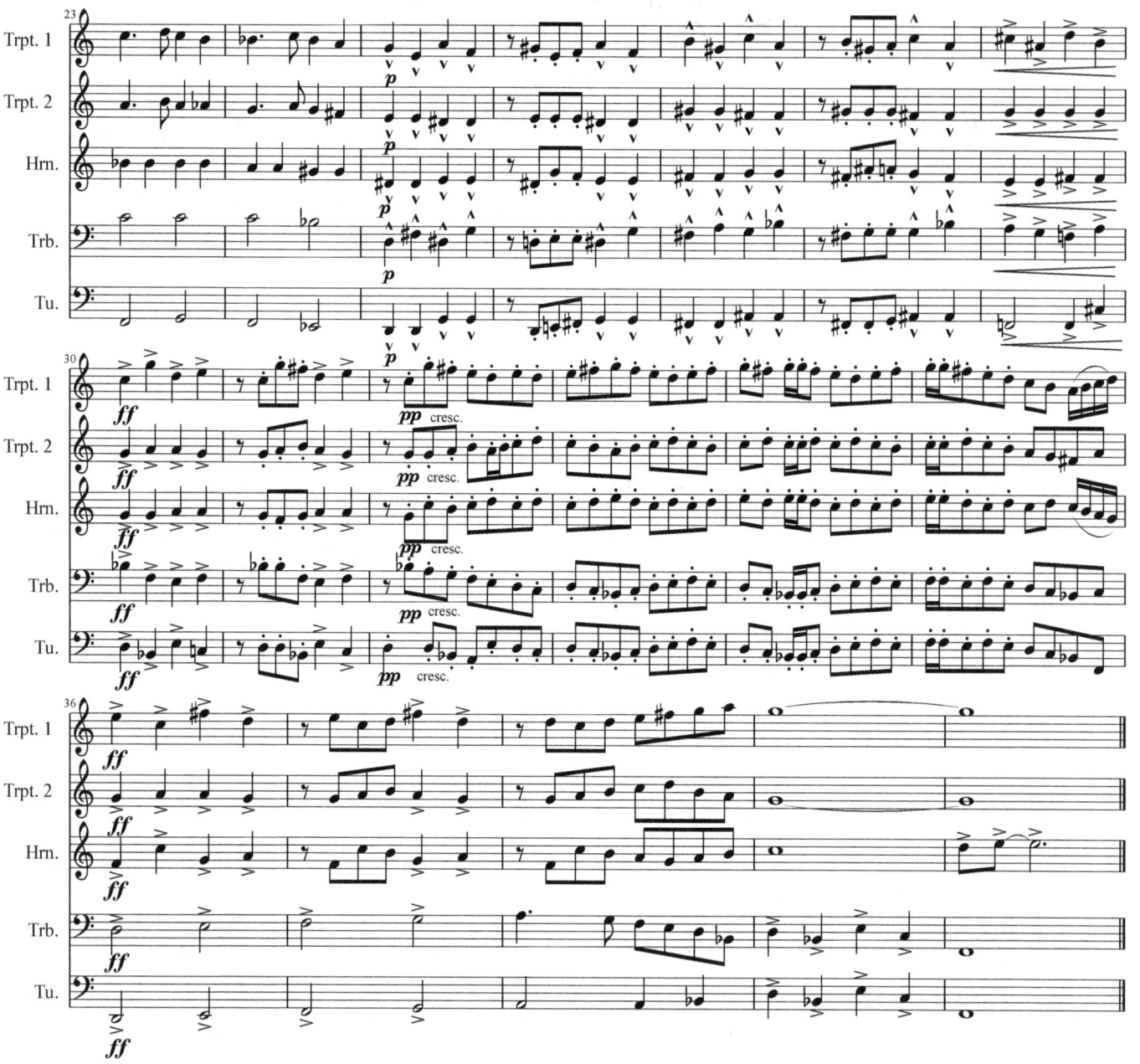

20

By Folly Comes Delight

II. Air

Ken Langer

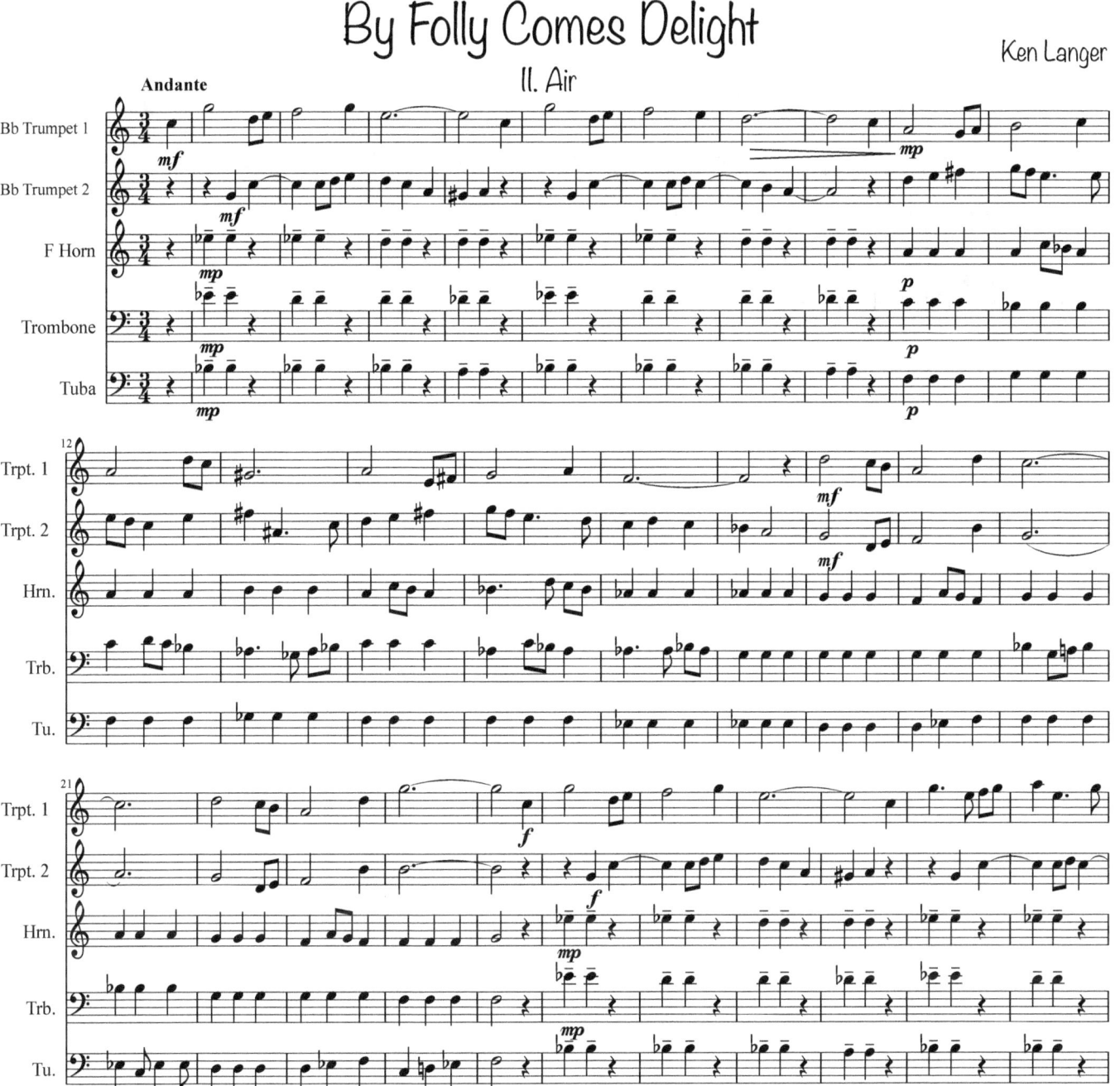

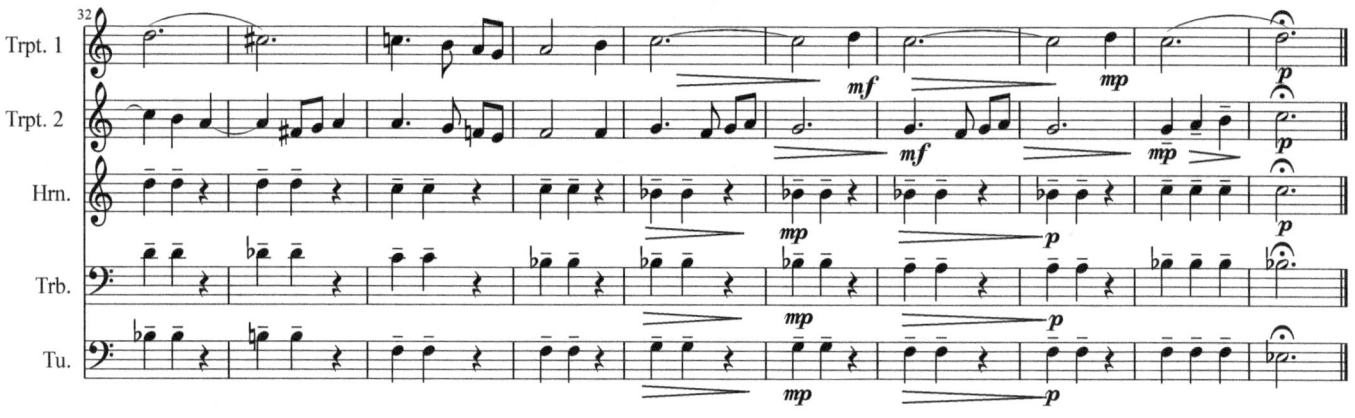

By Folly Comes Delight

III. Rondo

Ken Langer

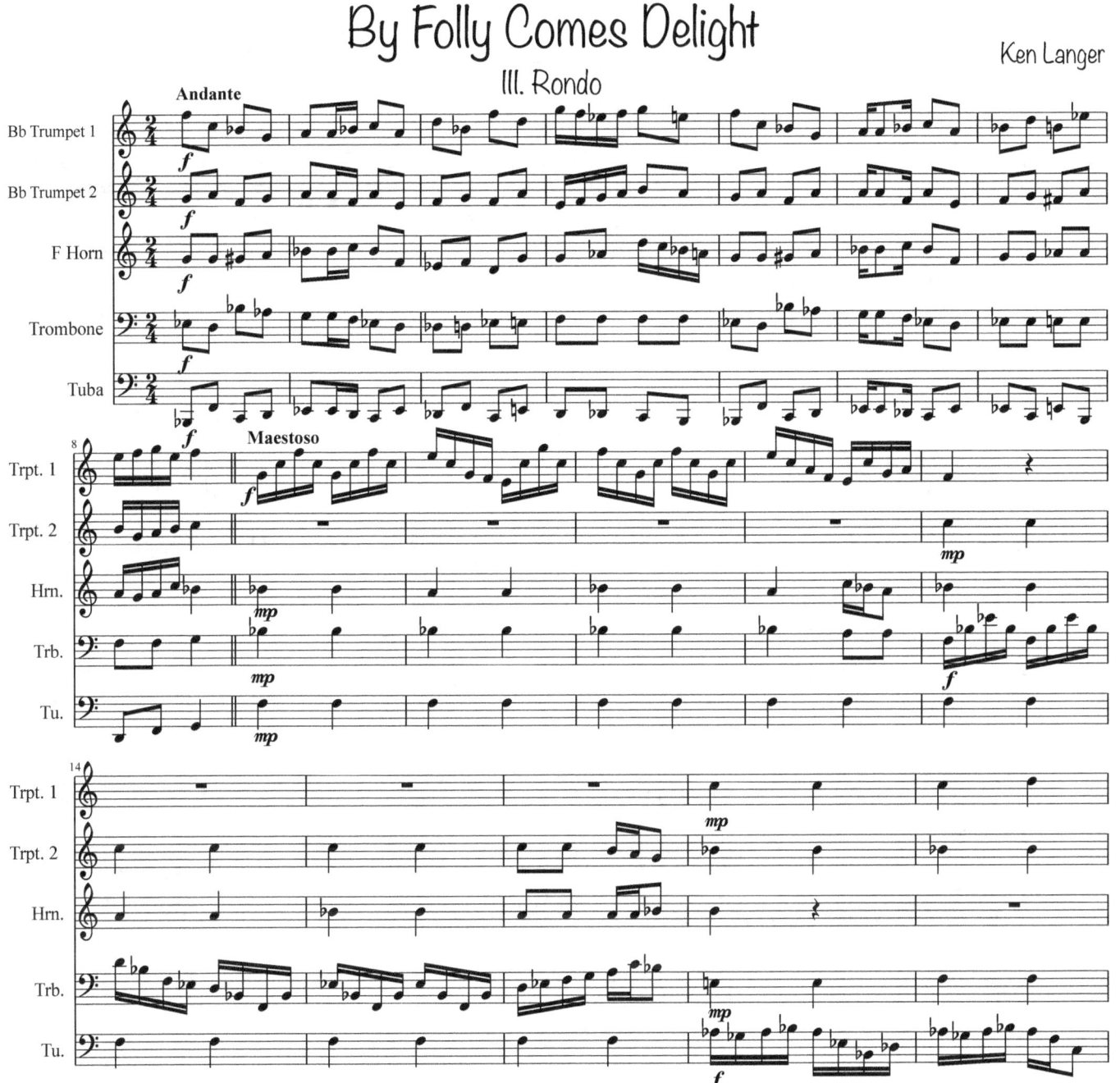

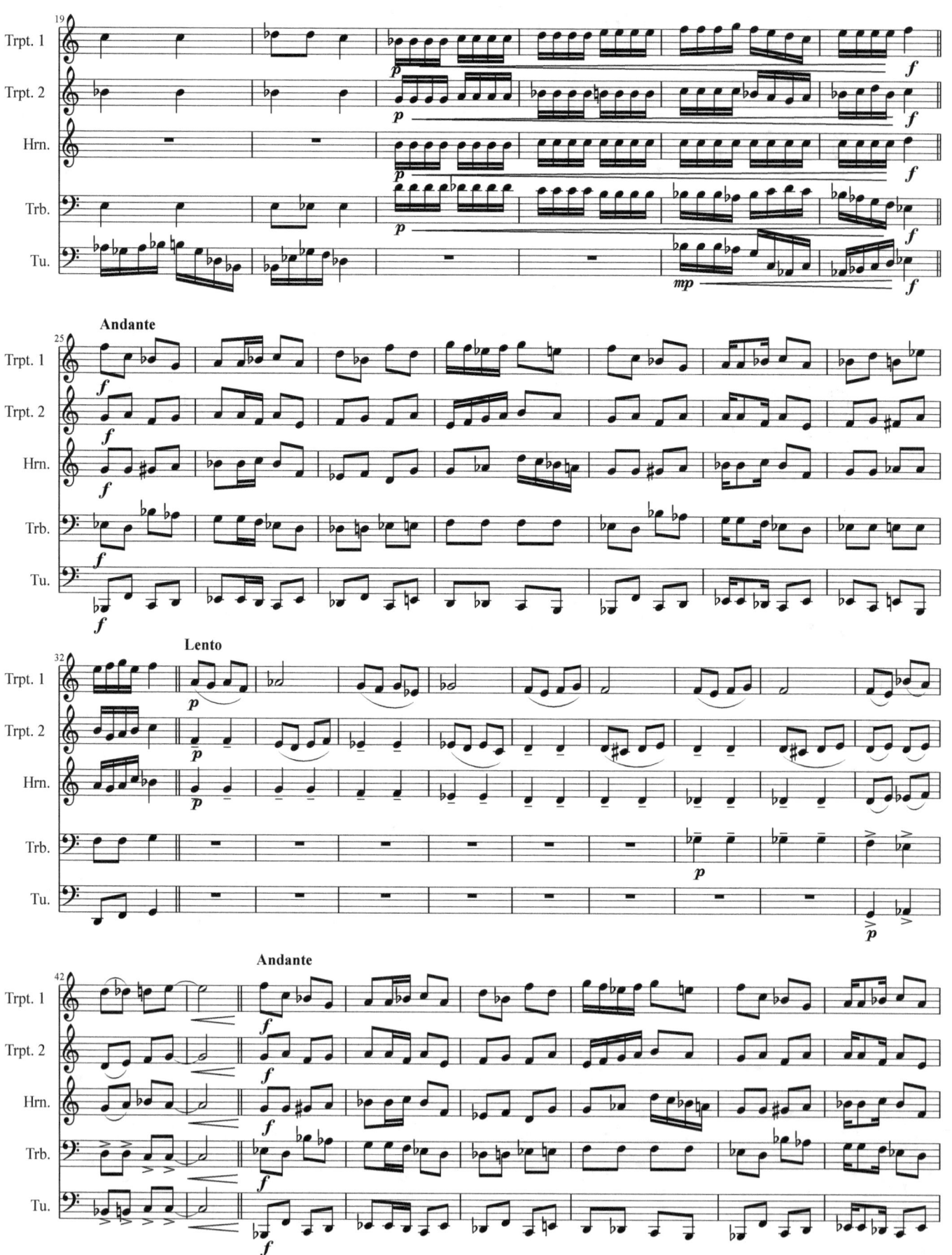

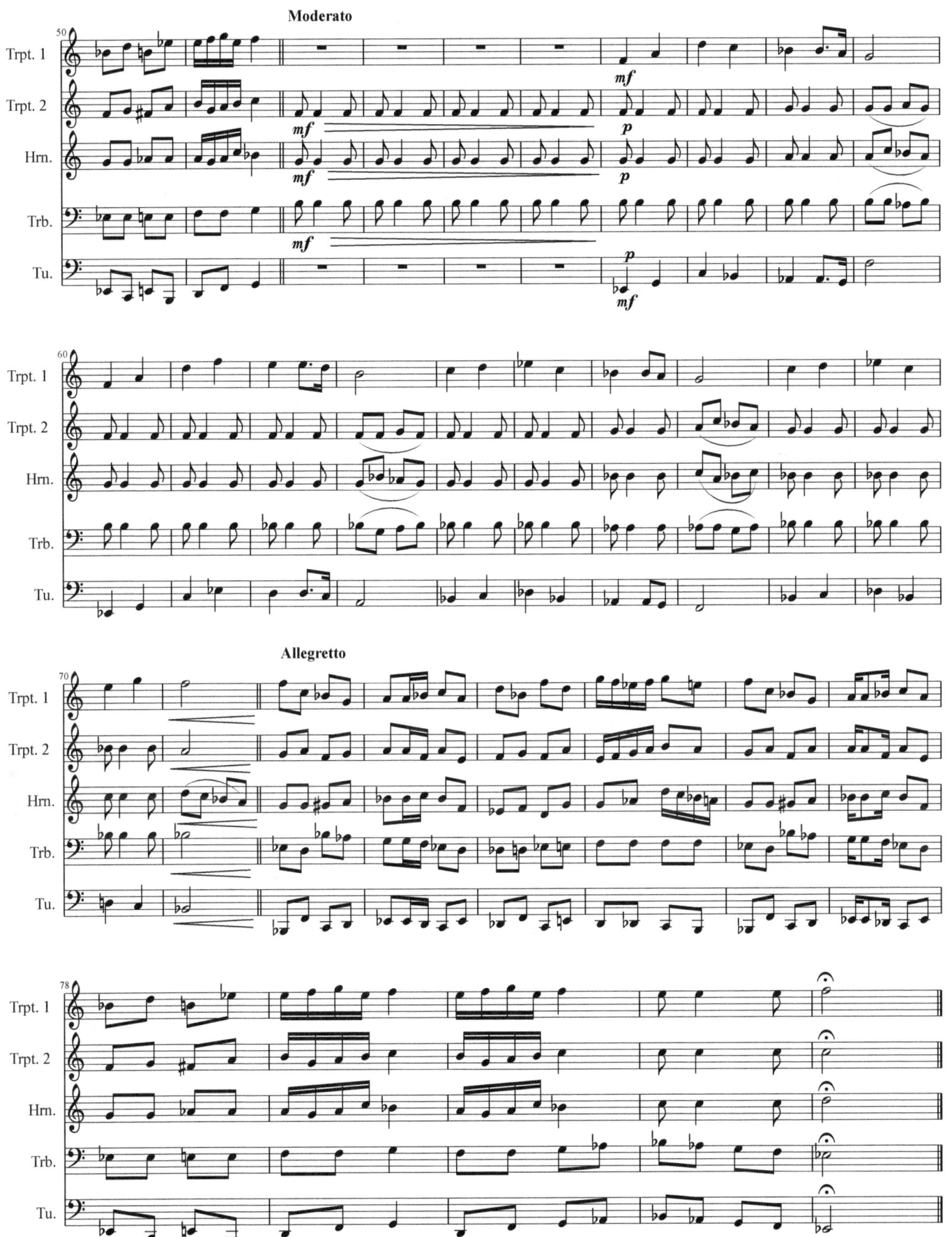

By Folly Comes Delight
IV. Air

Ken Langer

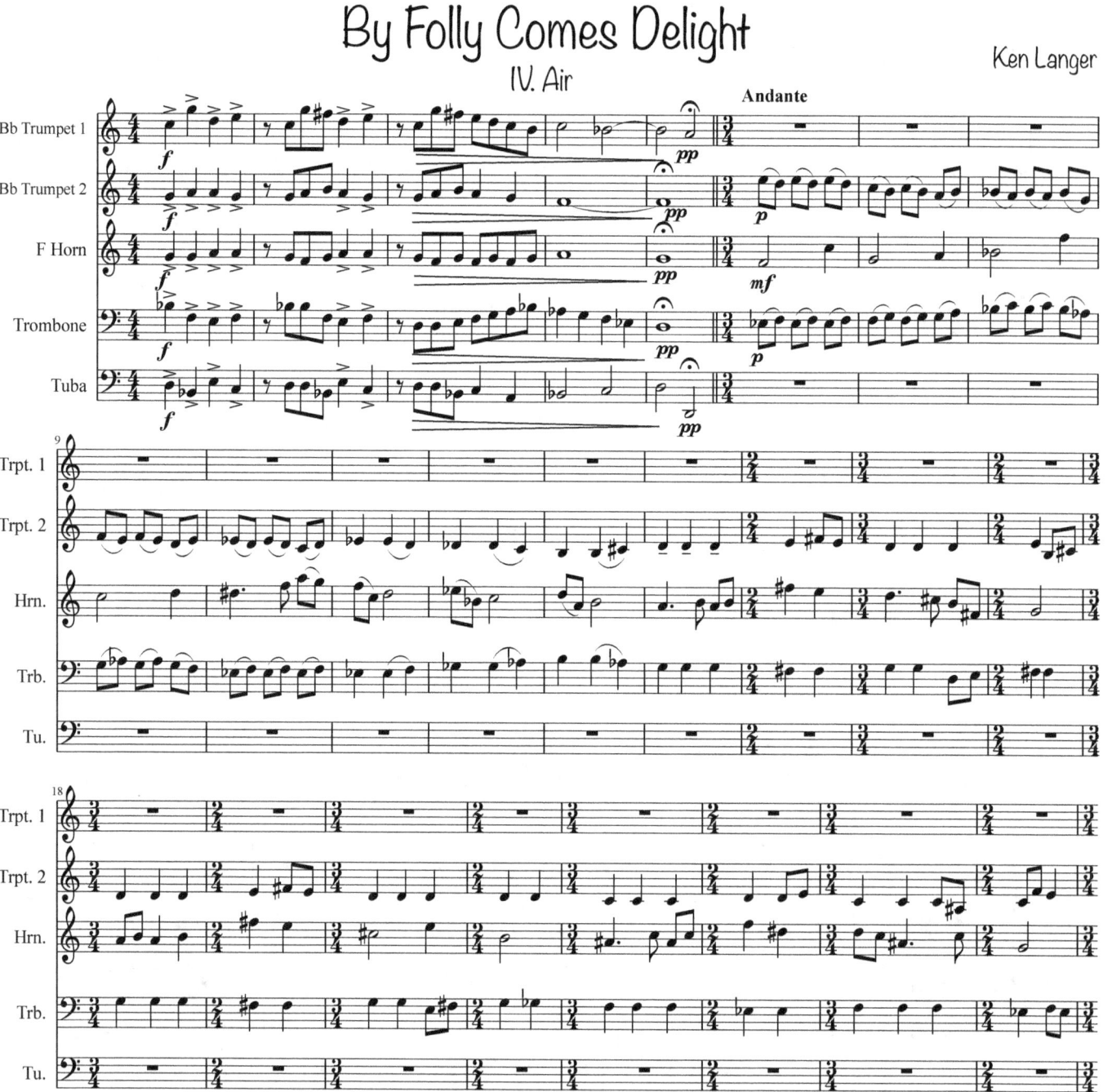

26

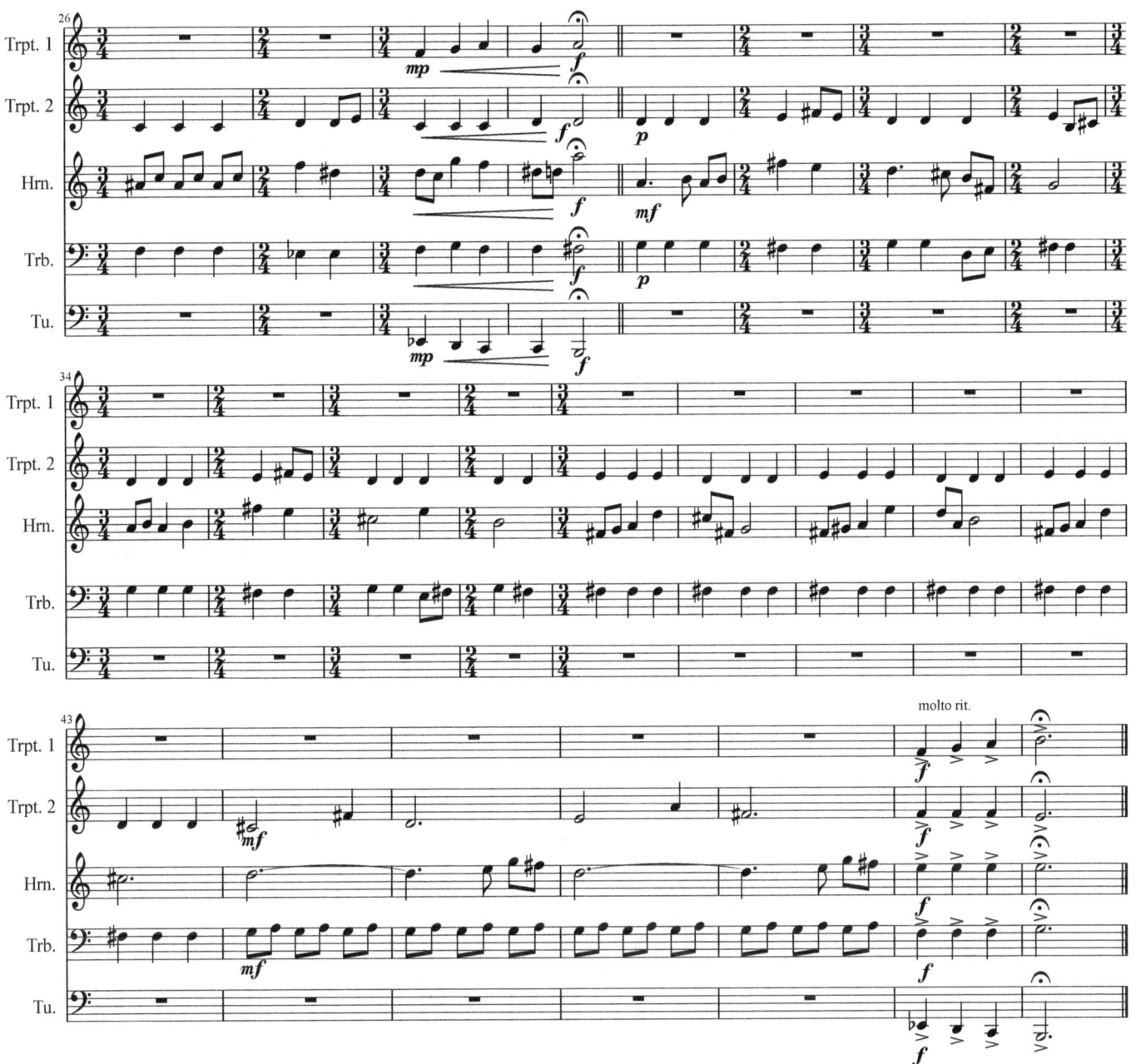

By Folly Comes Delight
V. Fugue and Chorale

Ken Langer

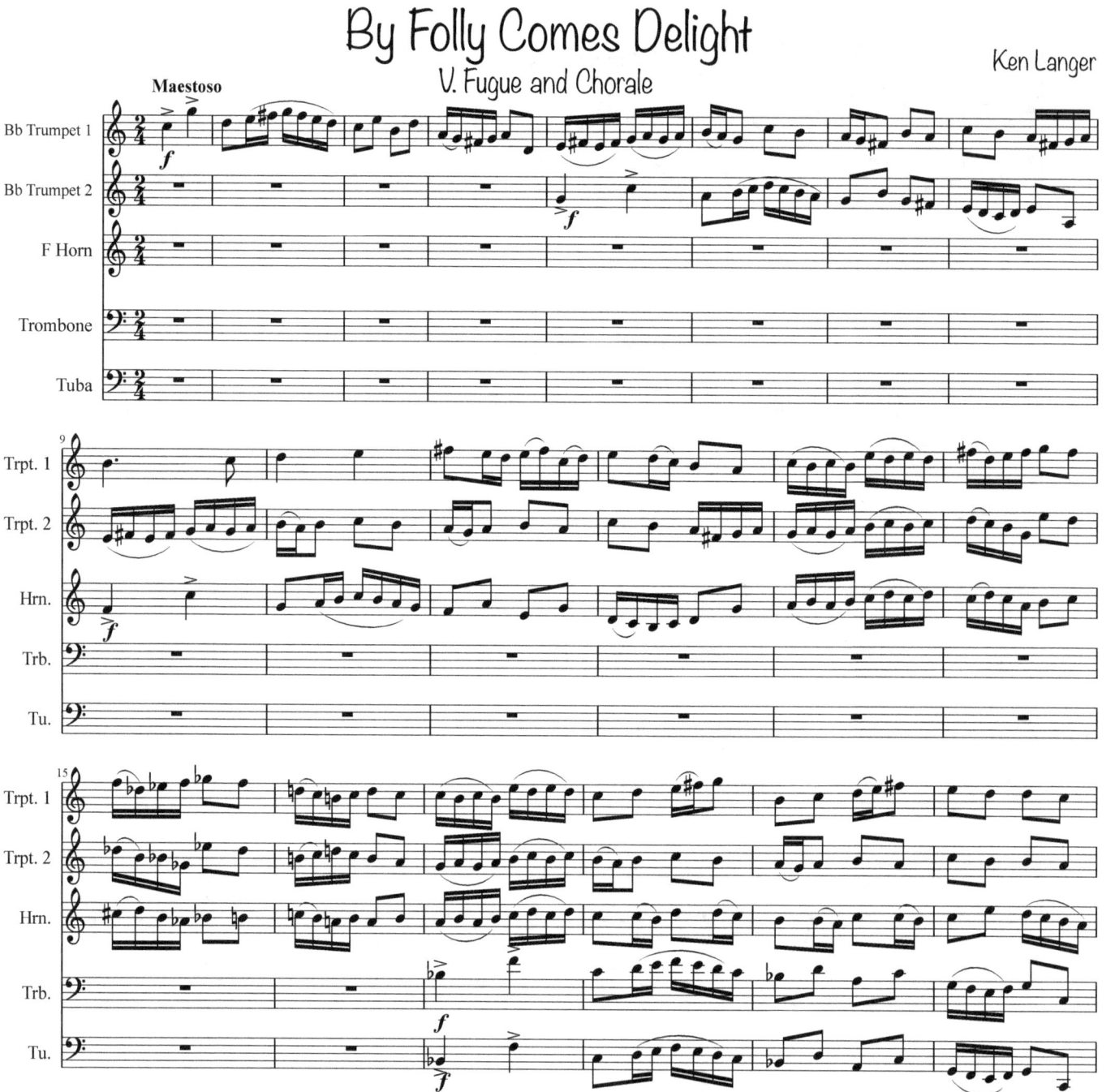

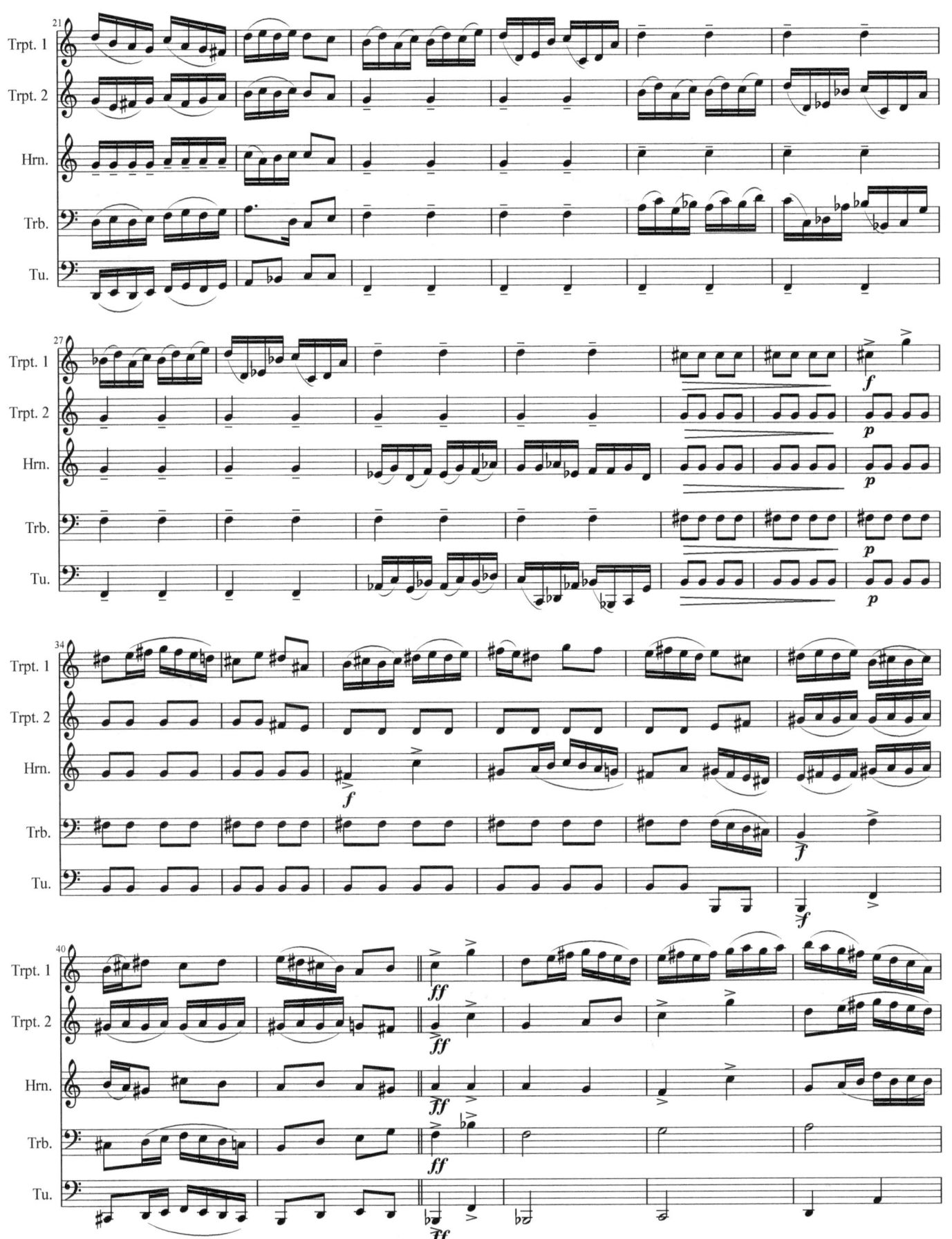

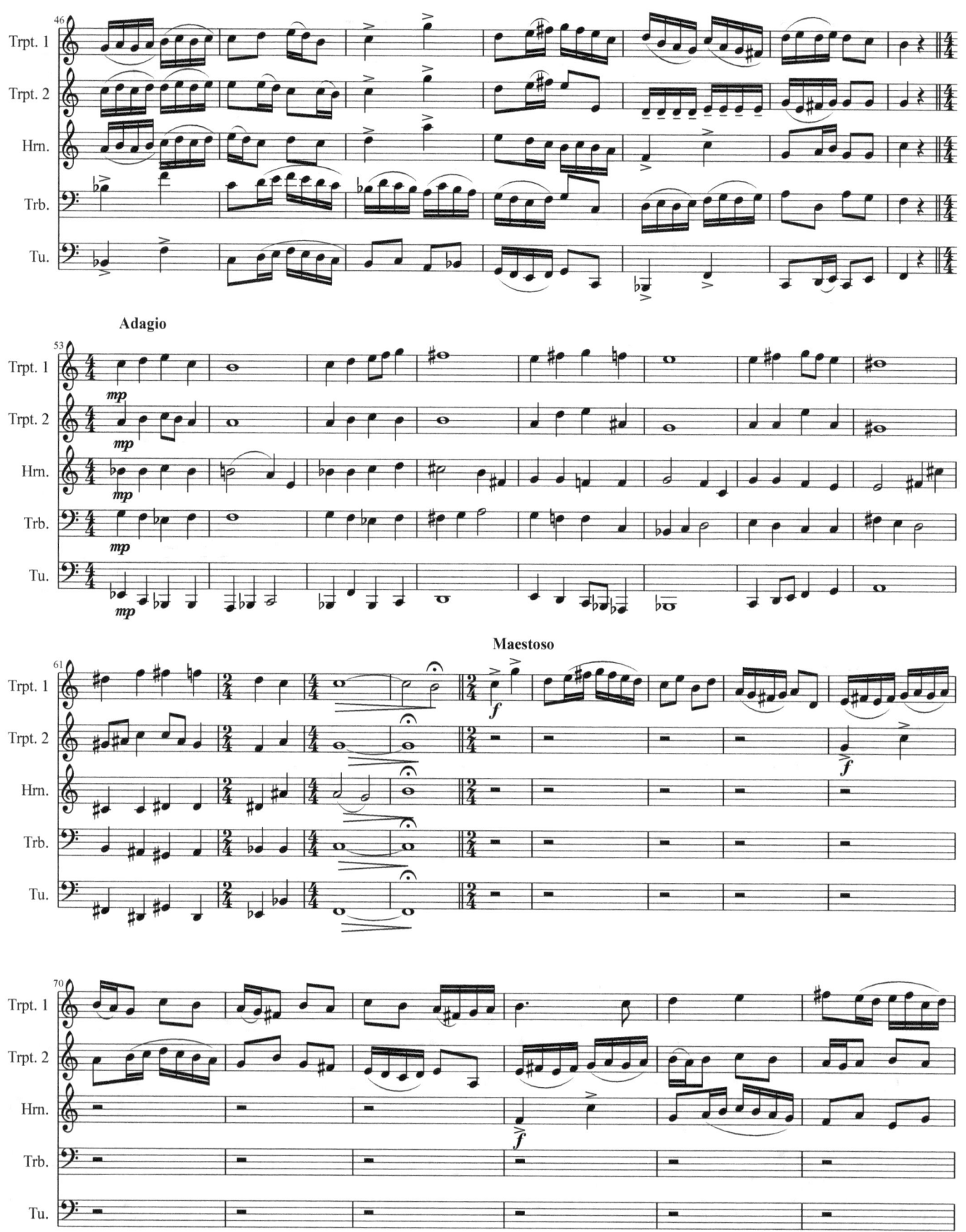

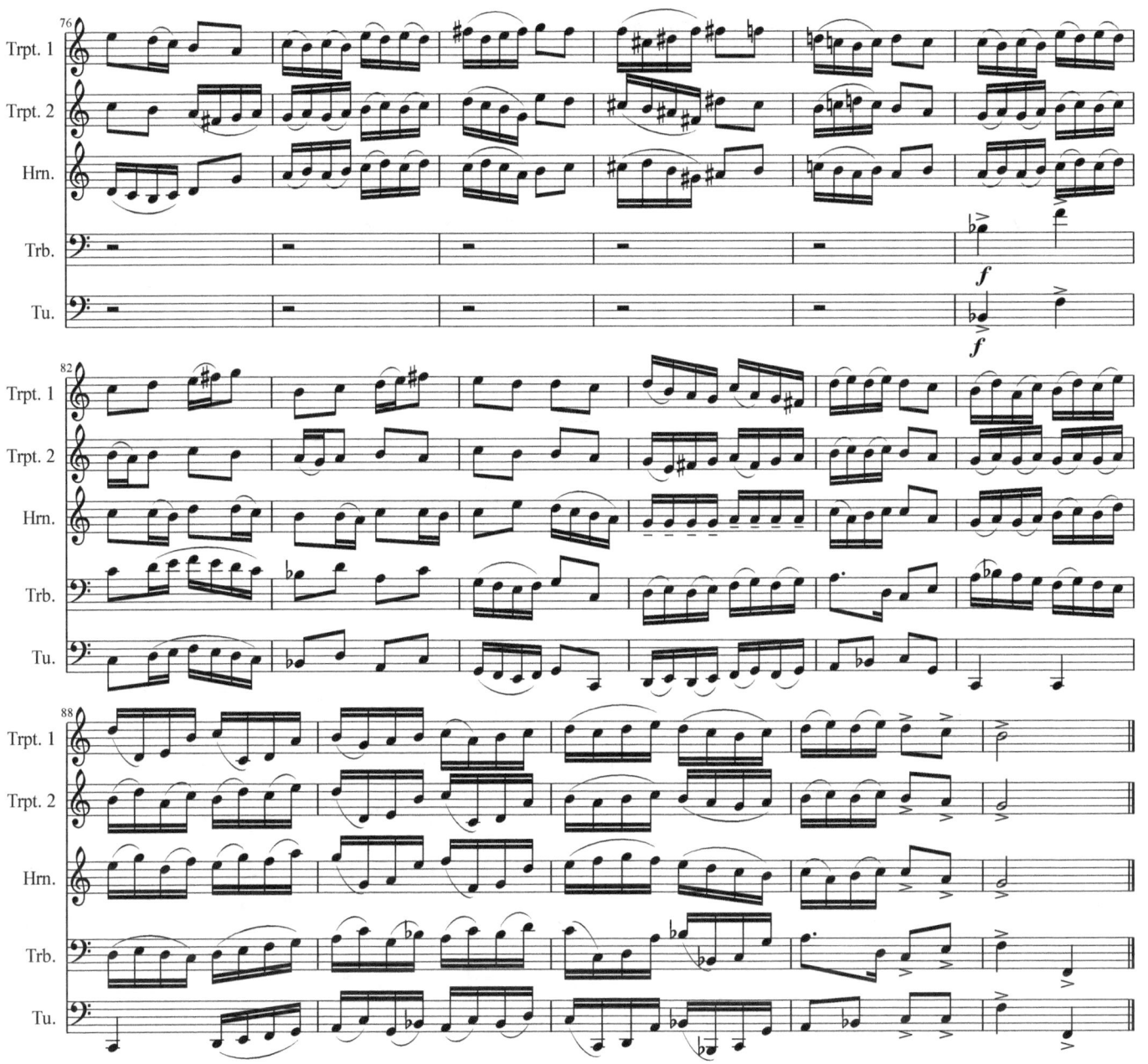

By Folly Comes Delight
VI. Air

Ken Langer

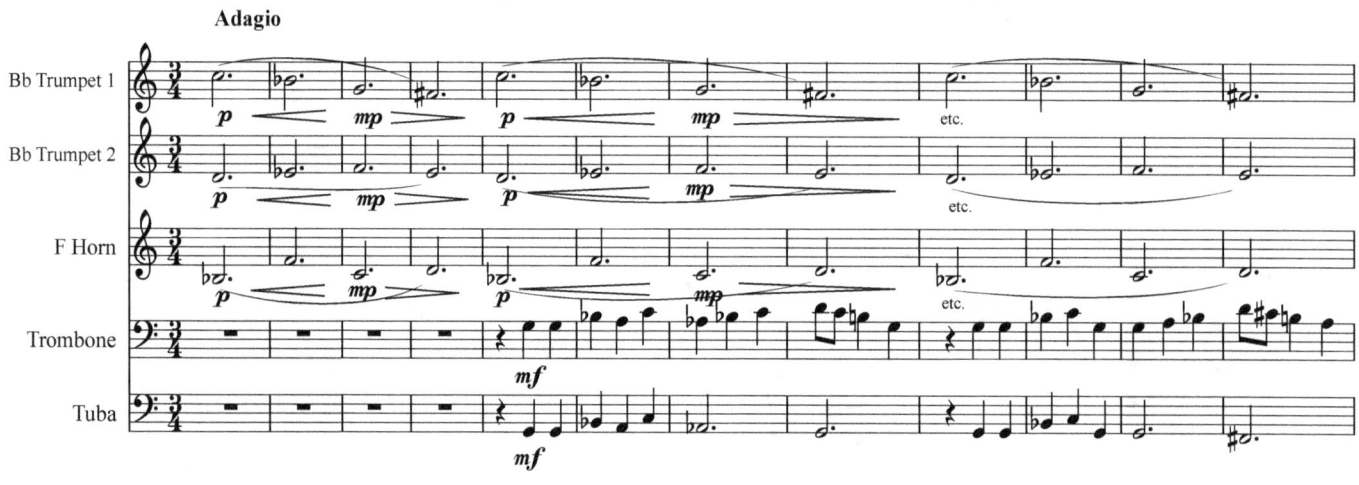
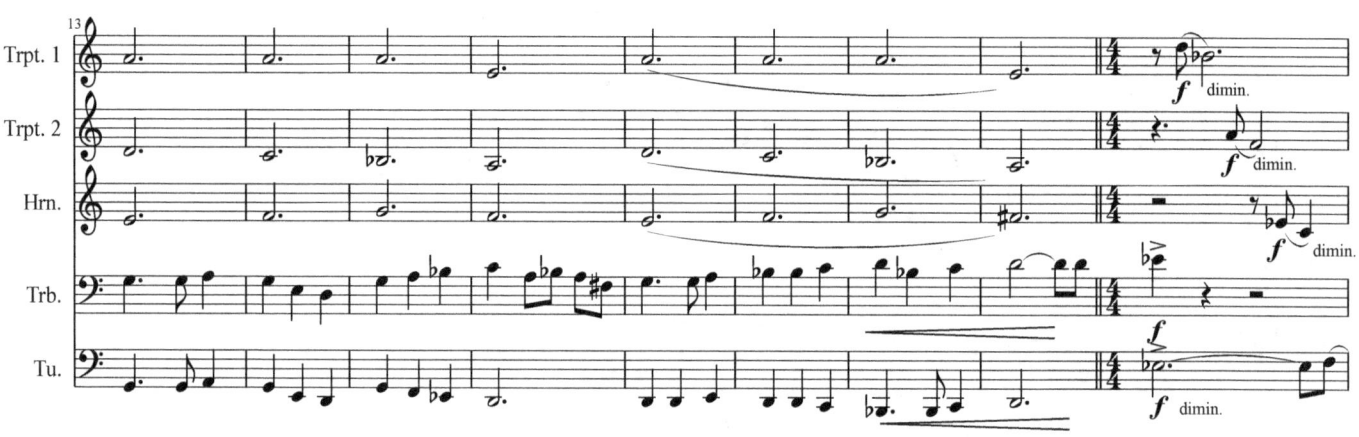
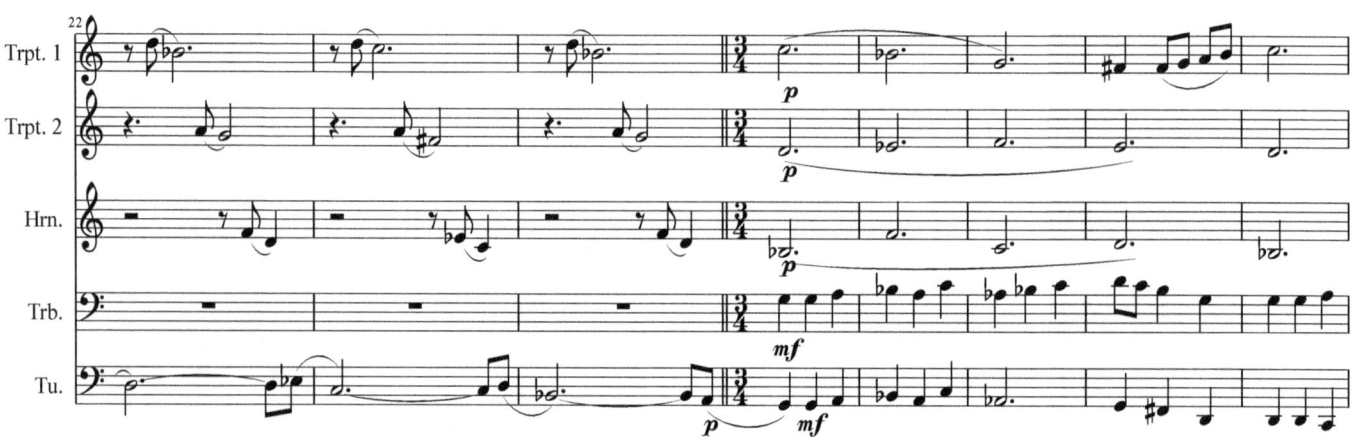

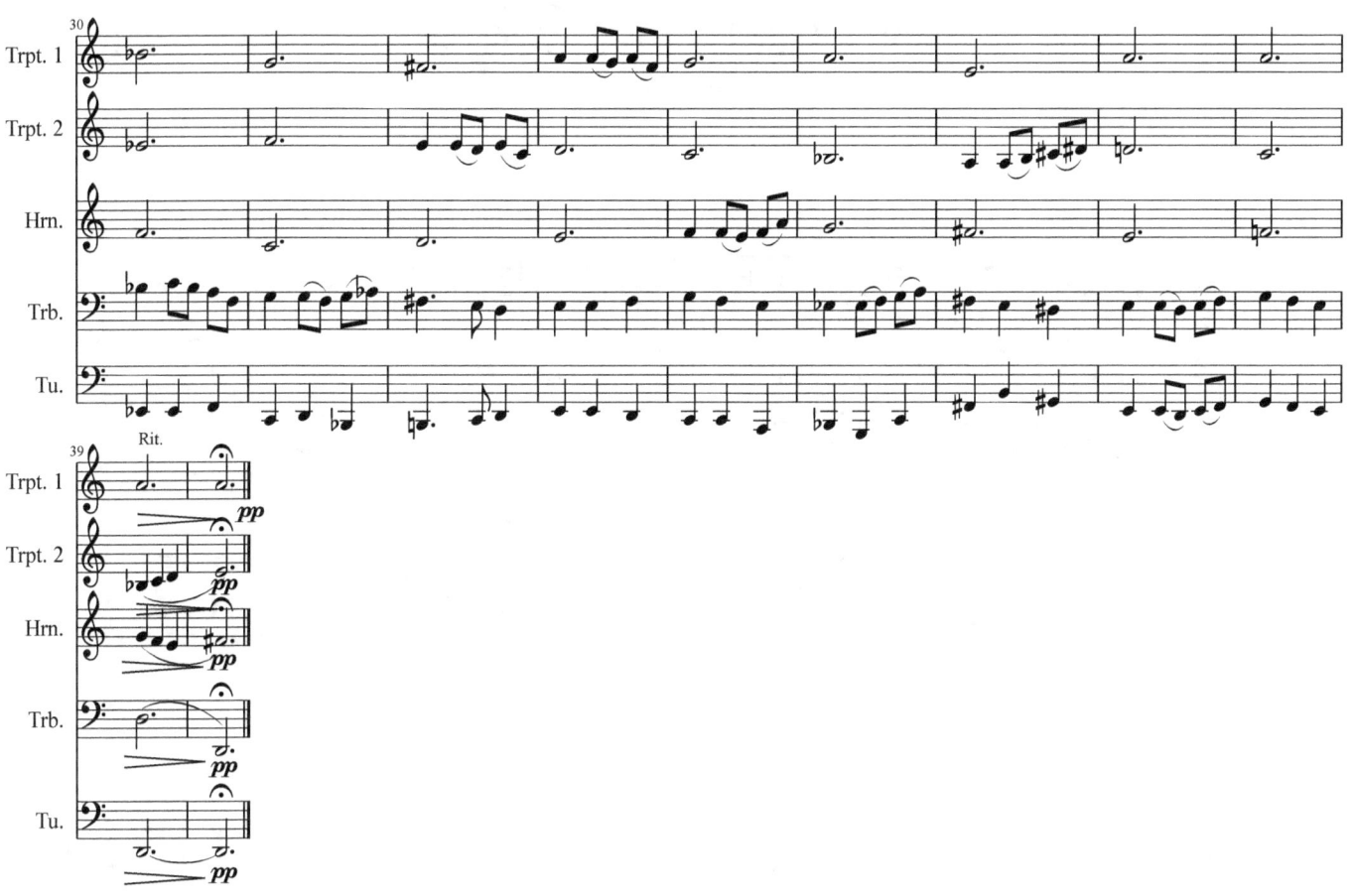

By Folly Comes Delight
VII. Finale

Ken Langer

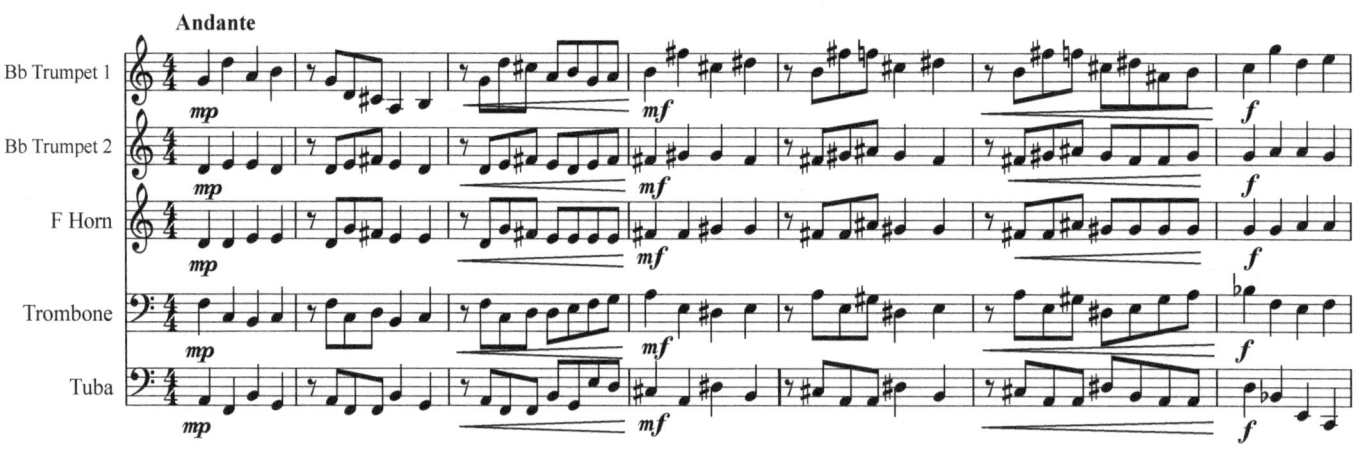
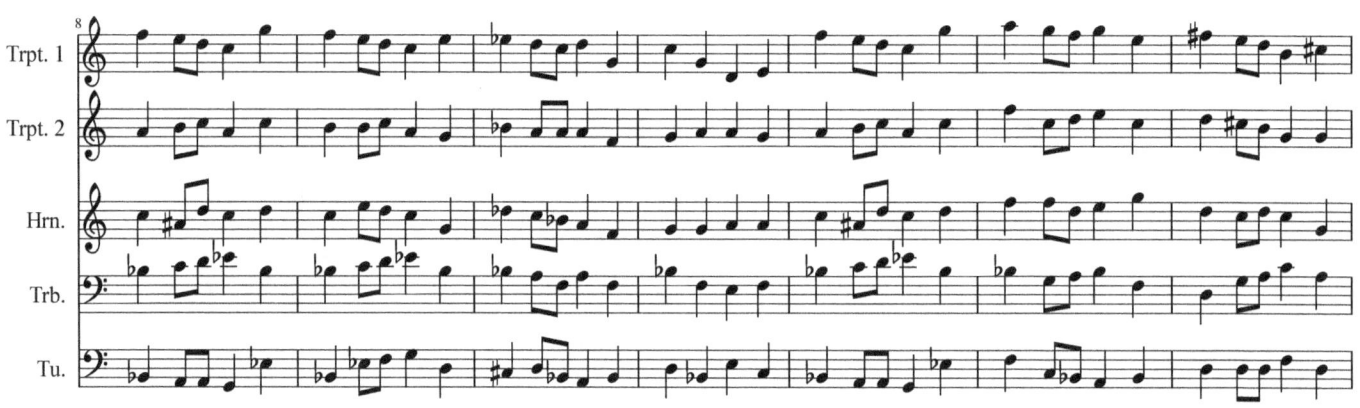
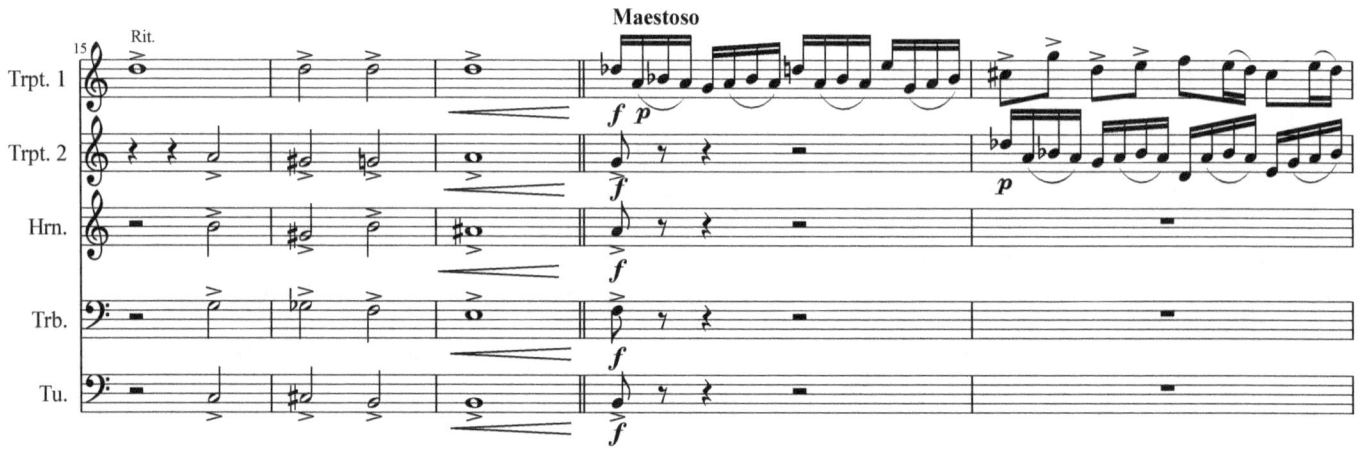

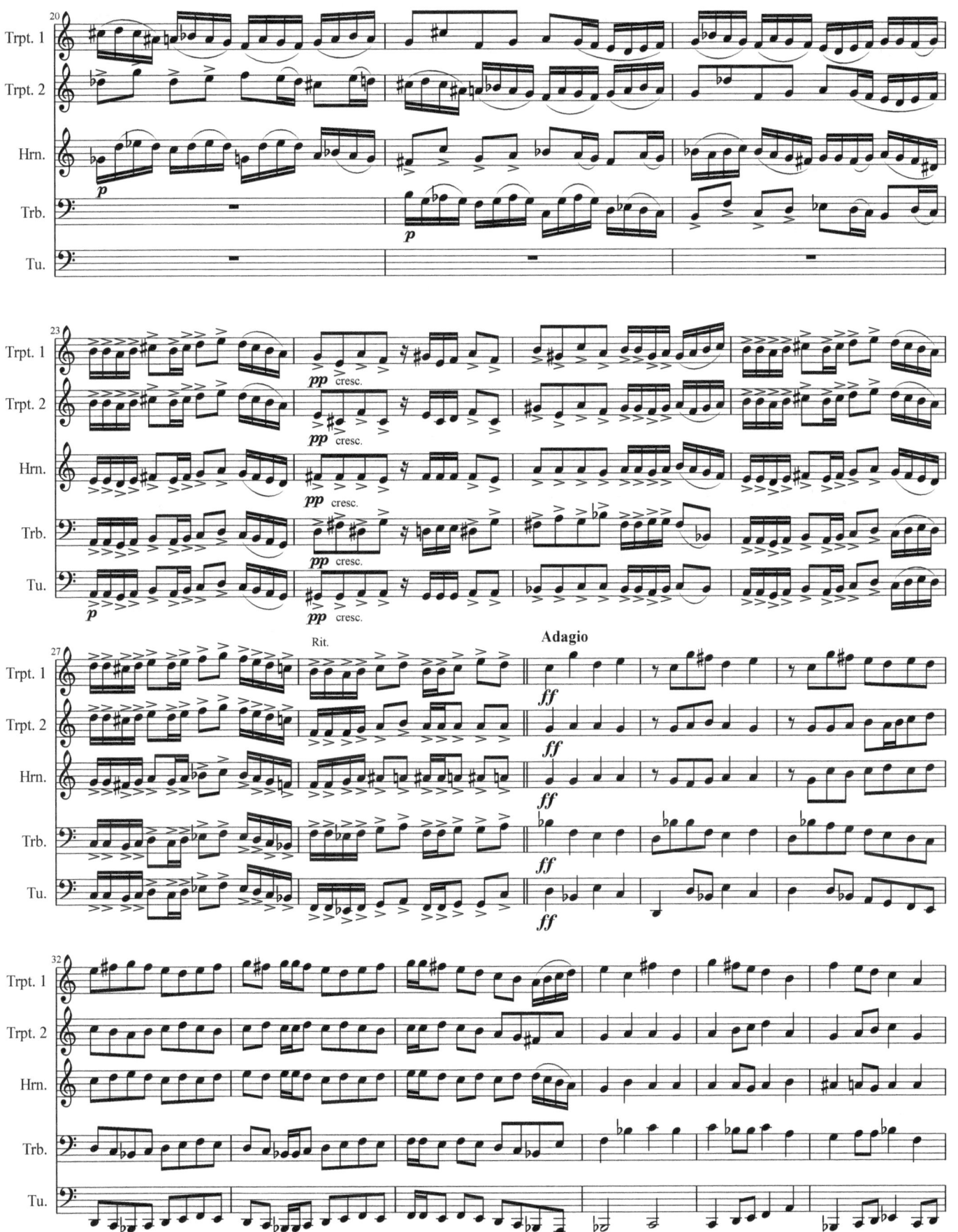

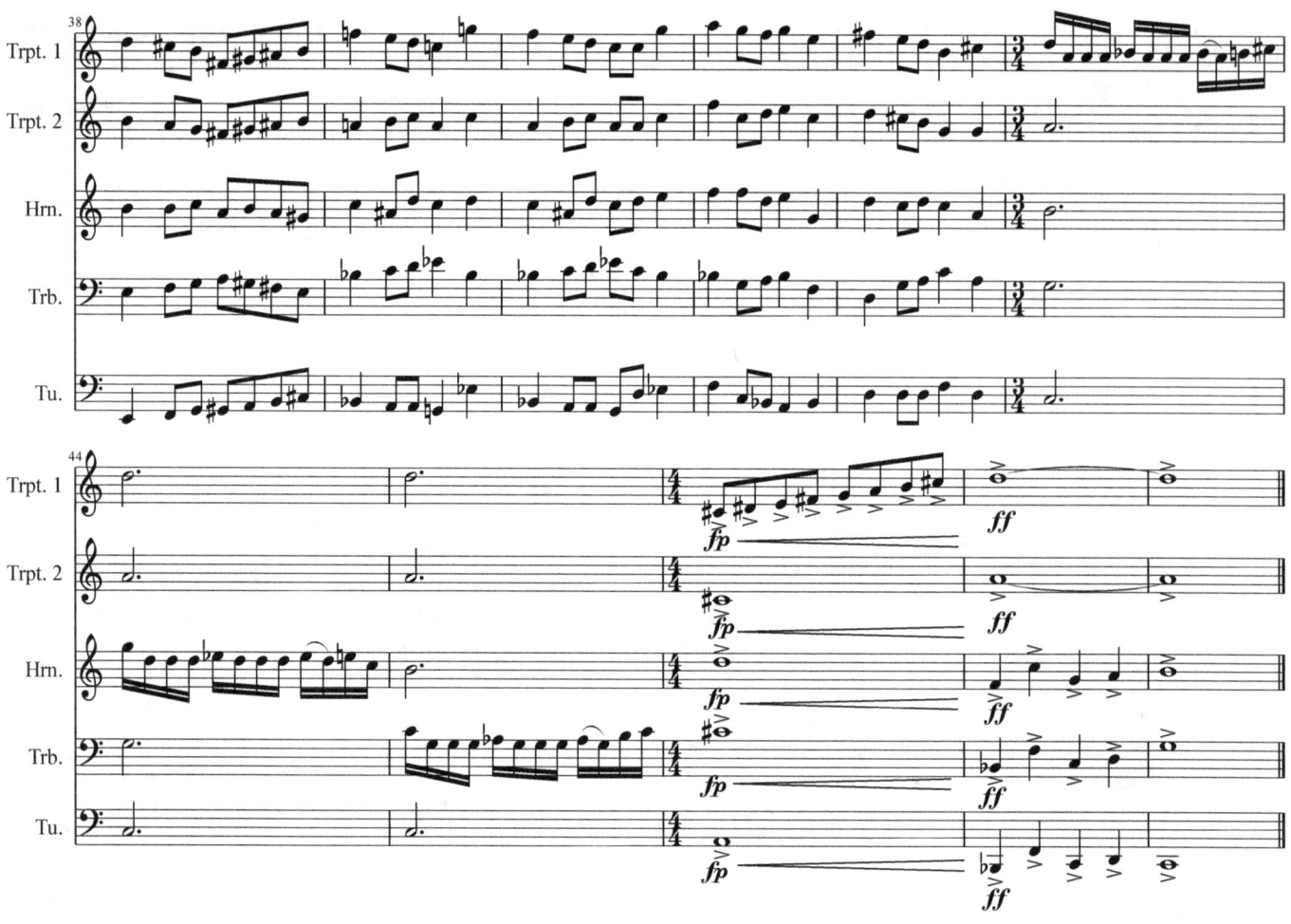

Concert Fanfare

Ken Langer

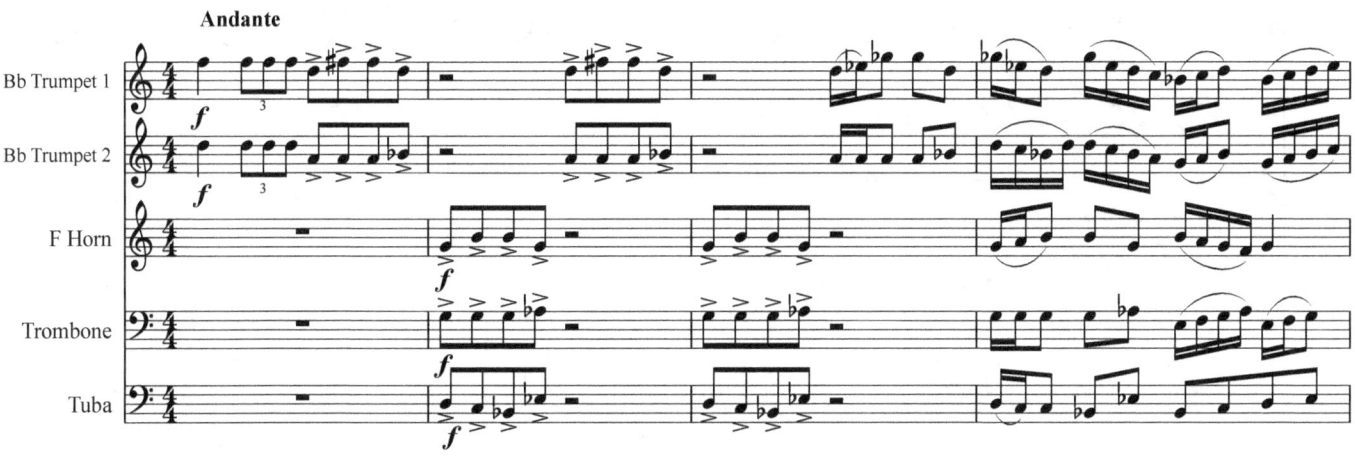
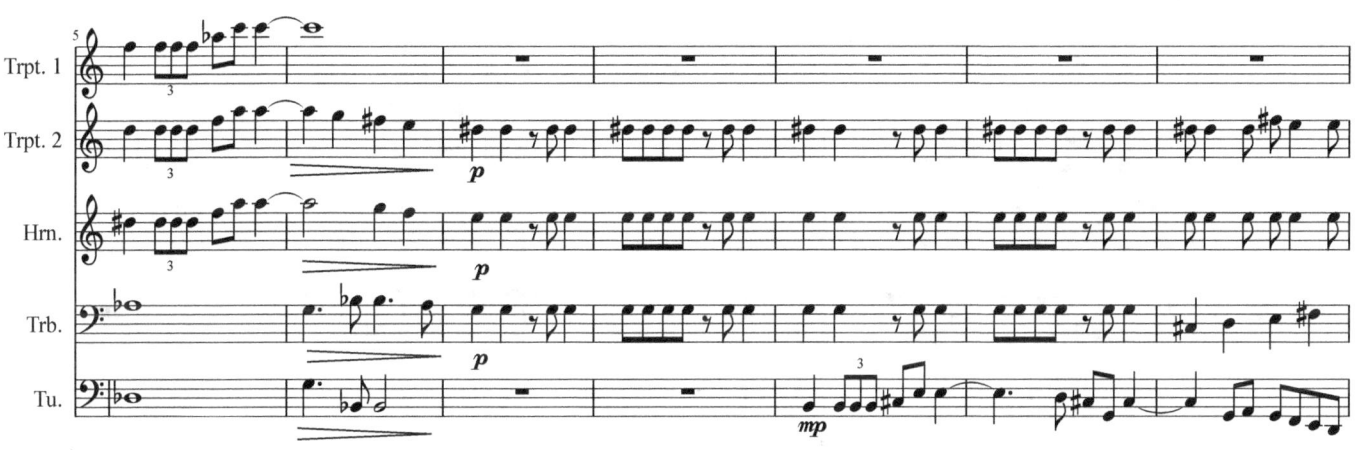
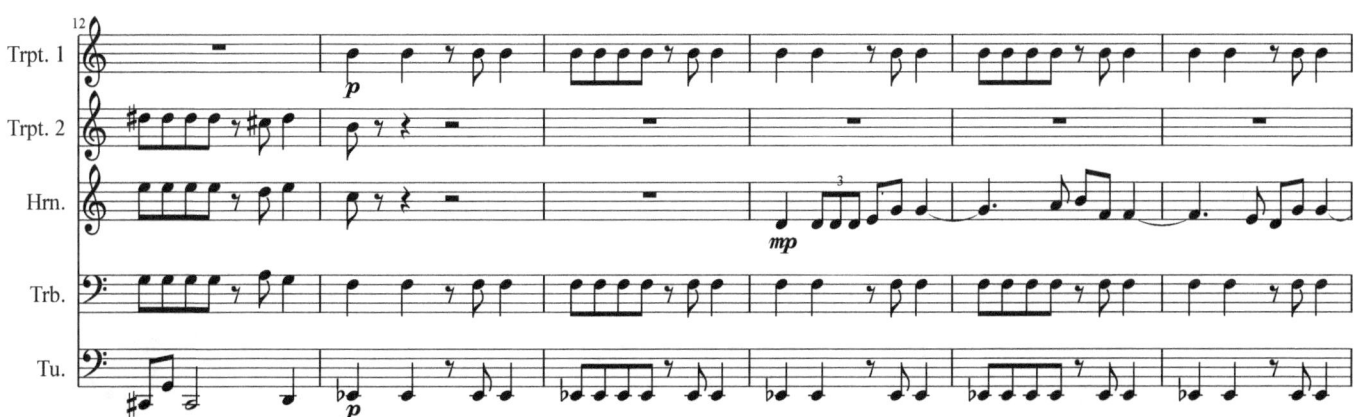

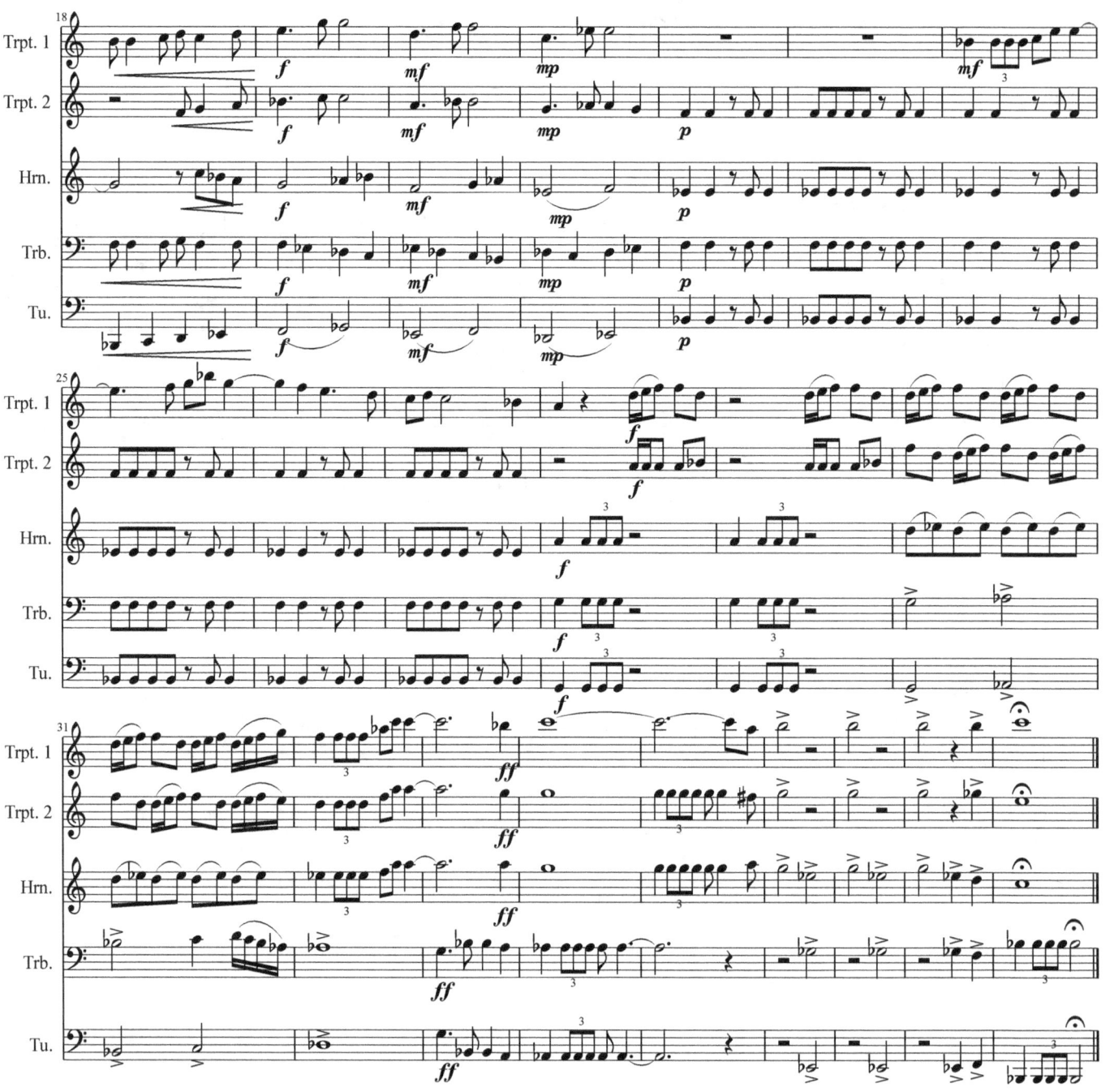

The Insulting Quintet

Ken Langer

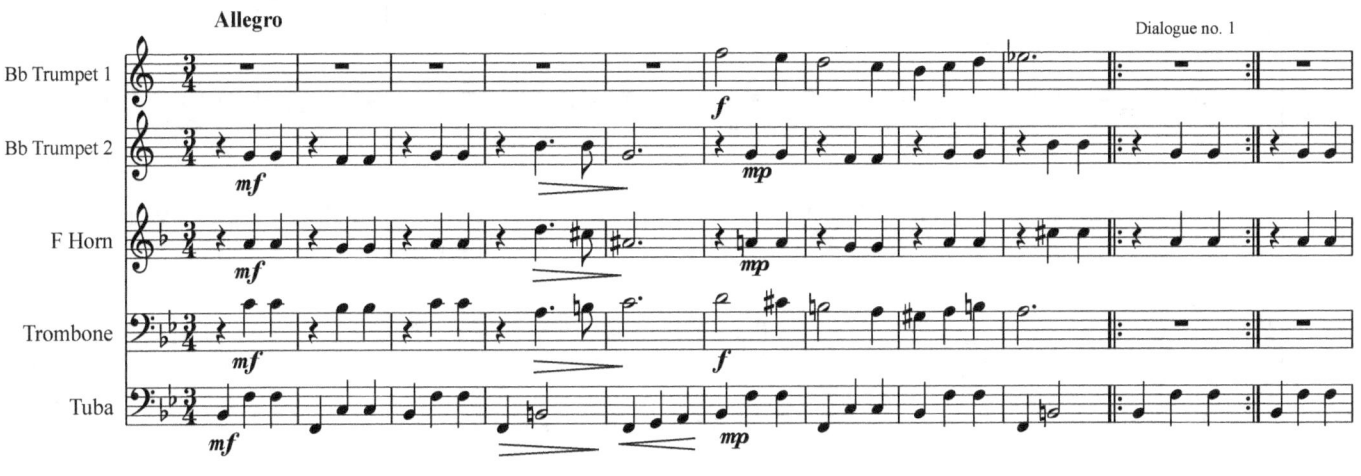
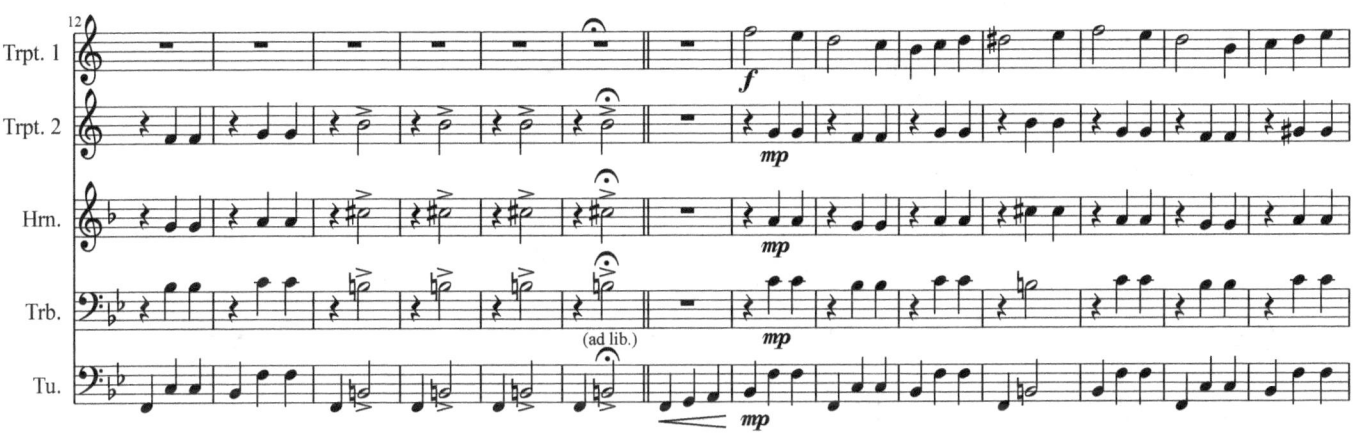
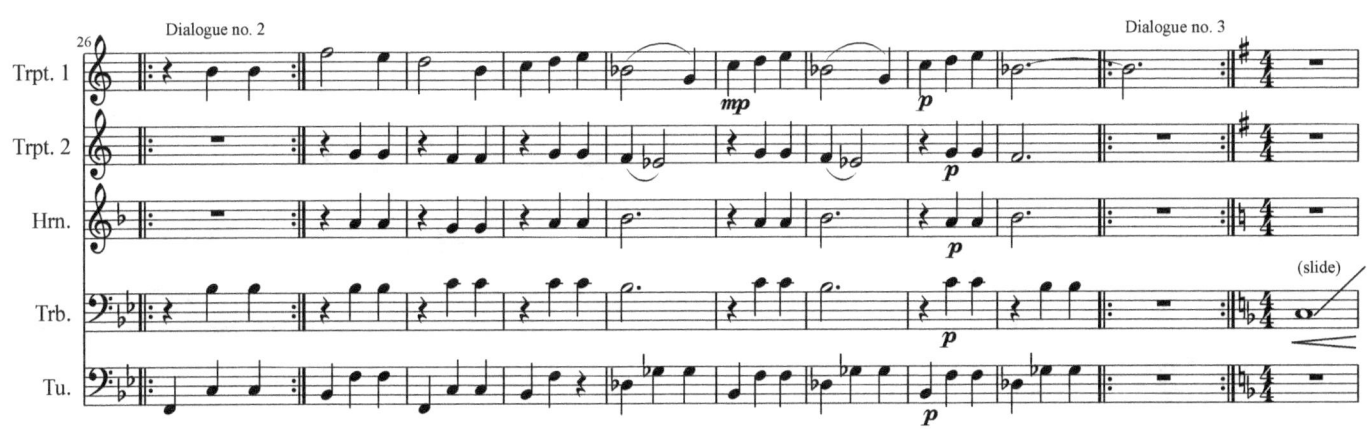

39

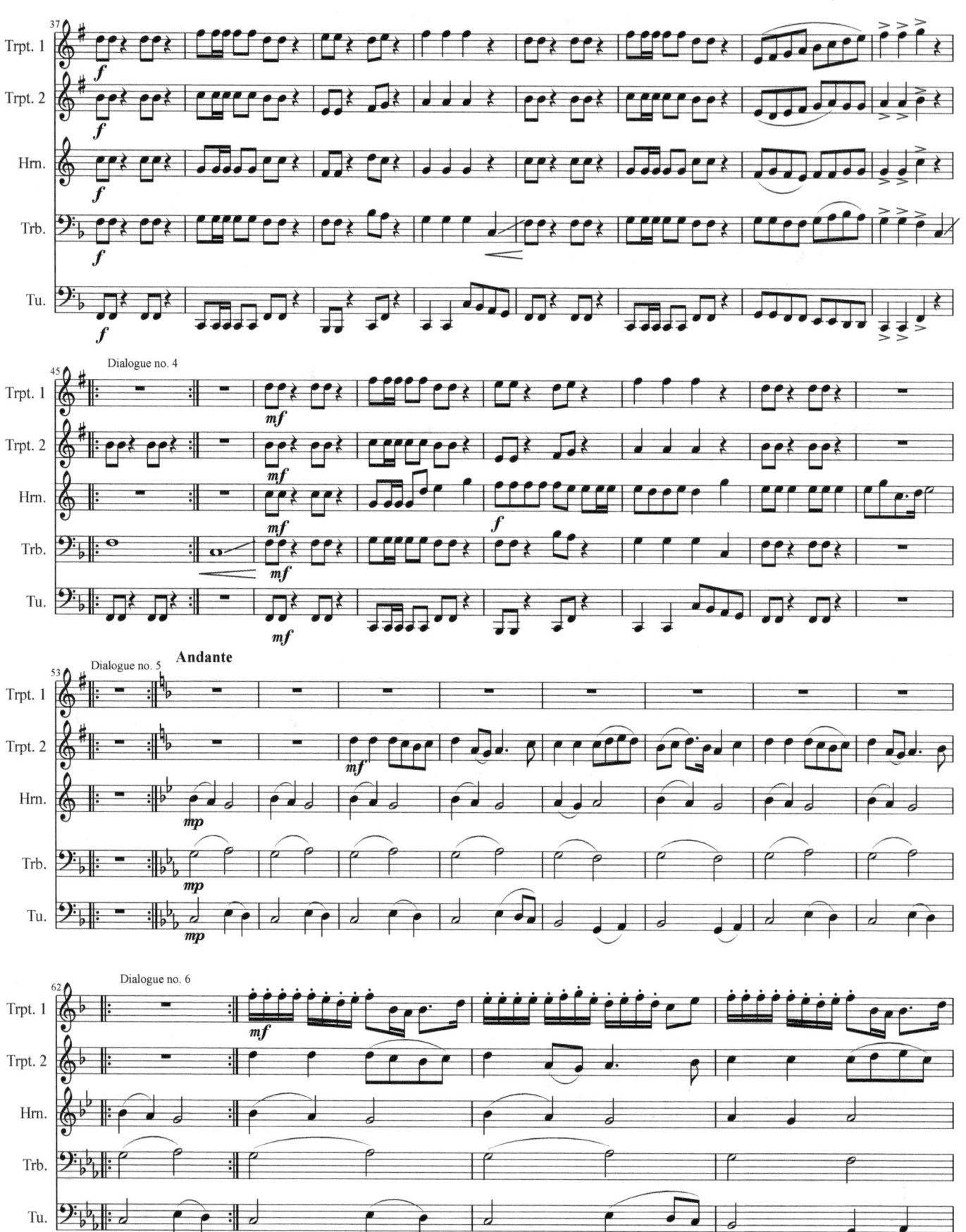

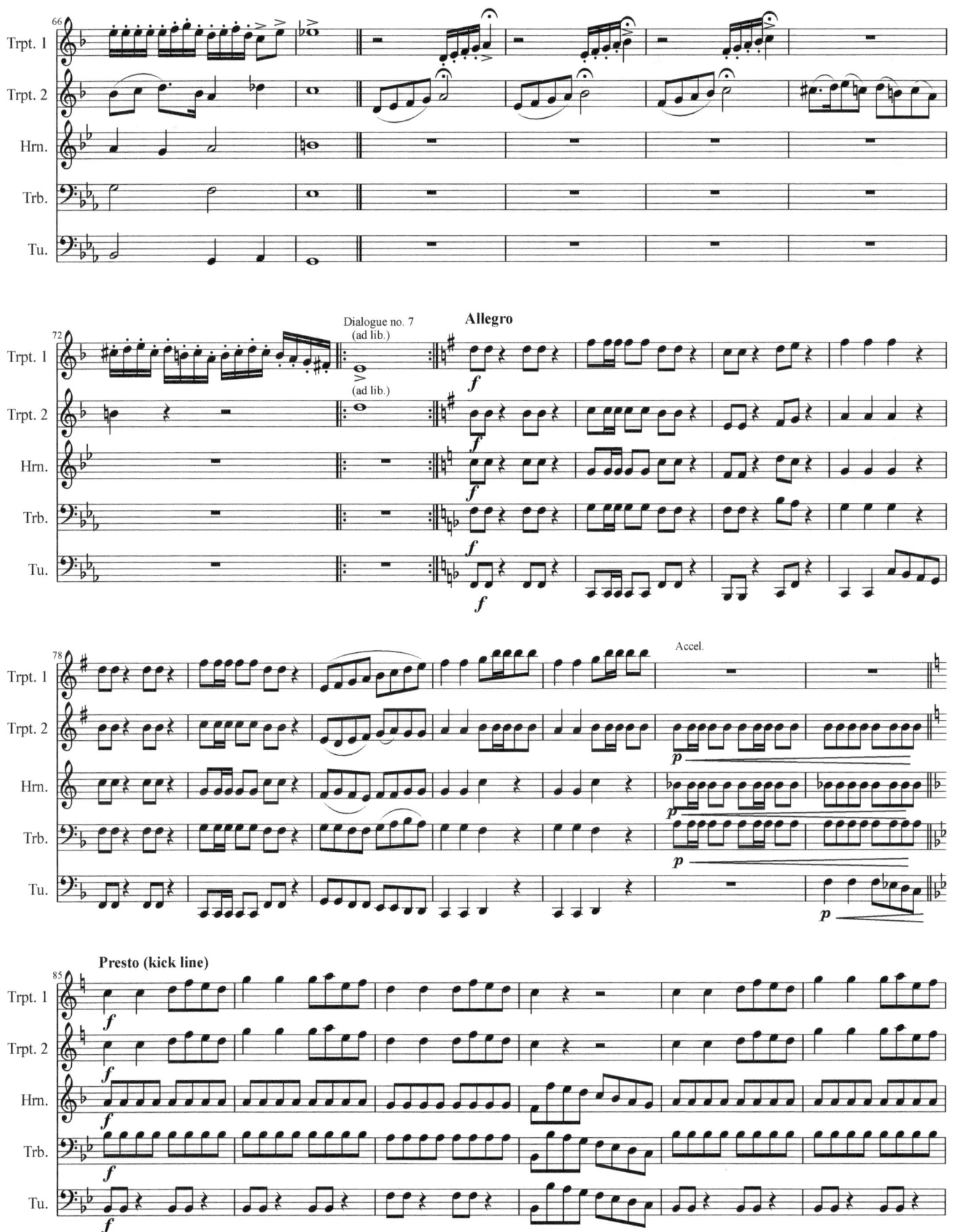

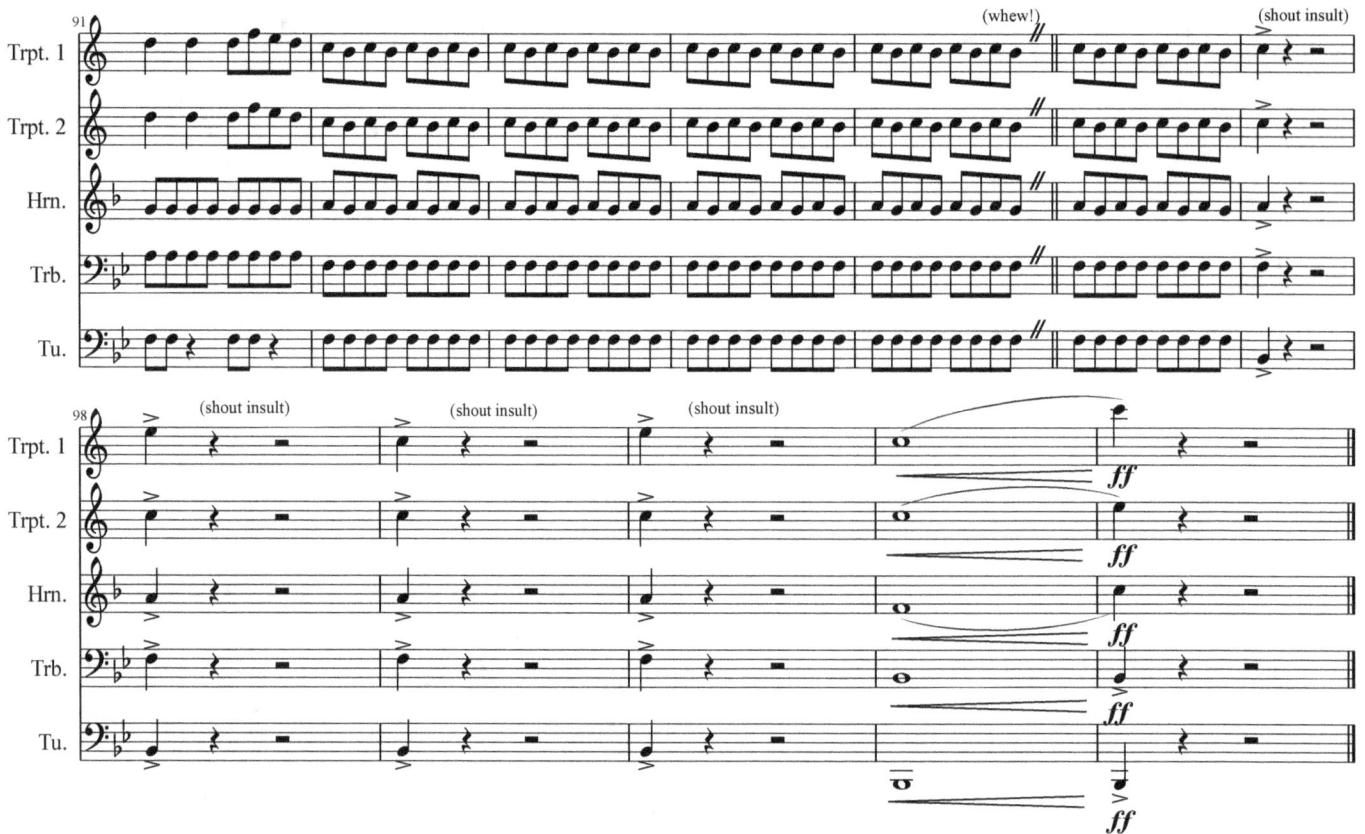

Dialogues are on page 144.

Moose River Suite

Ken Langer

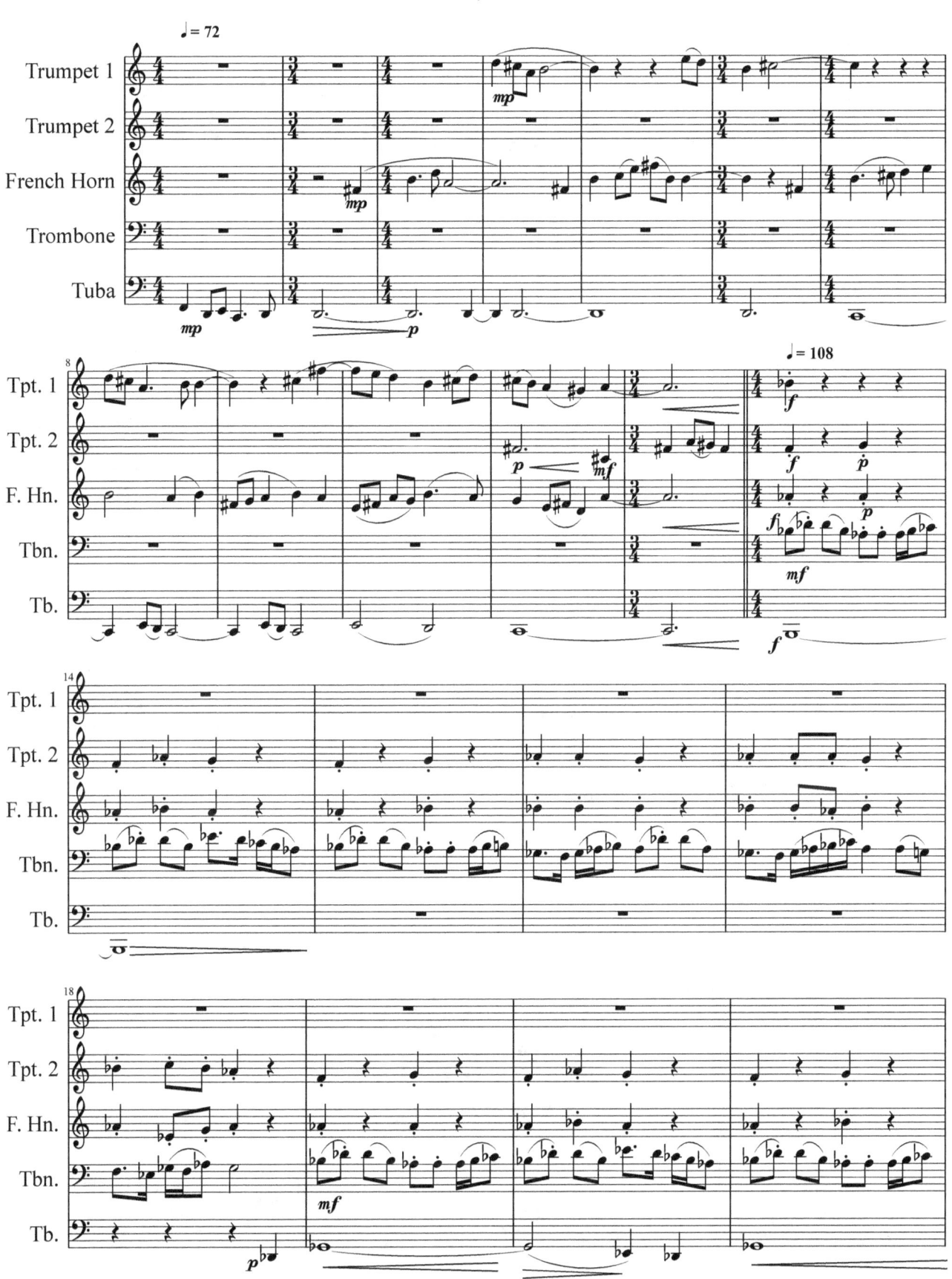

43

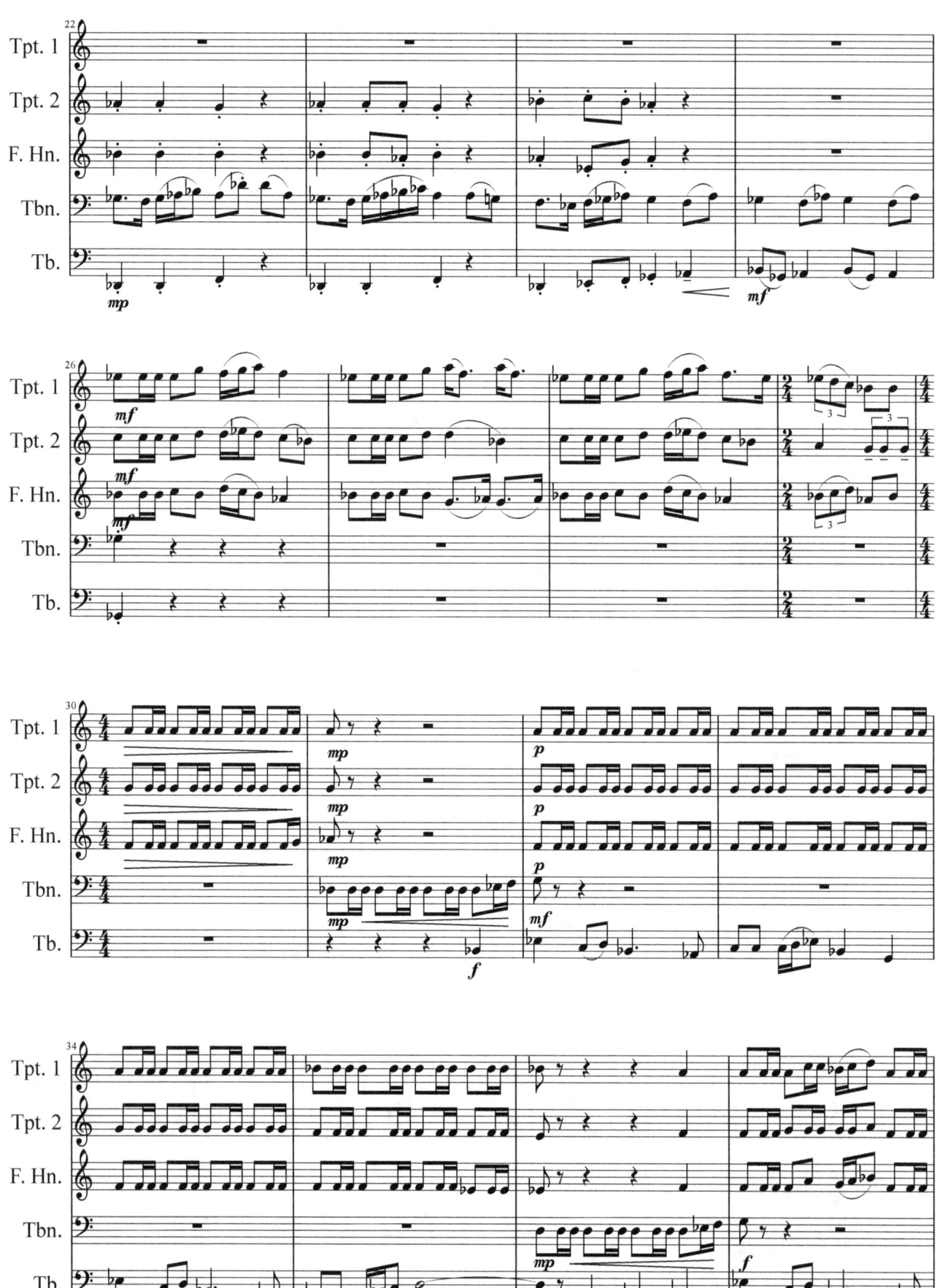

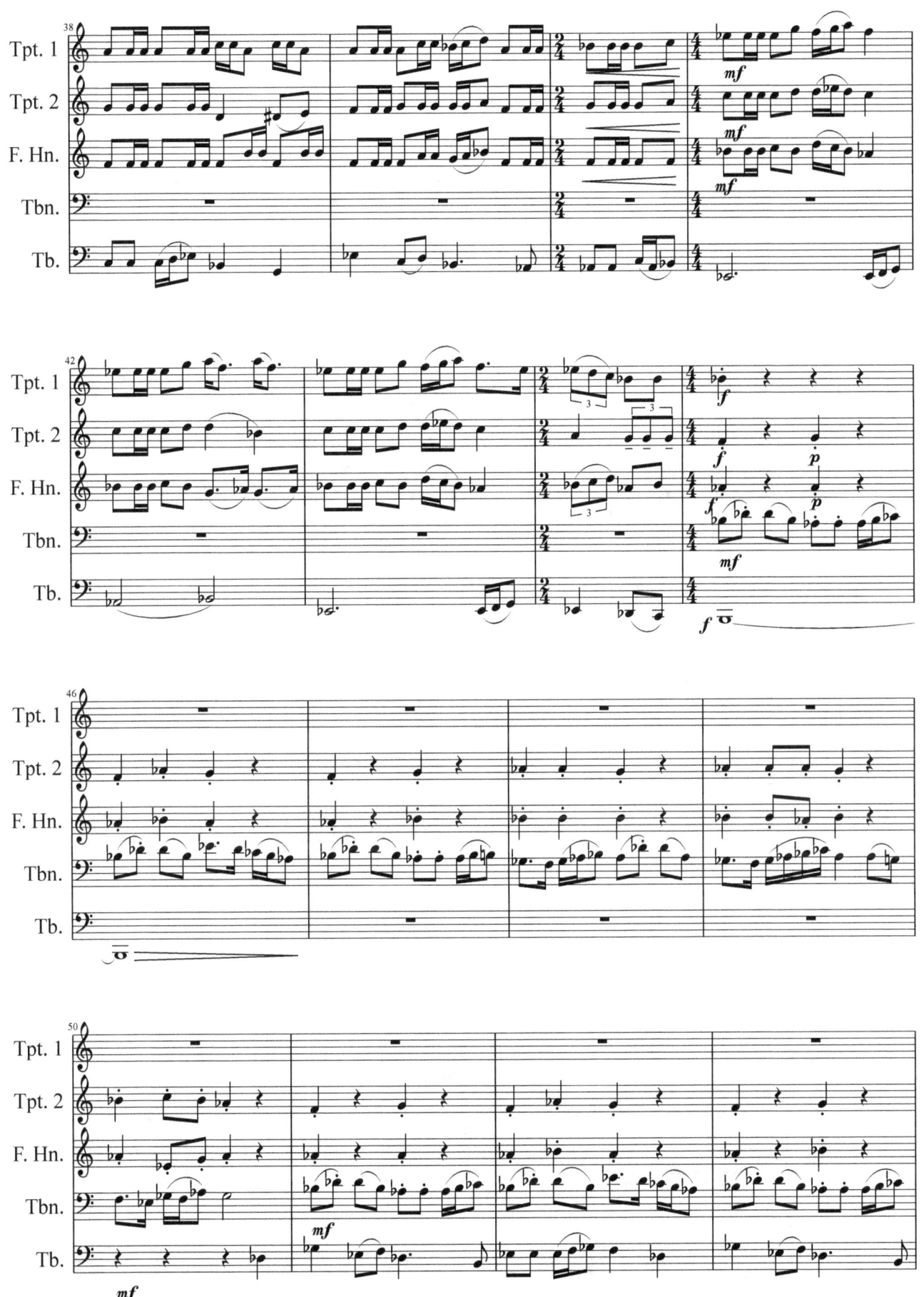

45

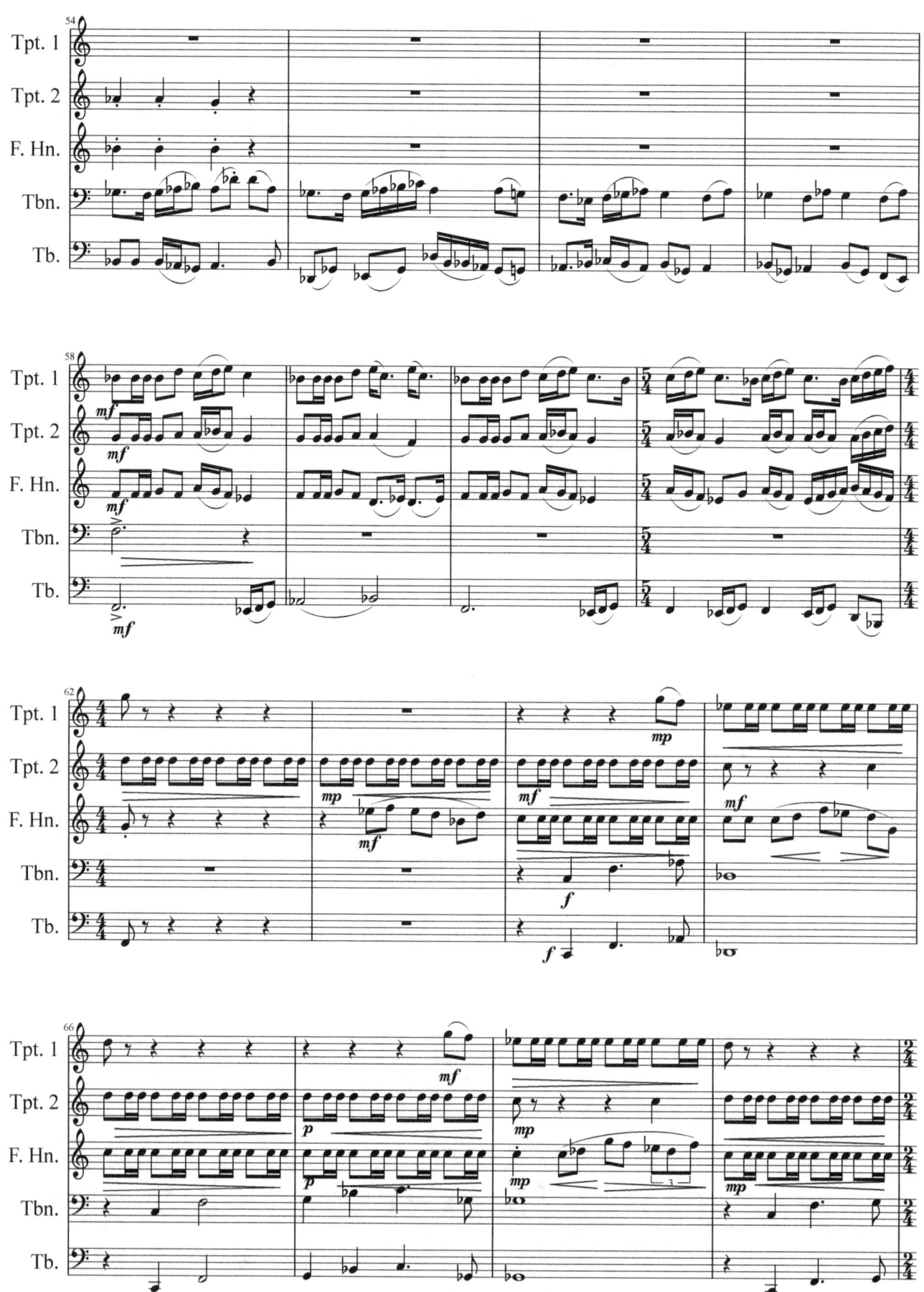

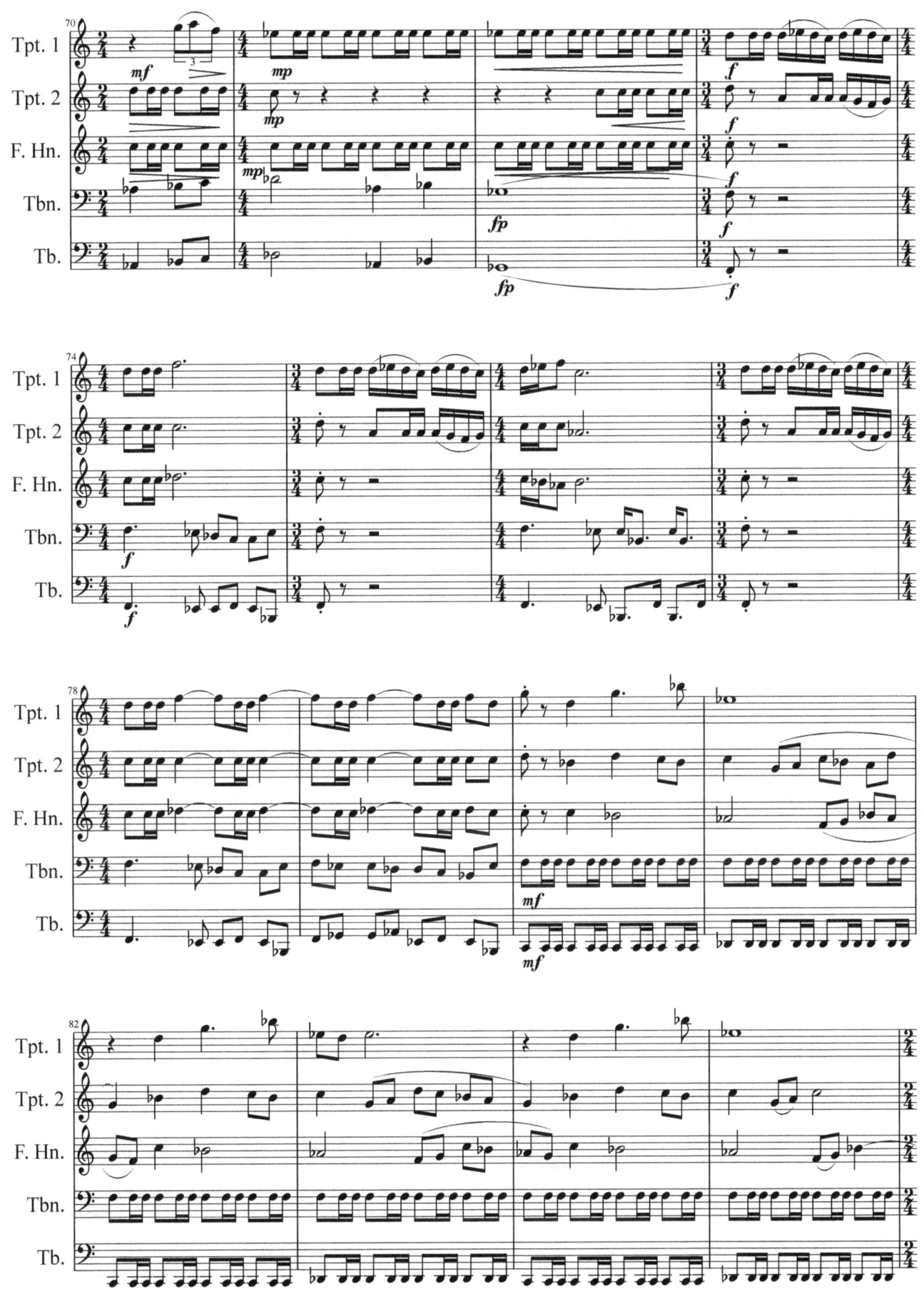

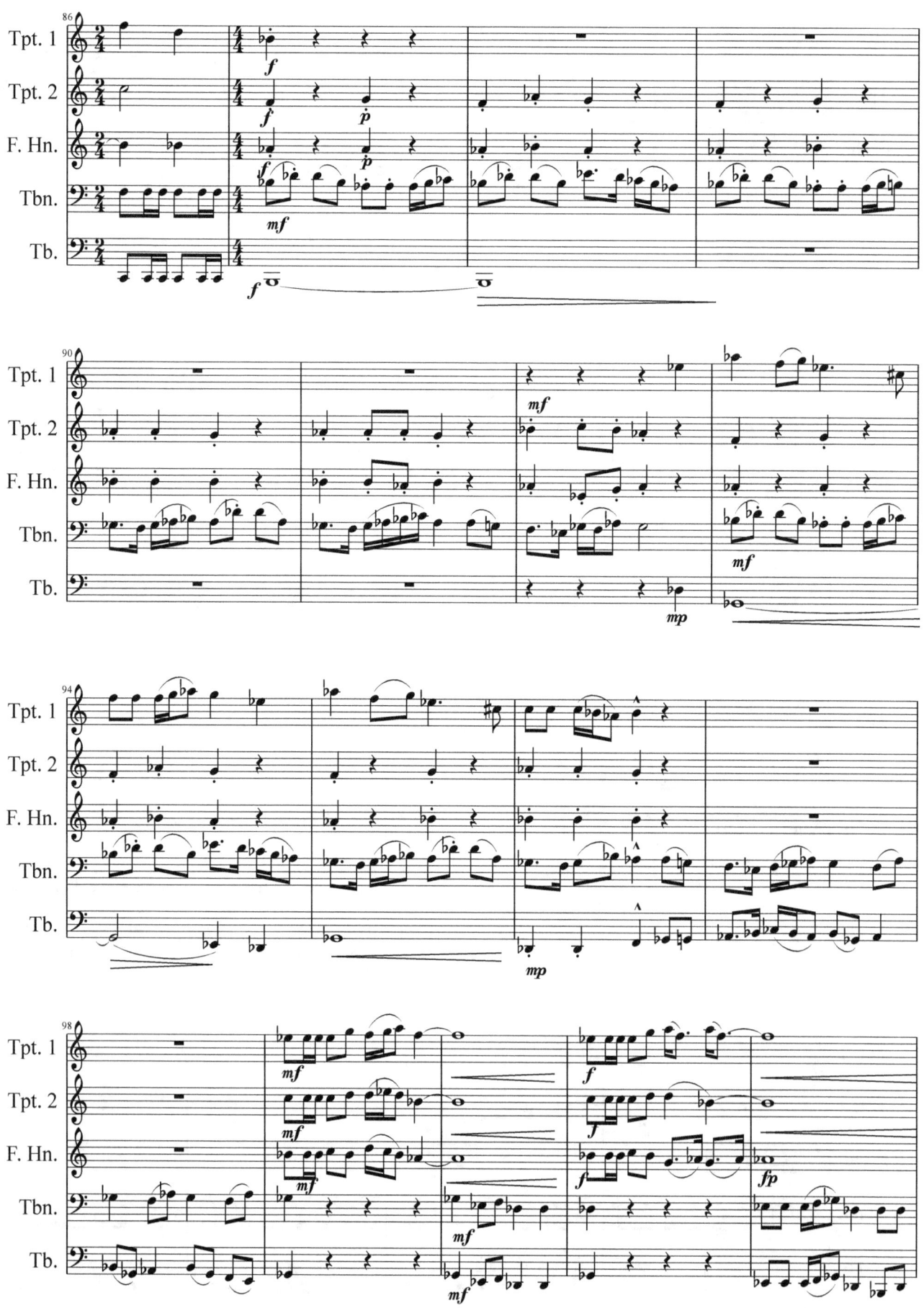

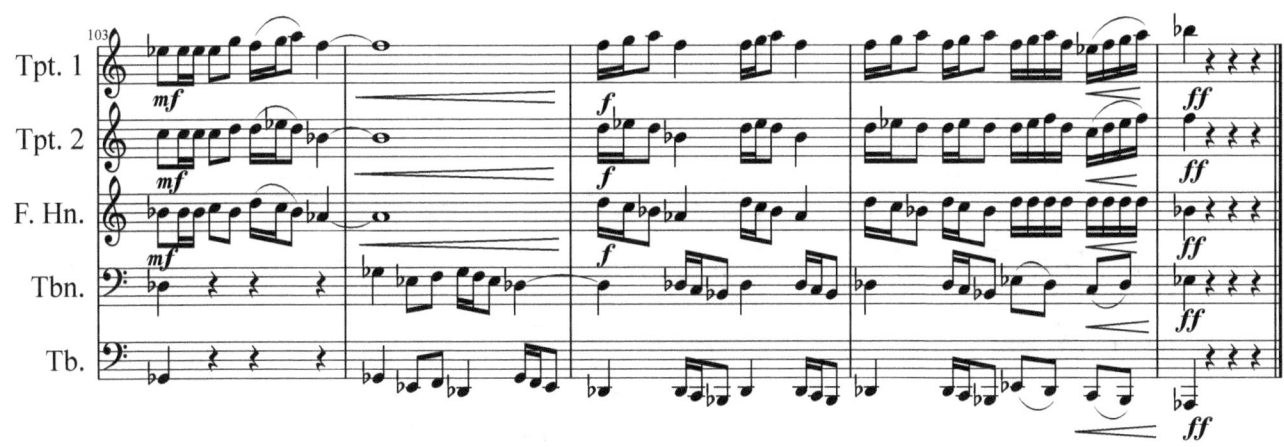

Moose River Suite
II

Ken Langer

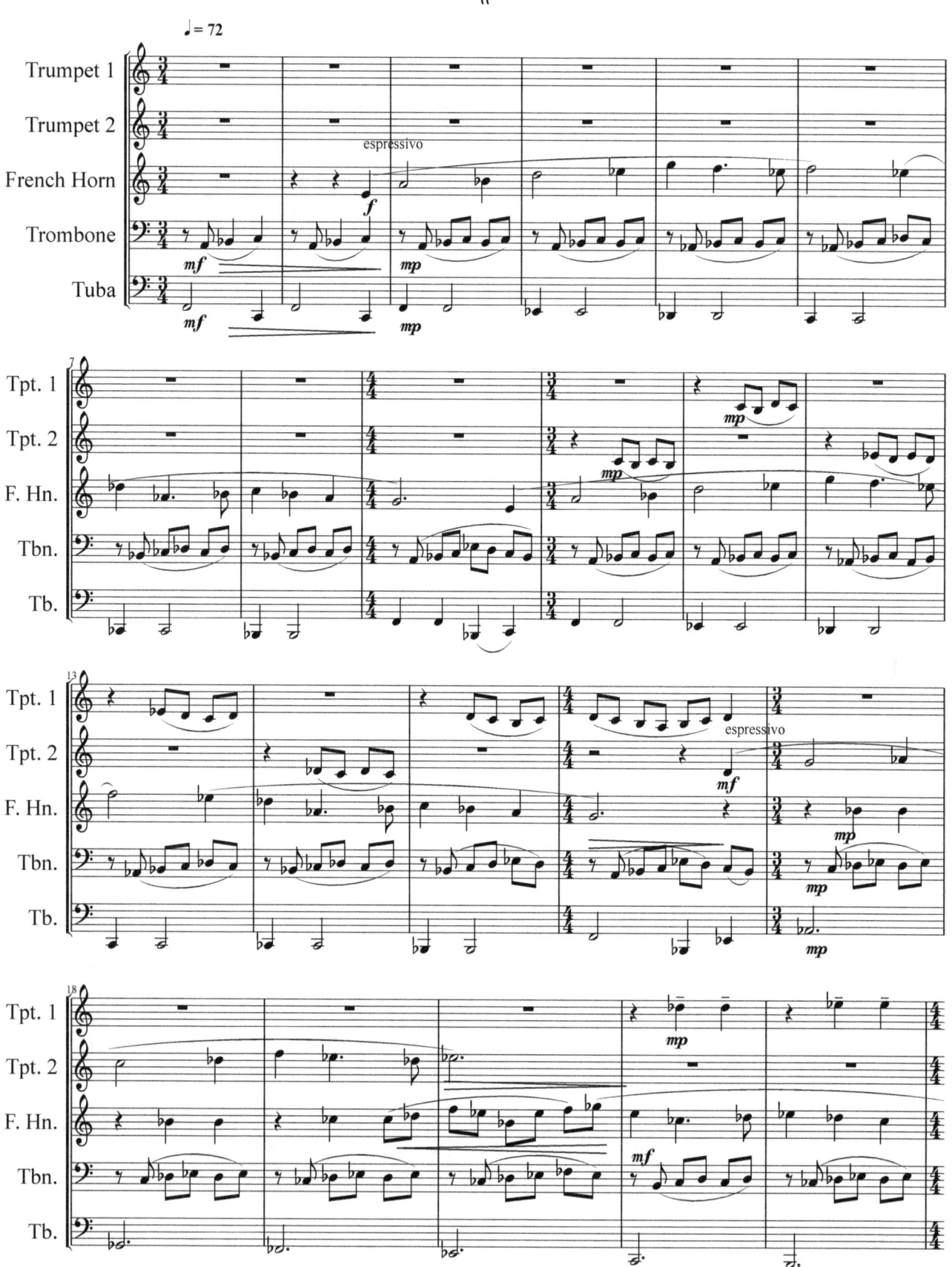

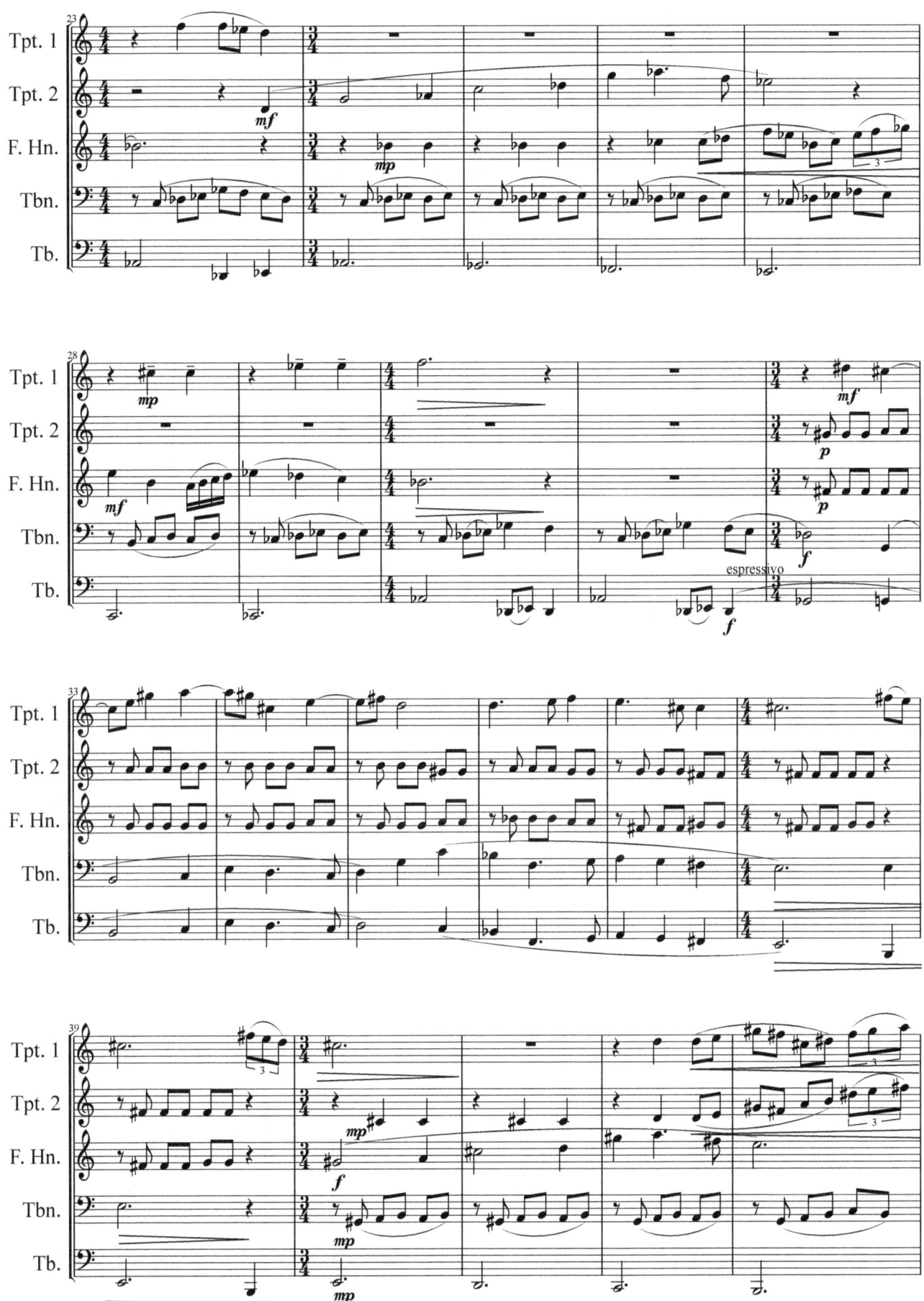

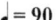

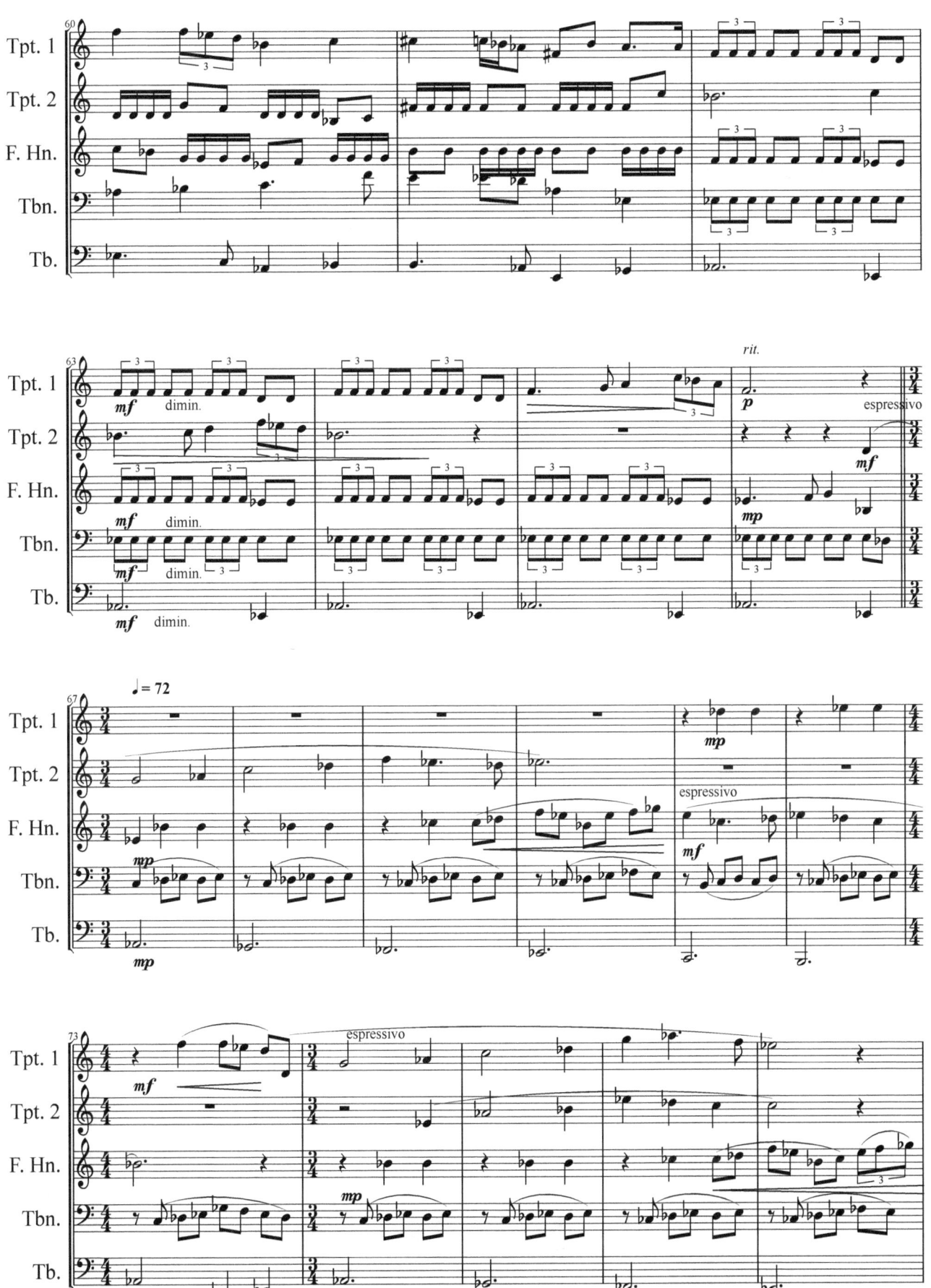

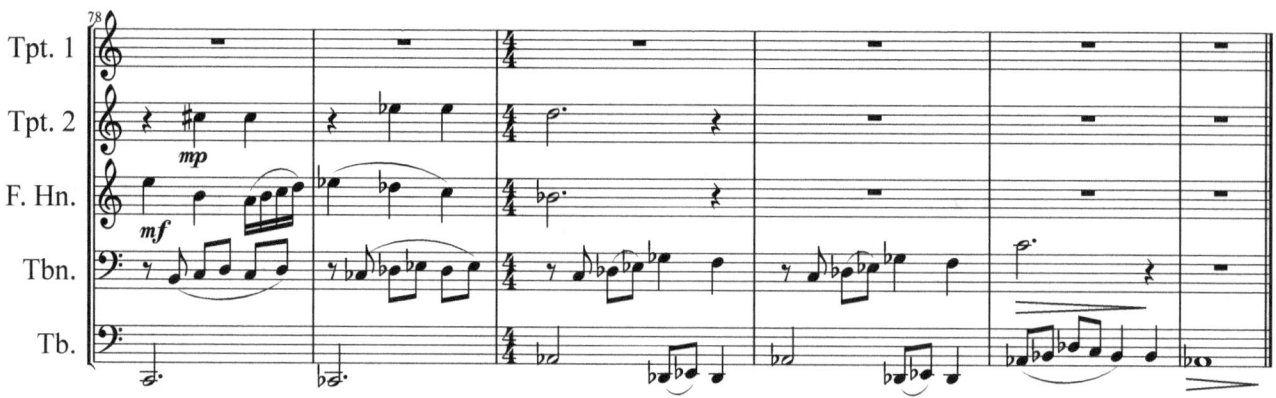

54

Moose River Suite
III

Ken Langer

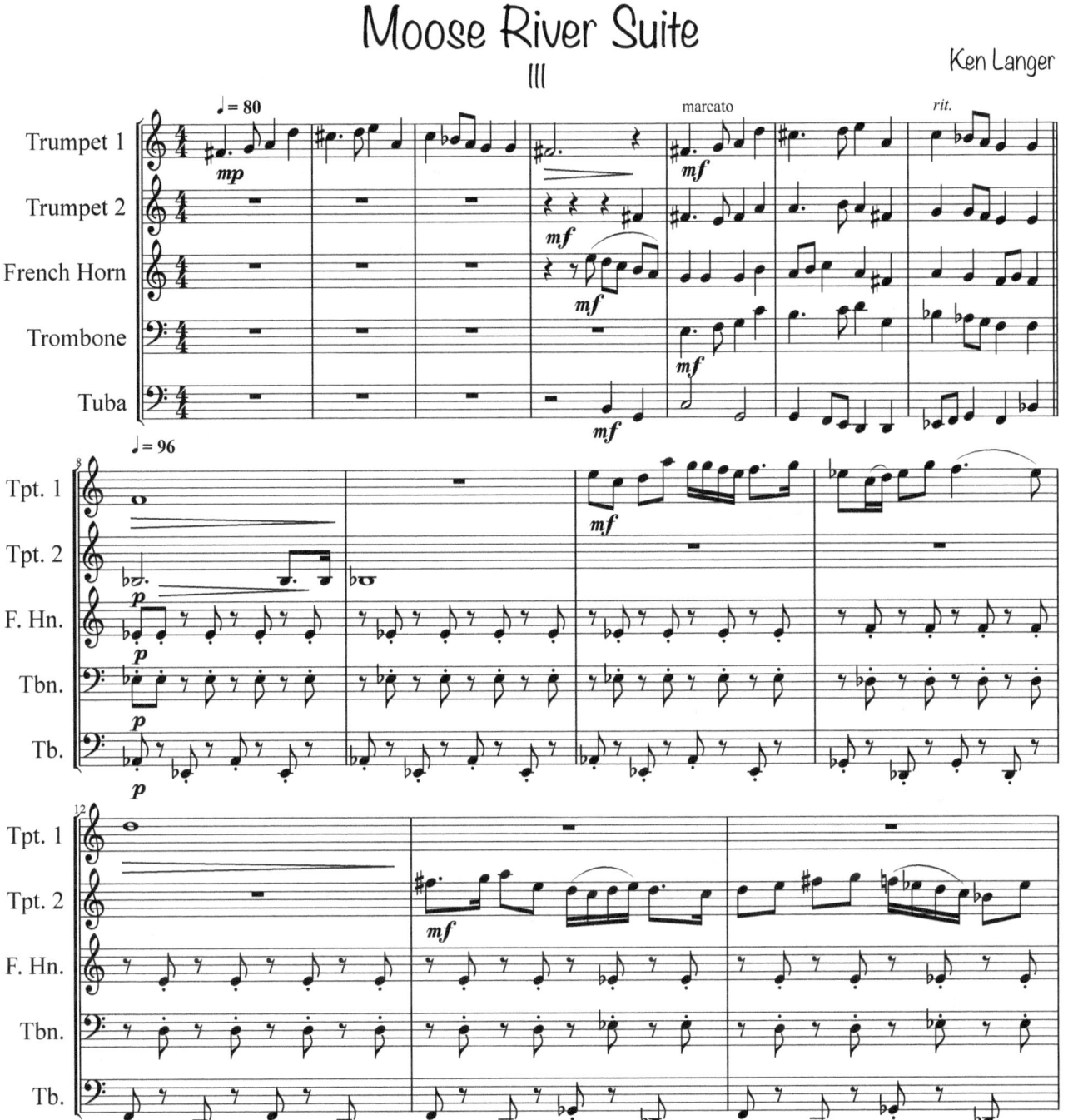

55

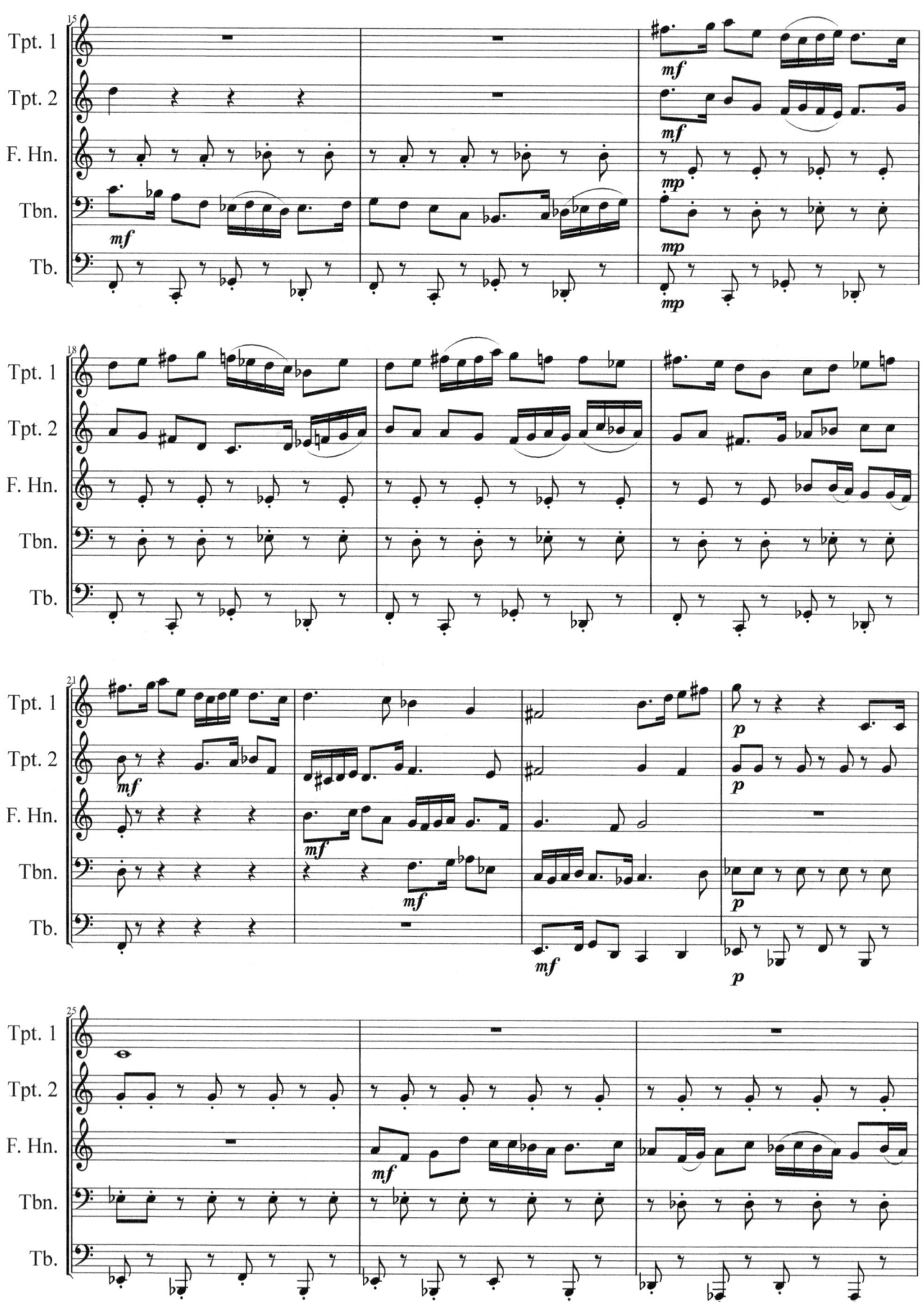

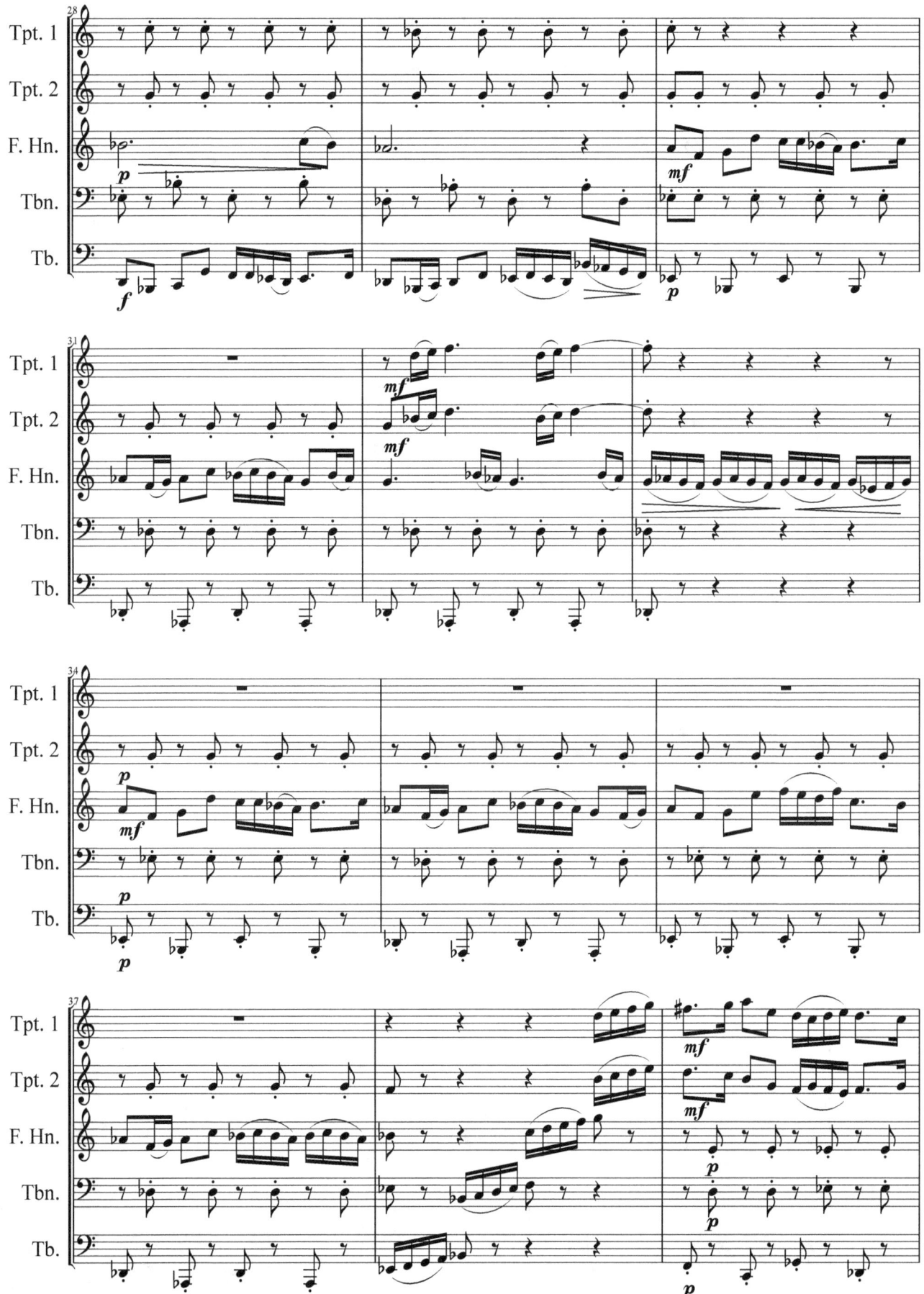

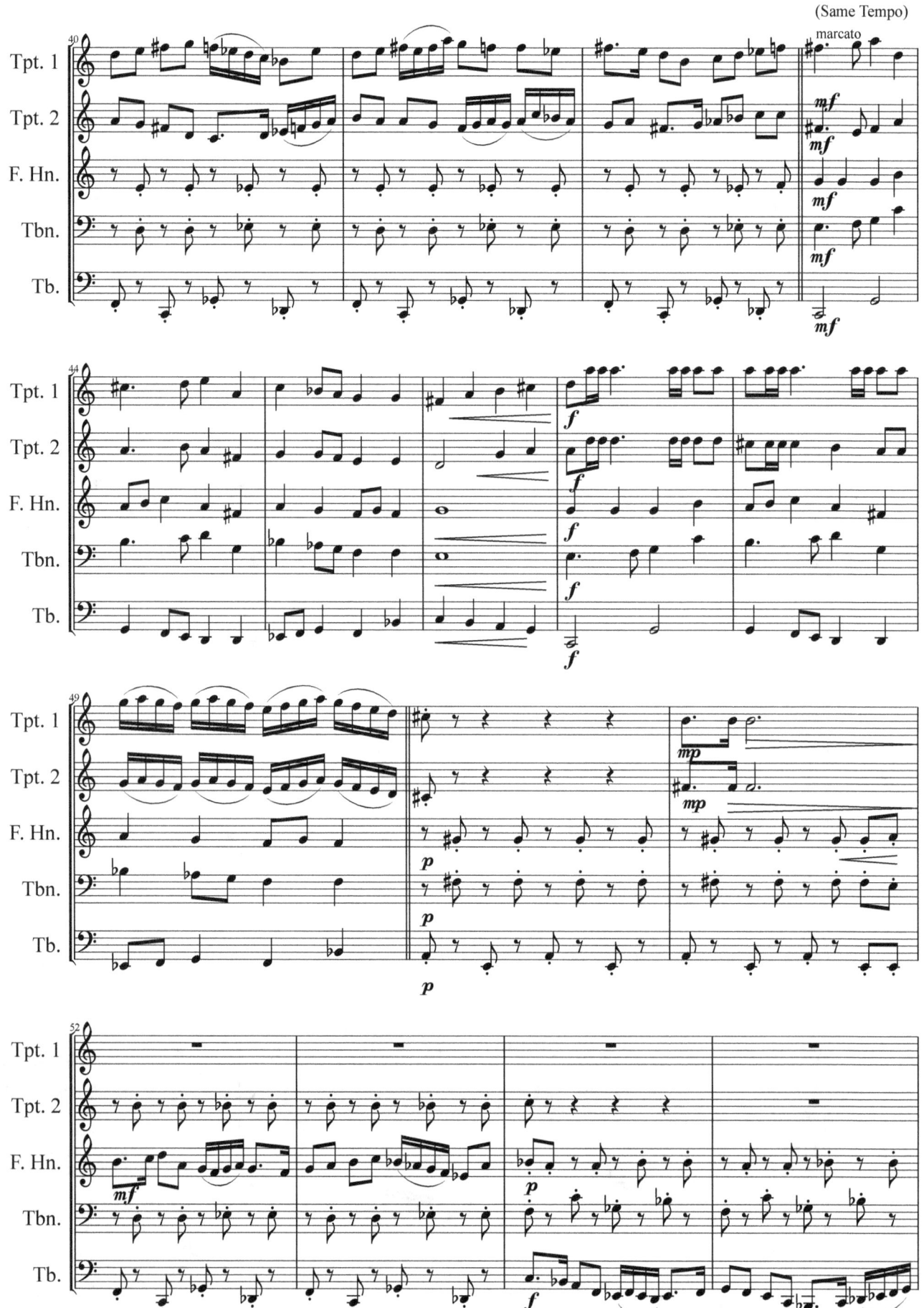

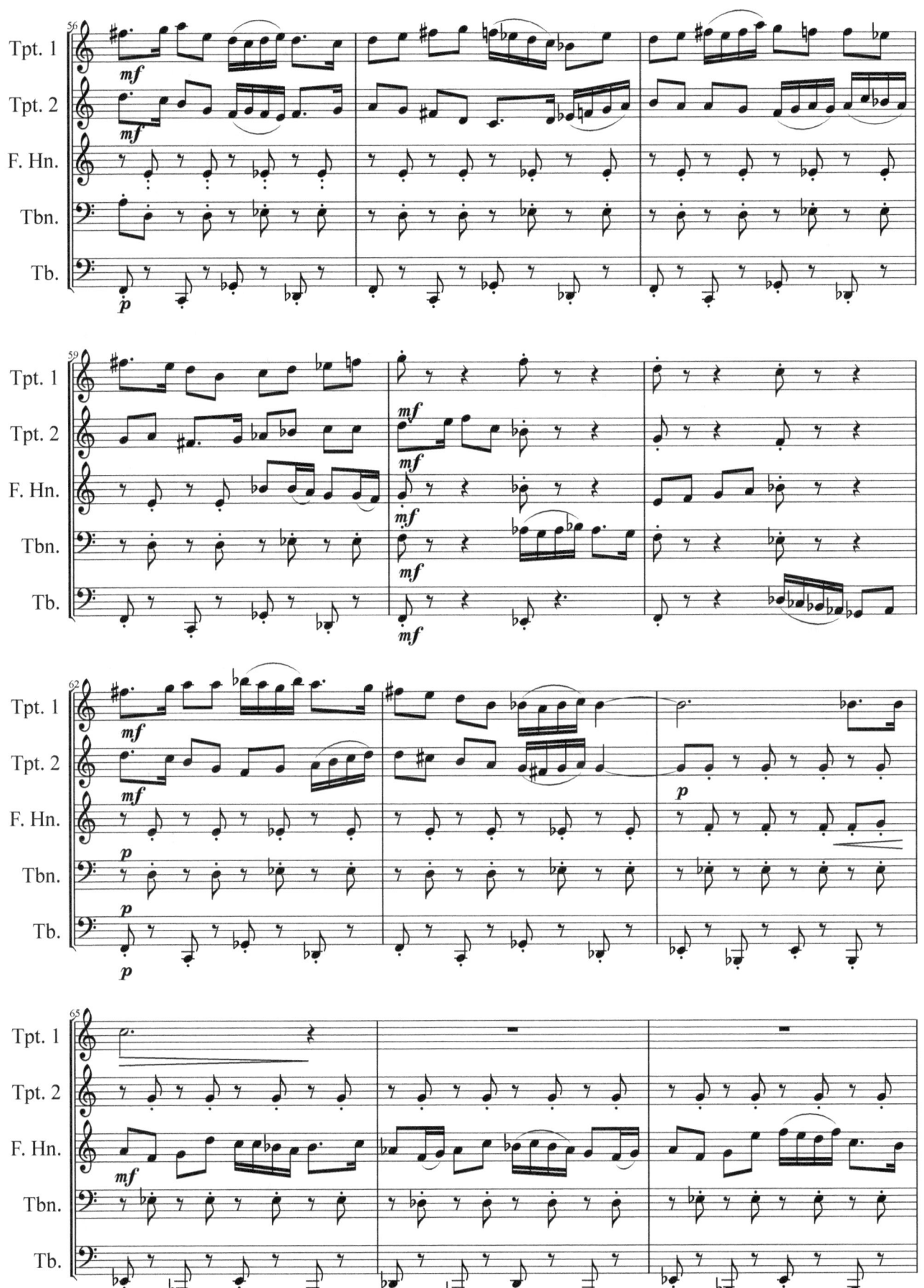

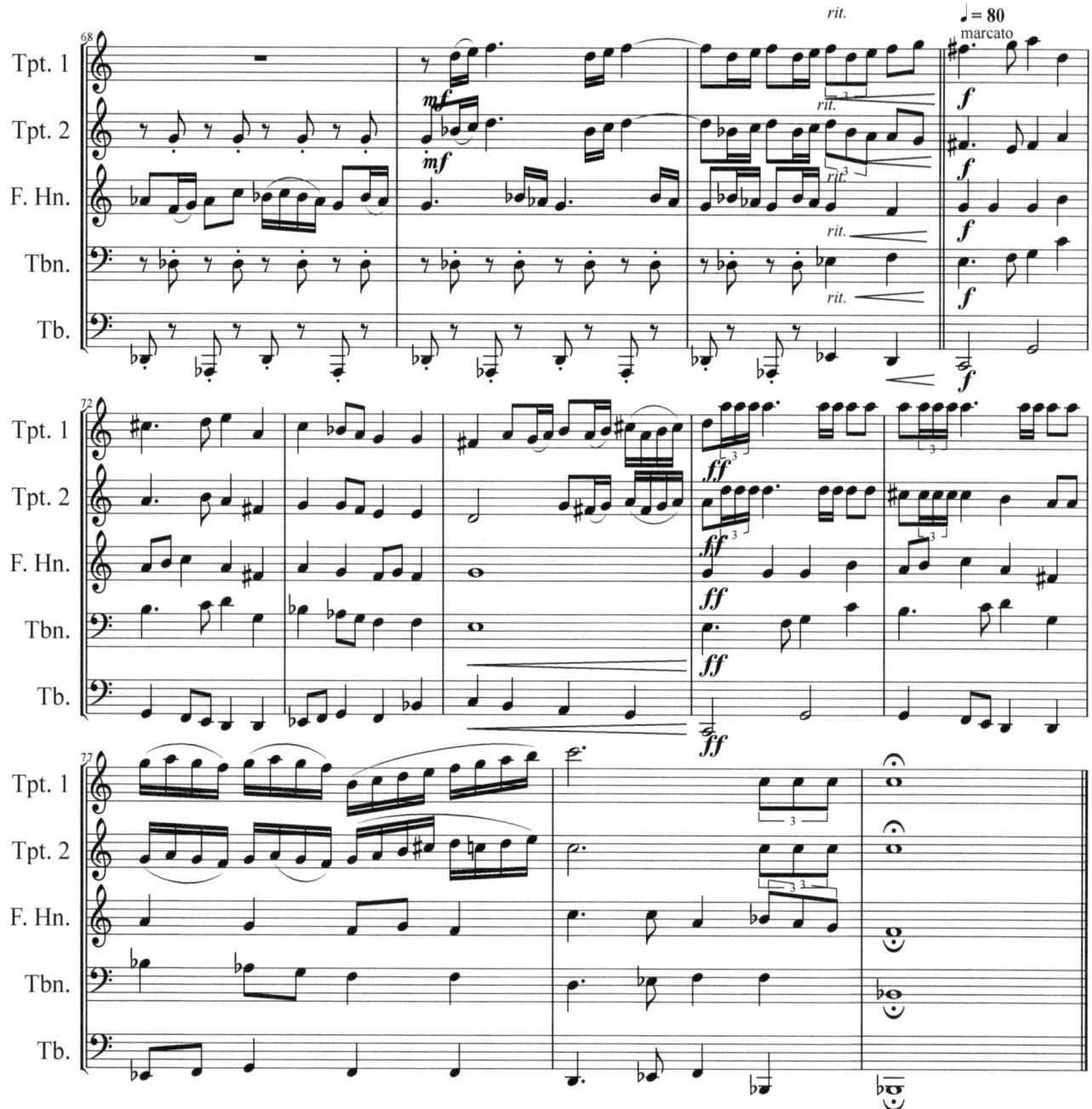

Moose River Suite
IV

Ken Langer

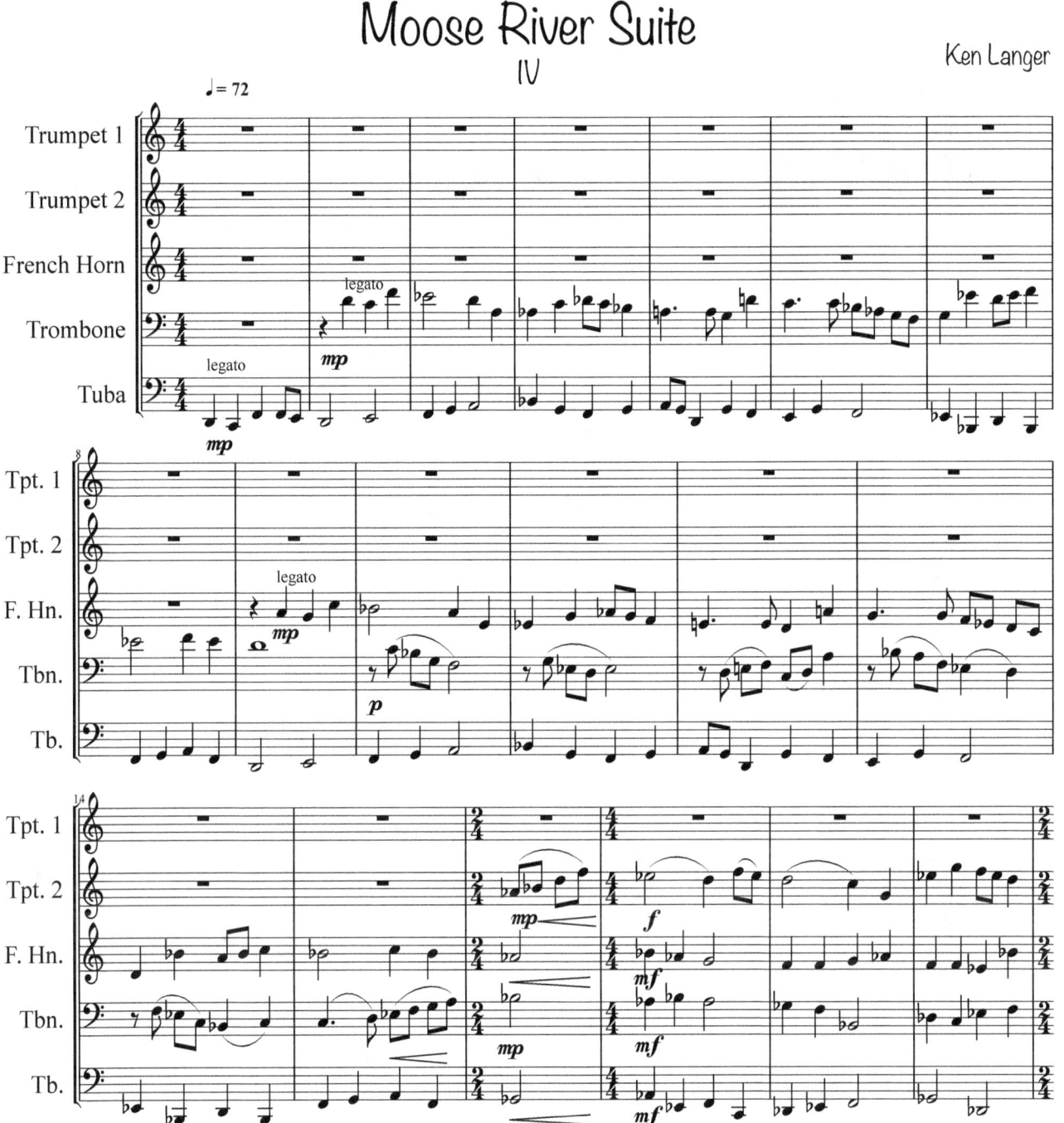

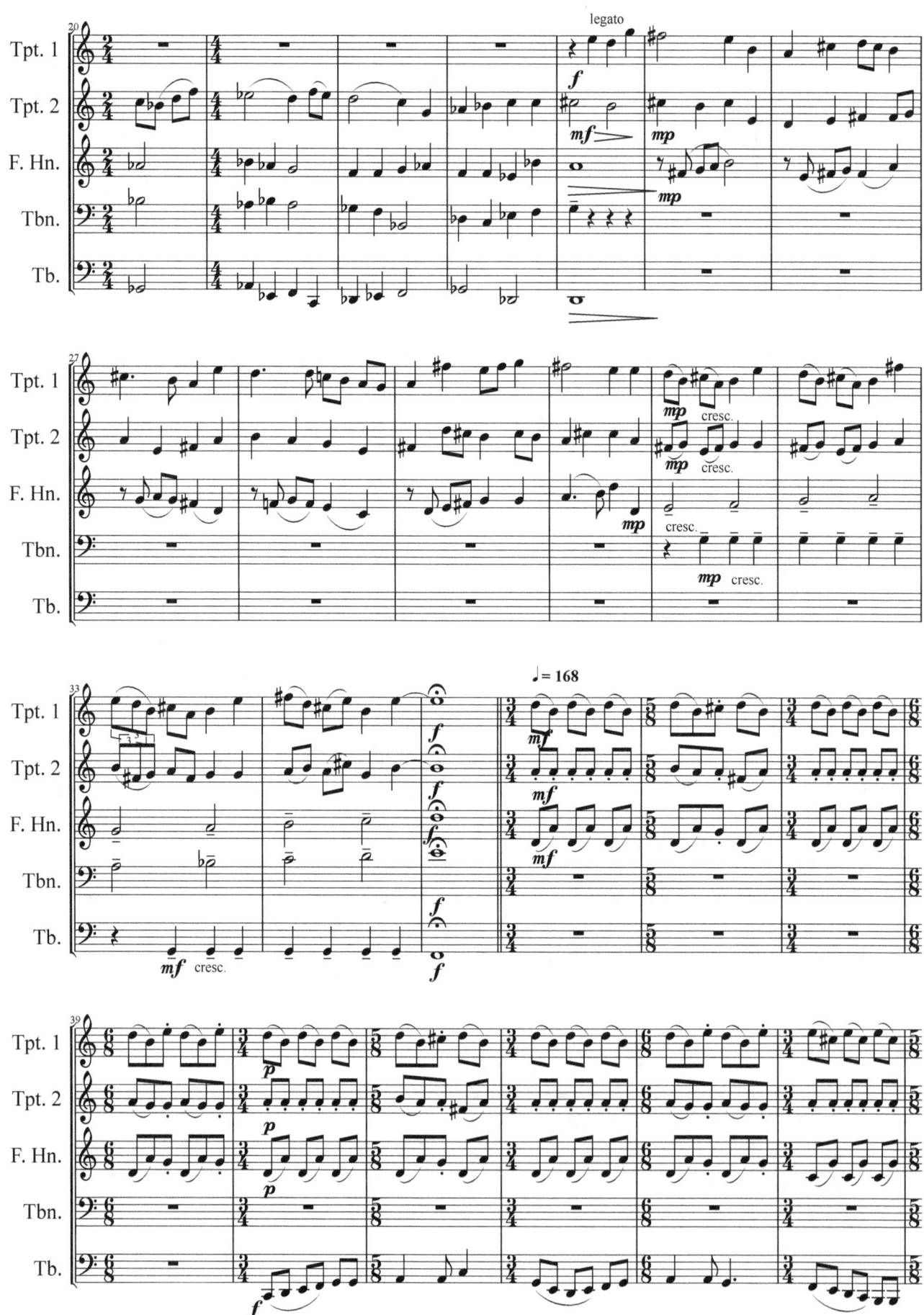

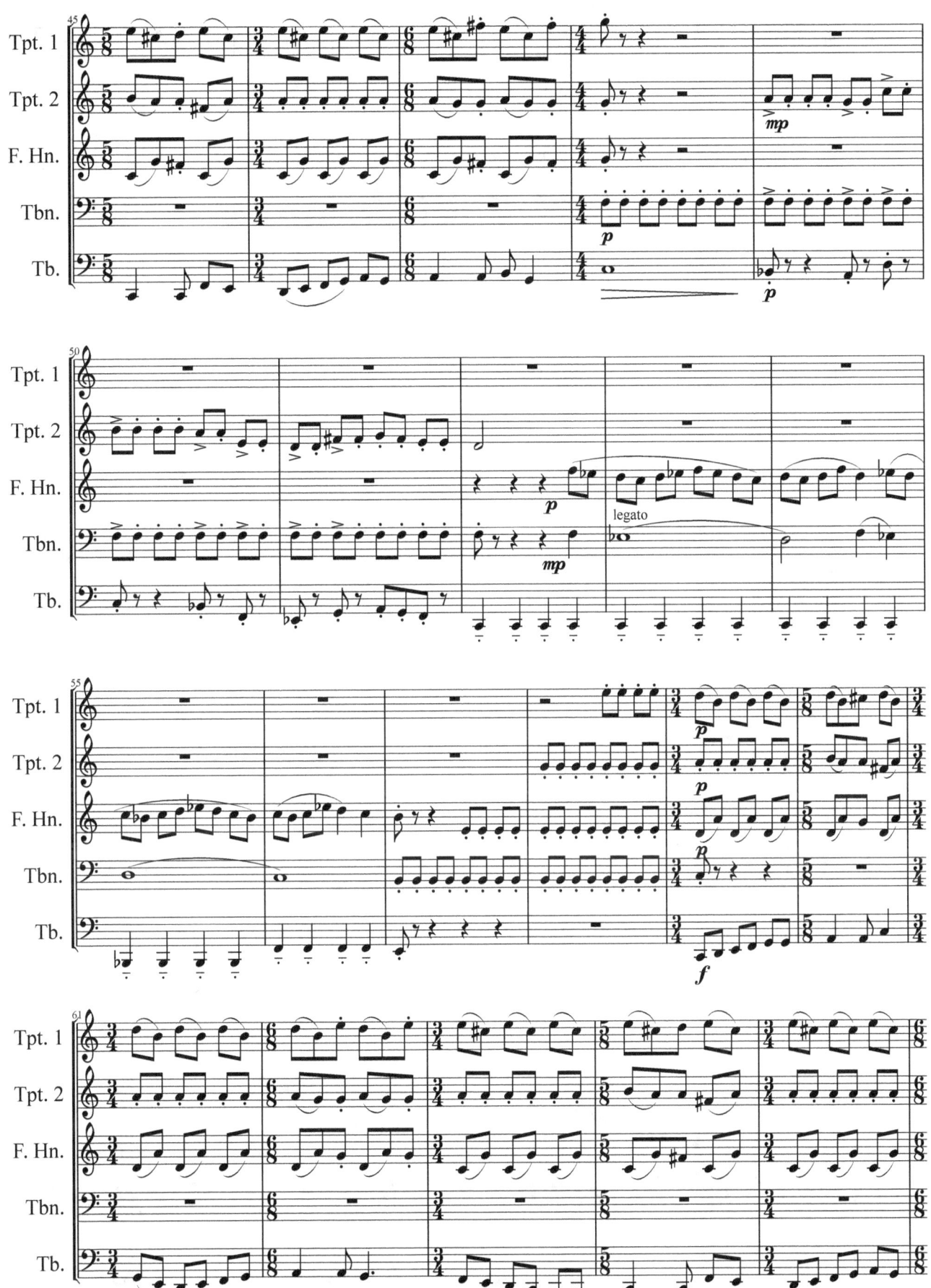

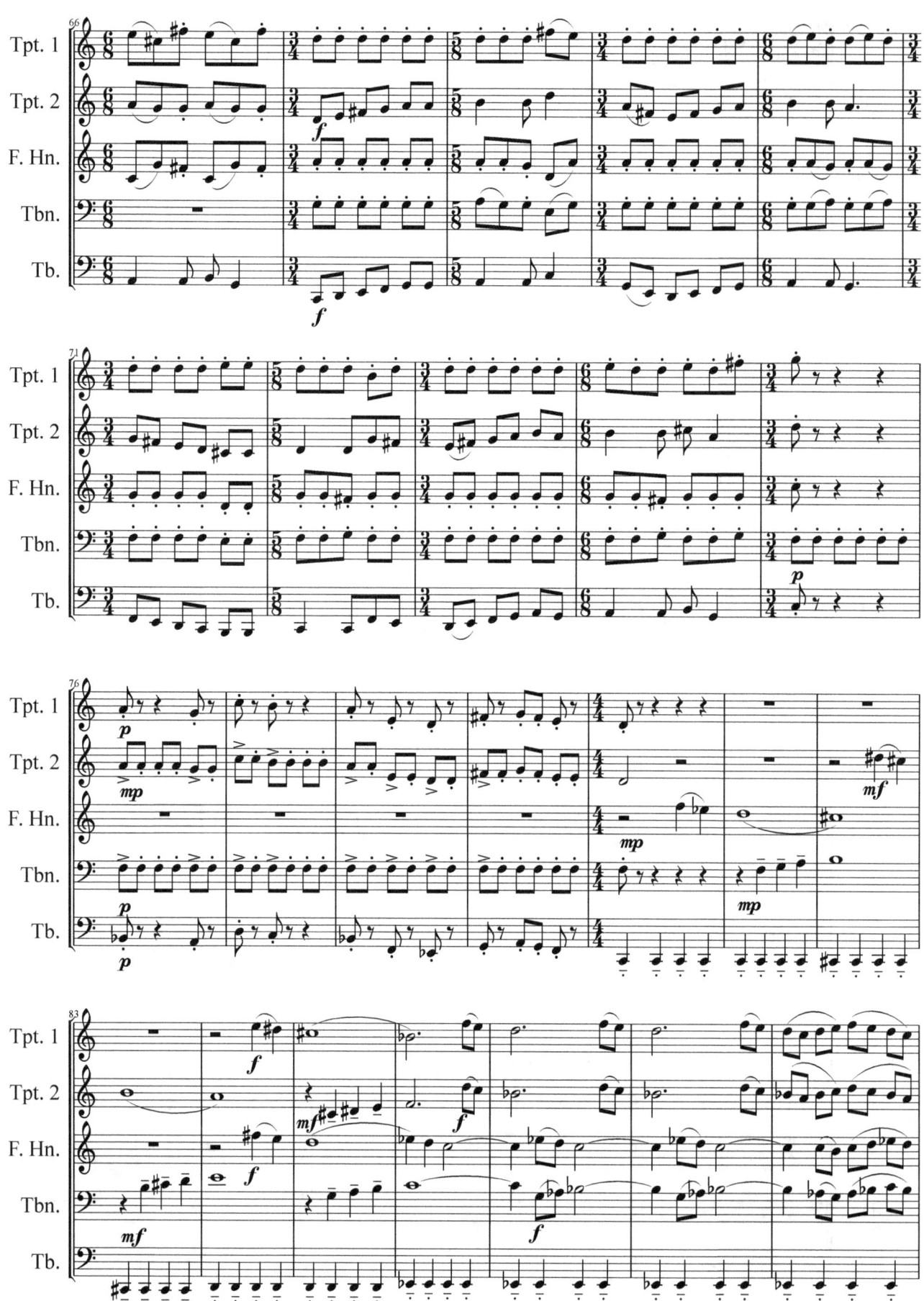

64

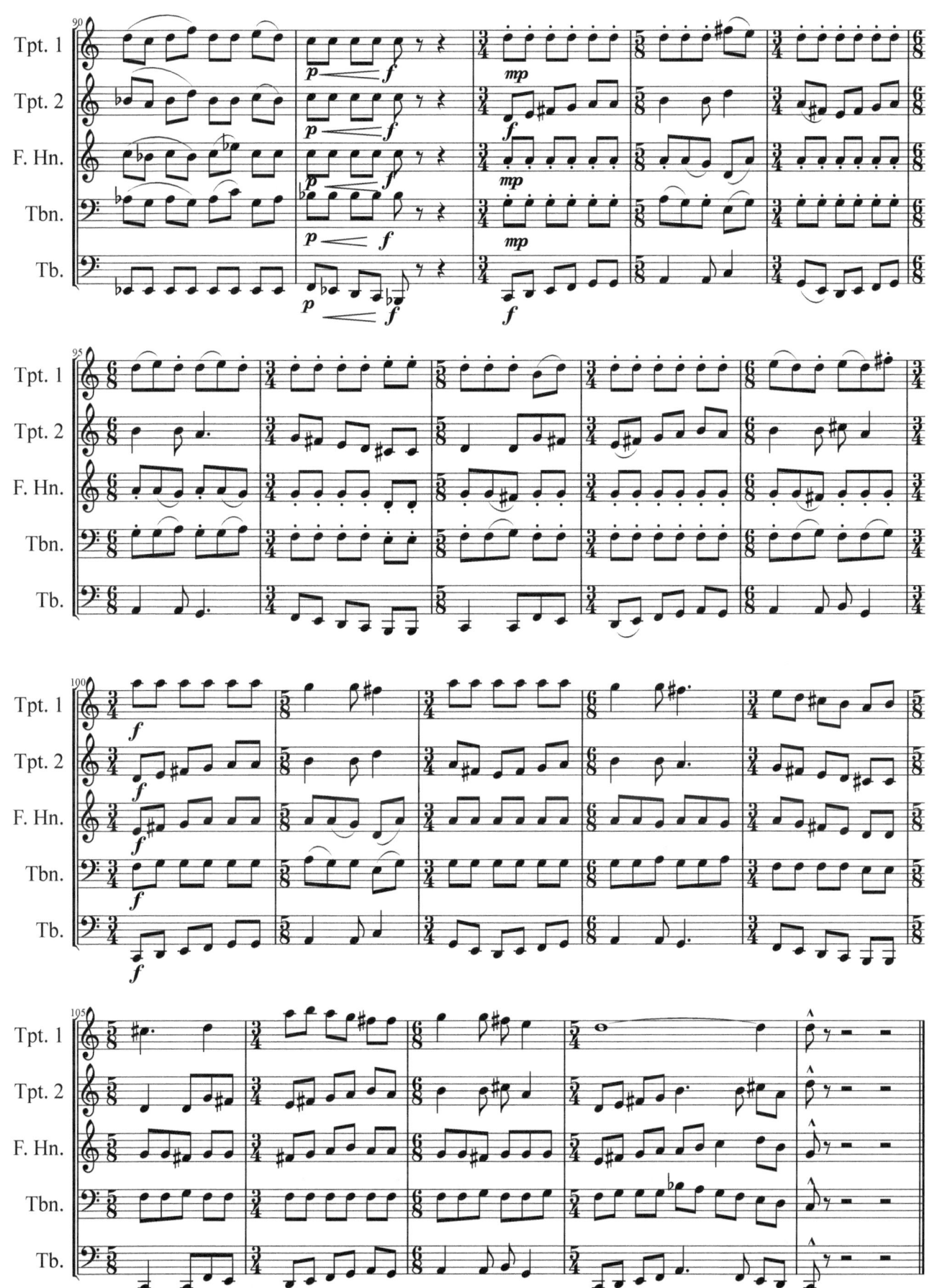

Six By Satie
I. from Gymnopedie no. 1

arr. Ken Langer

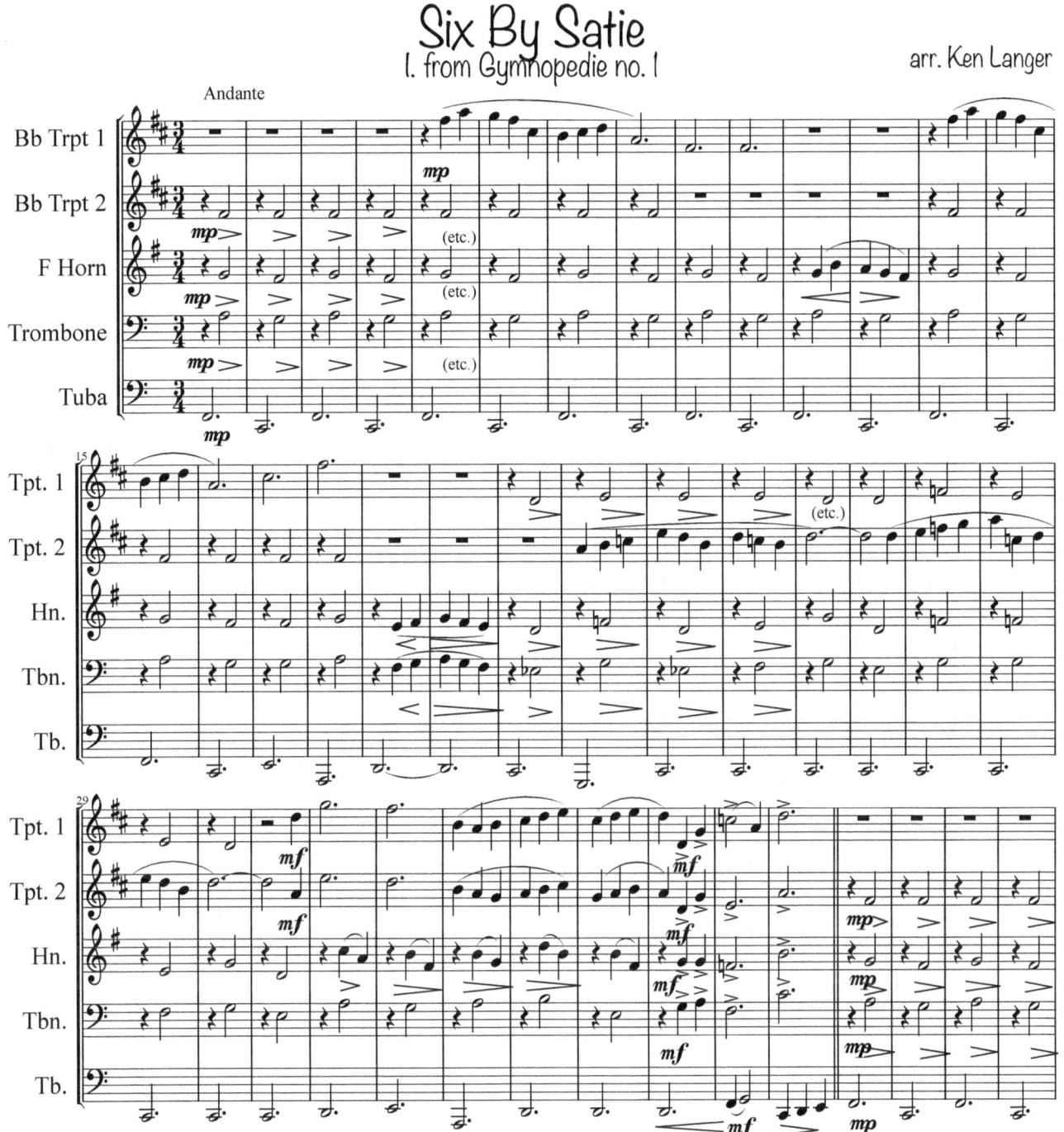

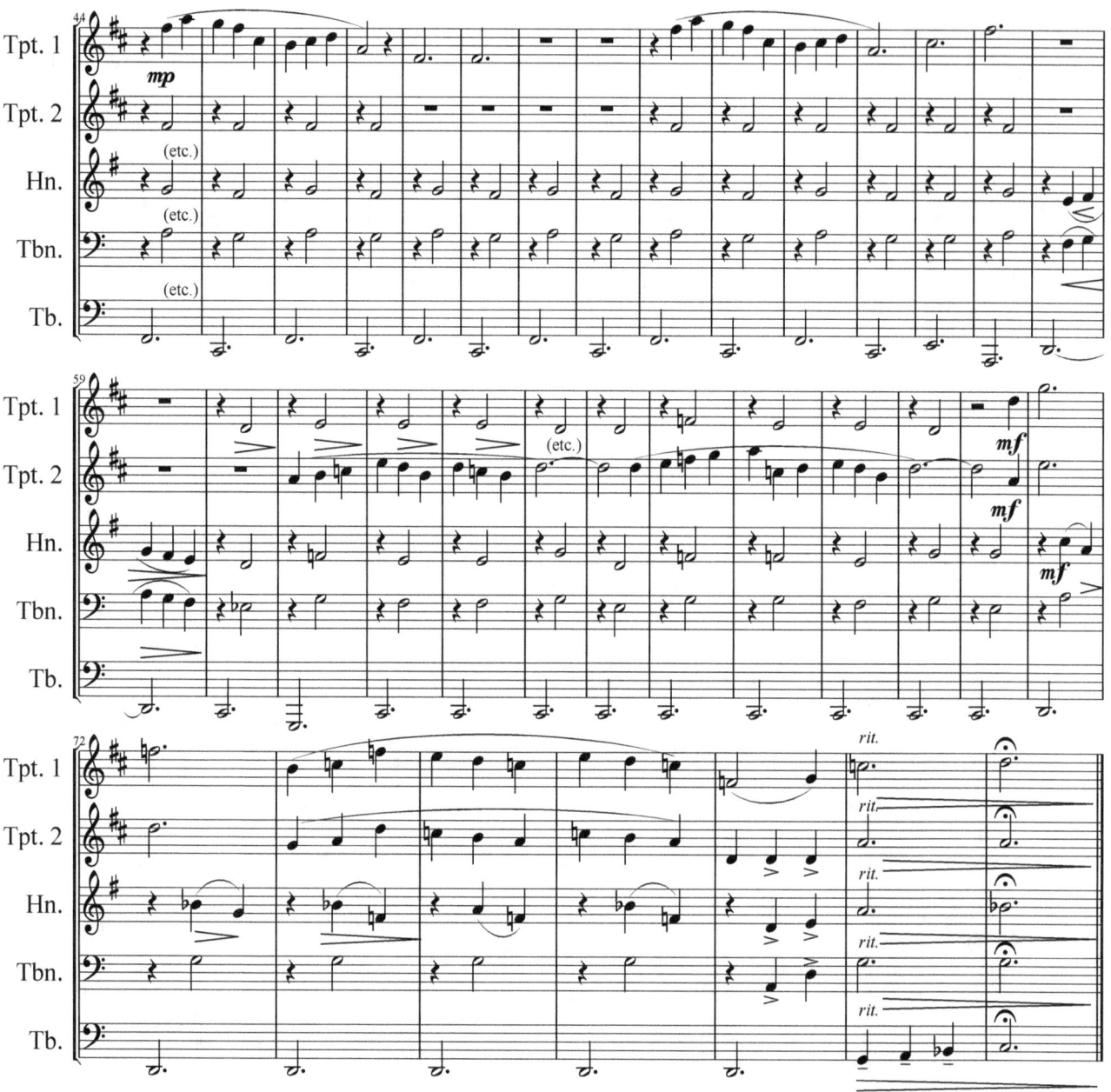

Six By Satie

2. from Sonatine Bureaucratique no. 1

arr. Ken Langer

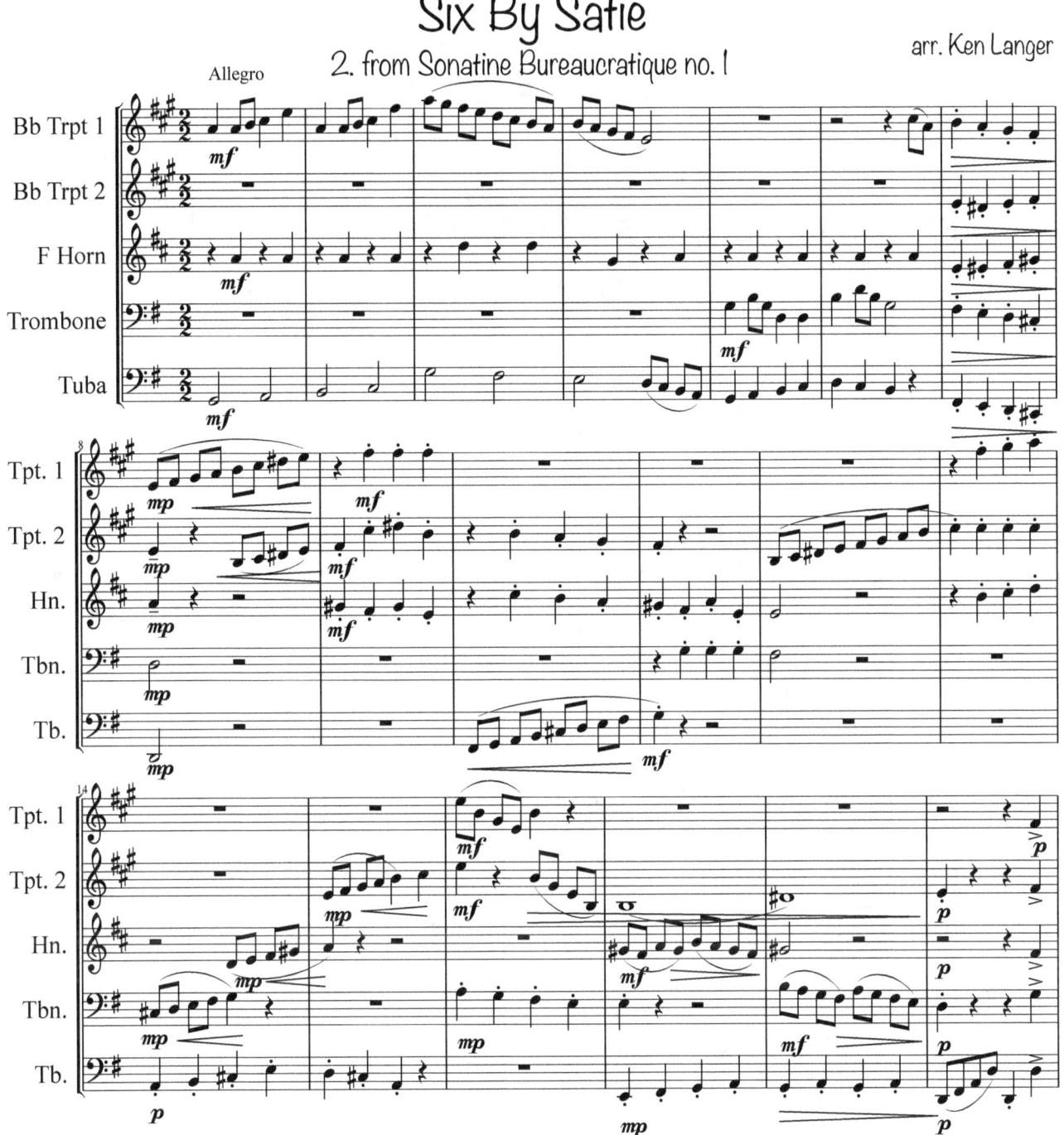

69

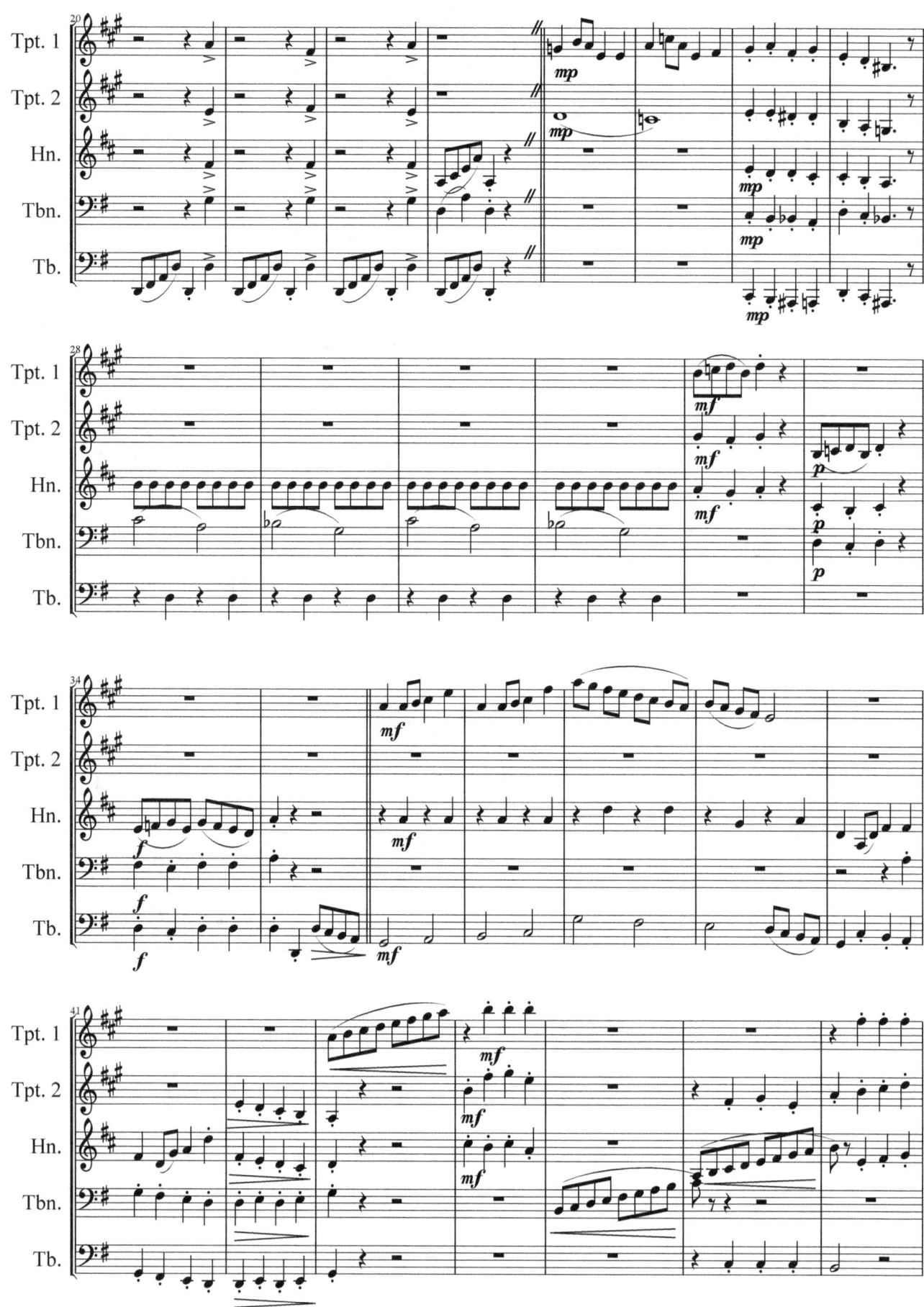

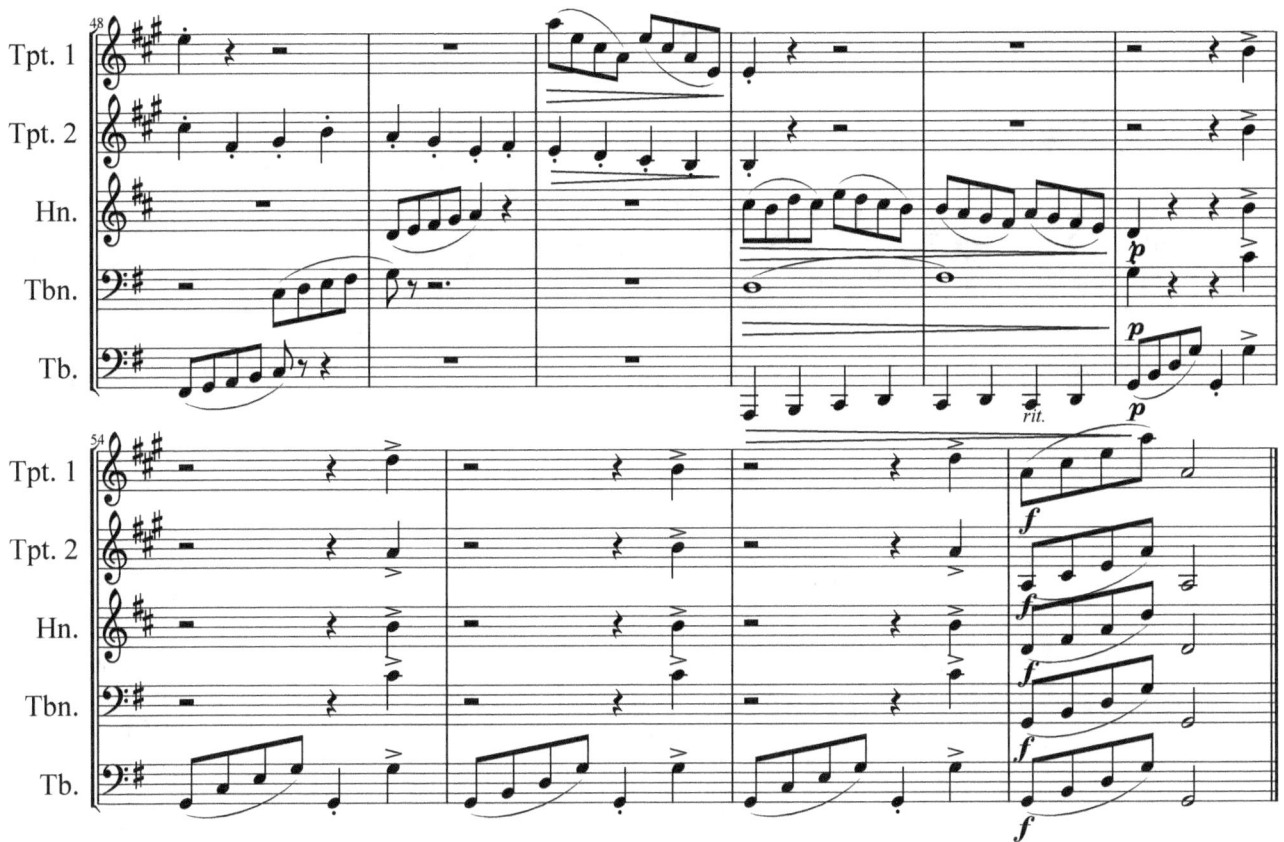

71

Six By Satie
3. from Gymnopedie 2

arr. Ken Langer

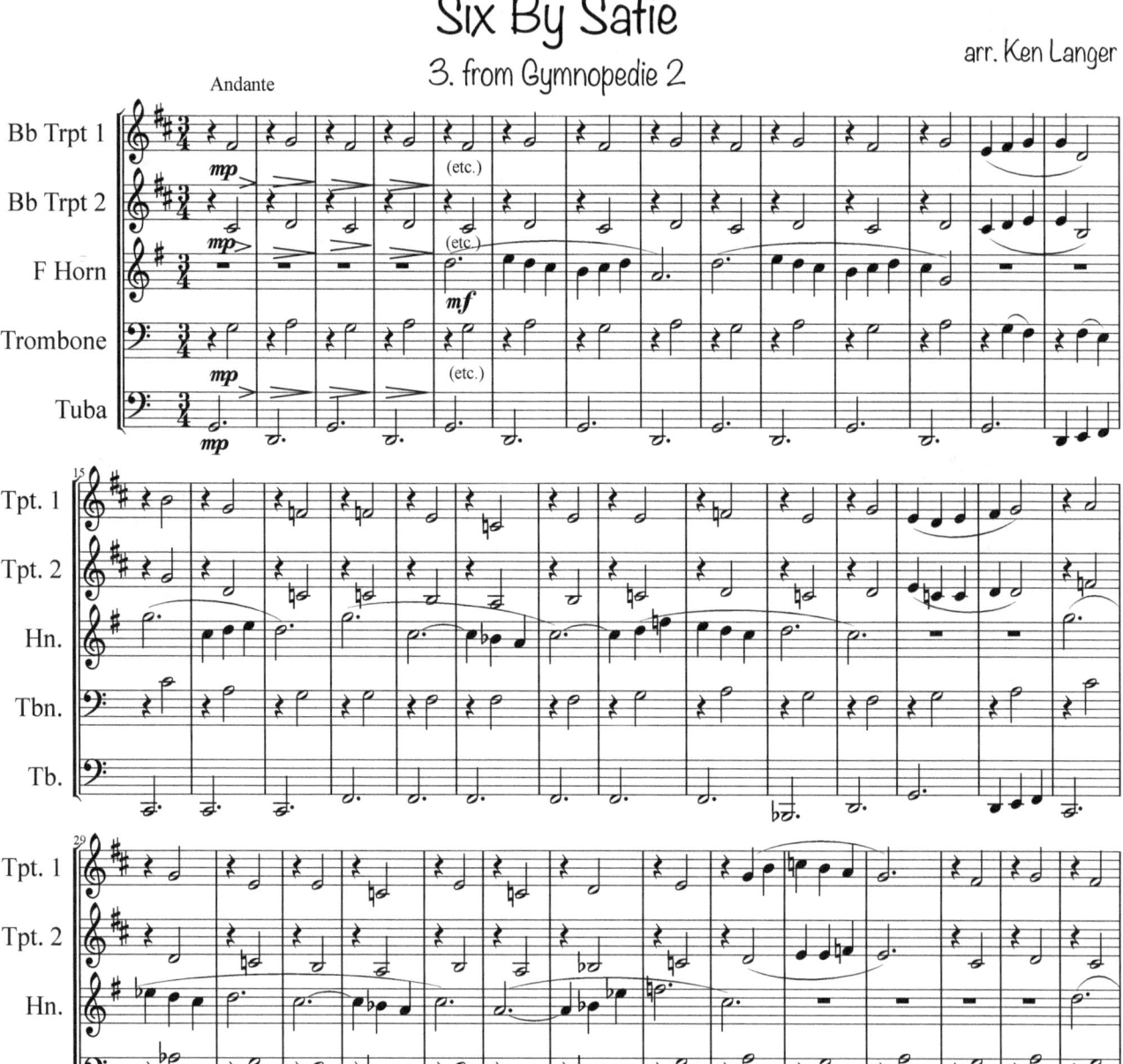

72

Six By Satie
4. from Sonatine Bureaucratique no. 2

arr. Ken Langer

Six By Satie
5. from Gymnopedie 3

arr. Ken Langer

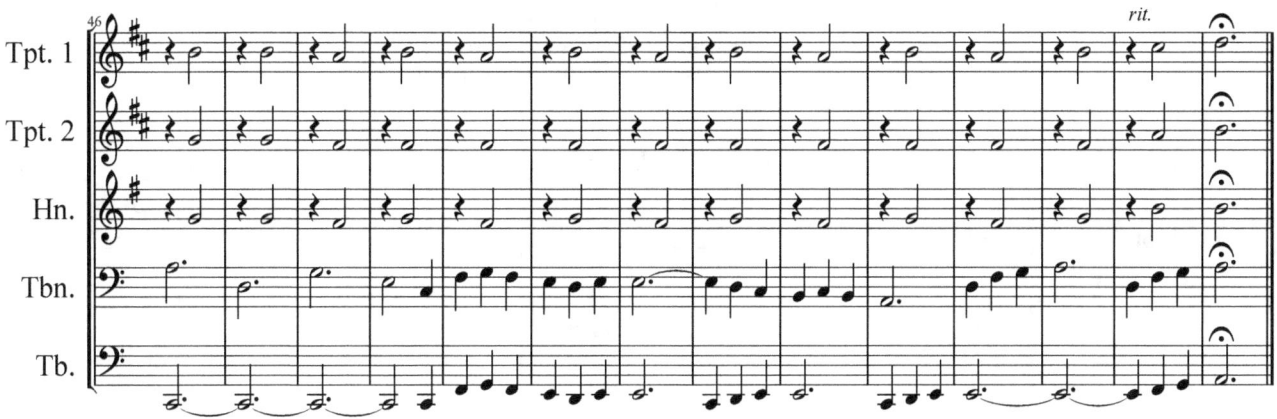

Six By Satie
6. from Sonatine Bureaucratique no. 3

arr. Ken Langer

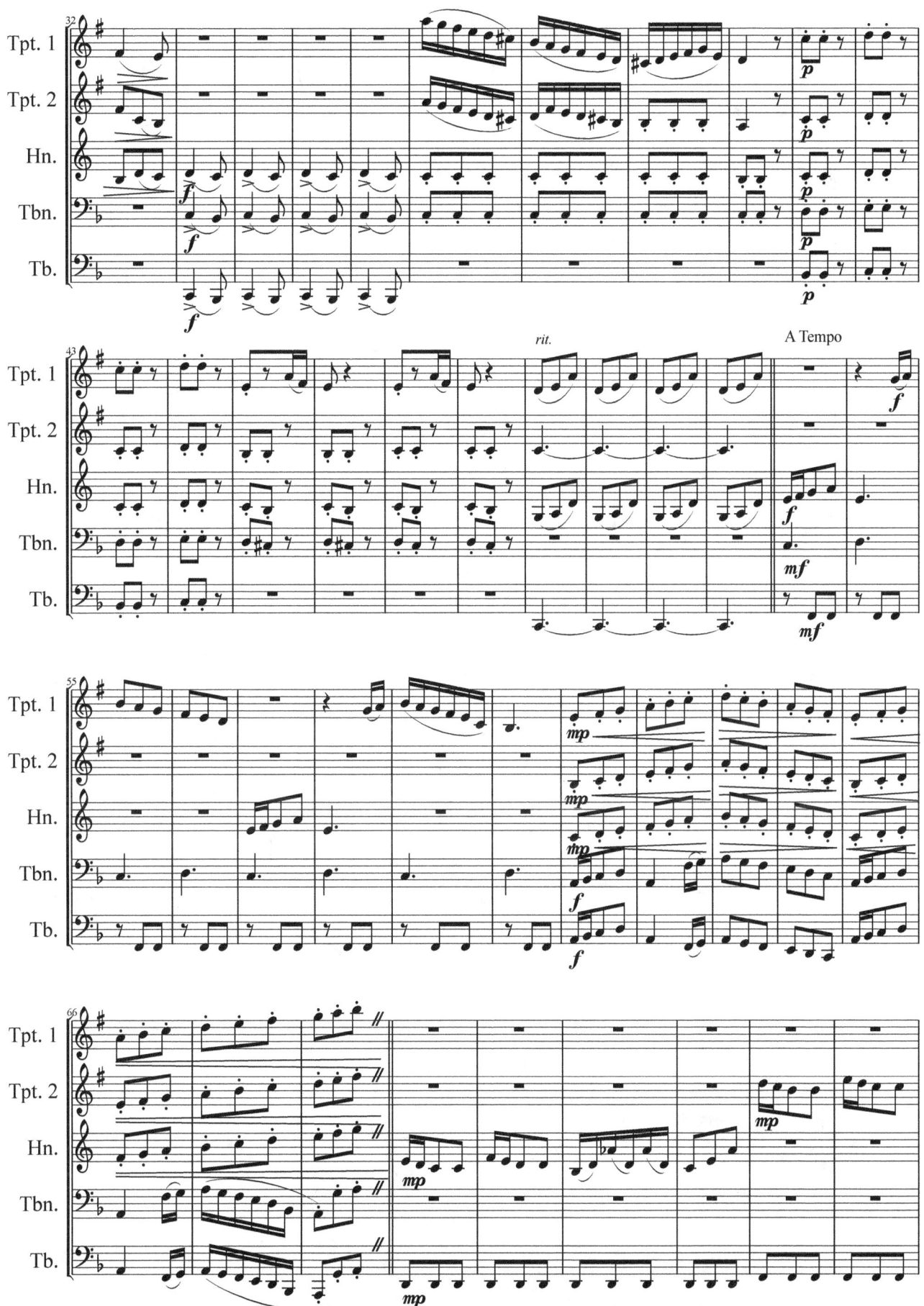

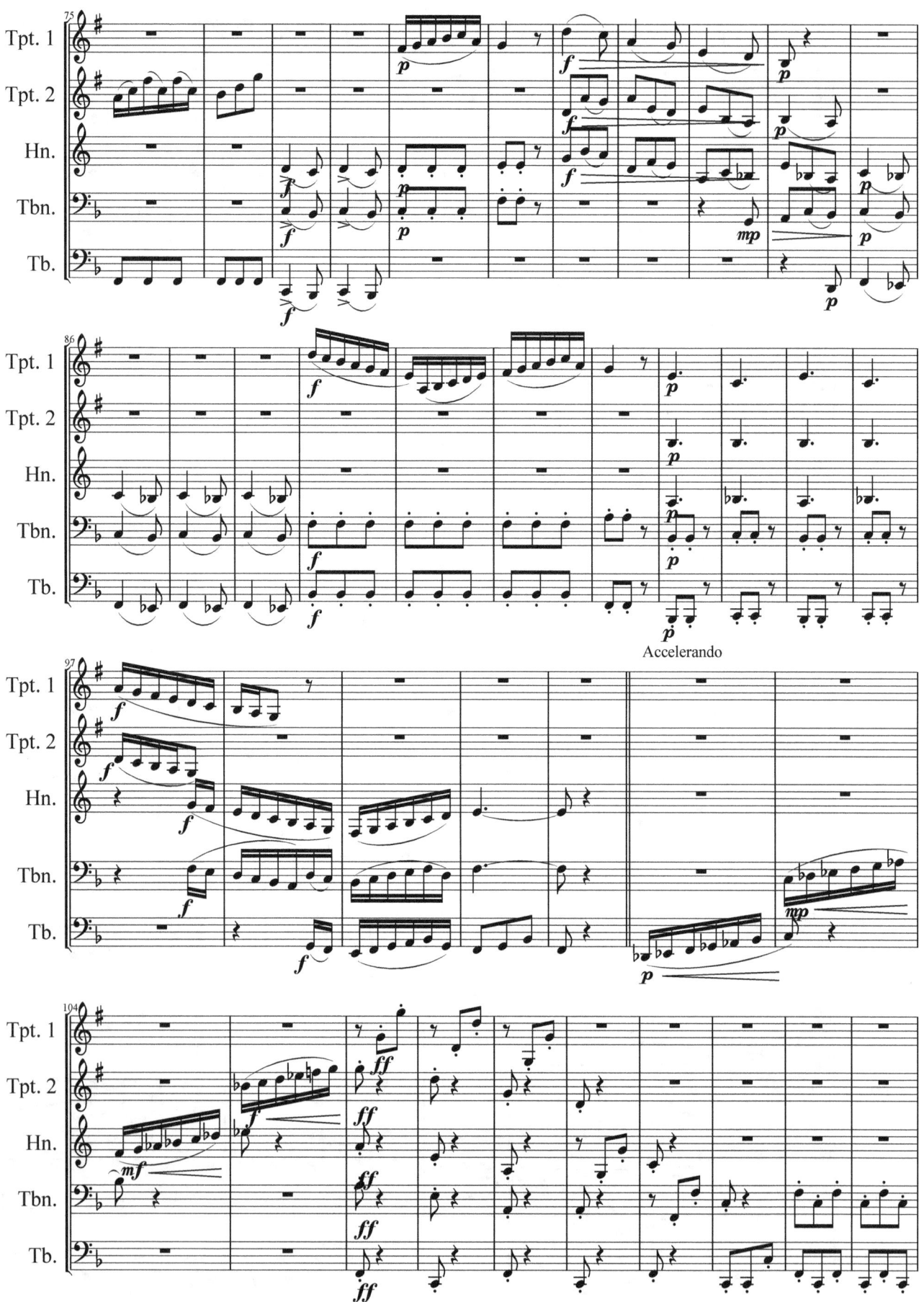

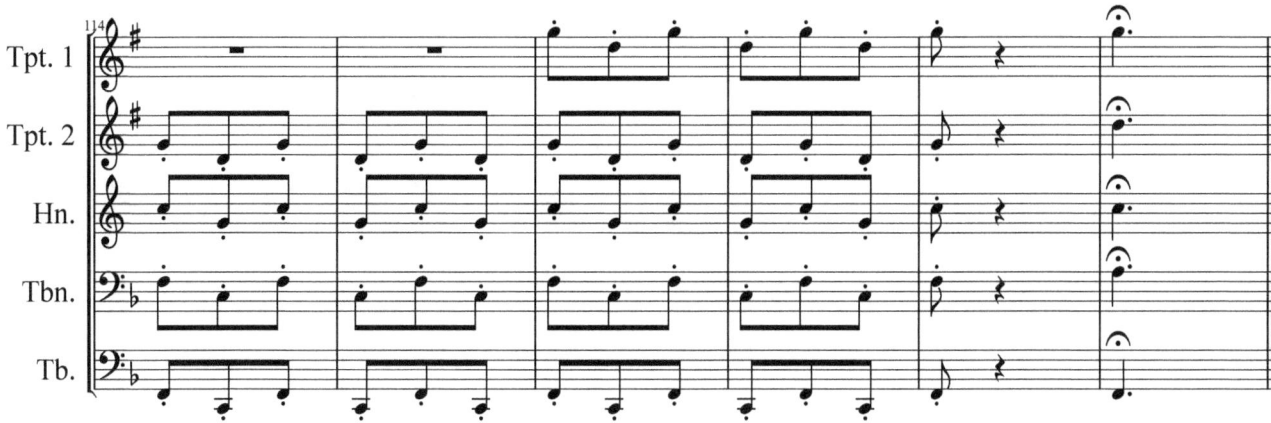

Six Chorales
Veri Floris Sub Figura

anonymous medieval conductus

Arr. Ken Langer

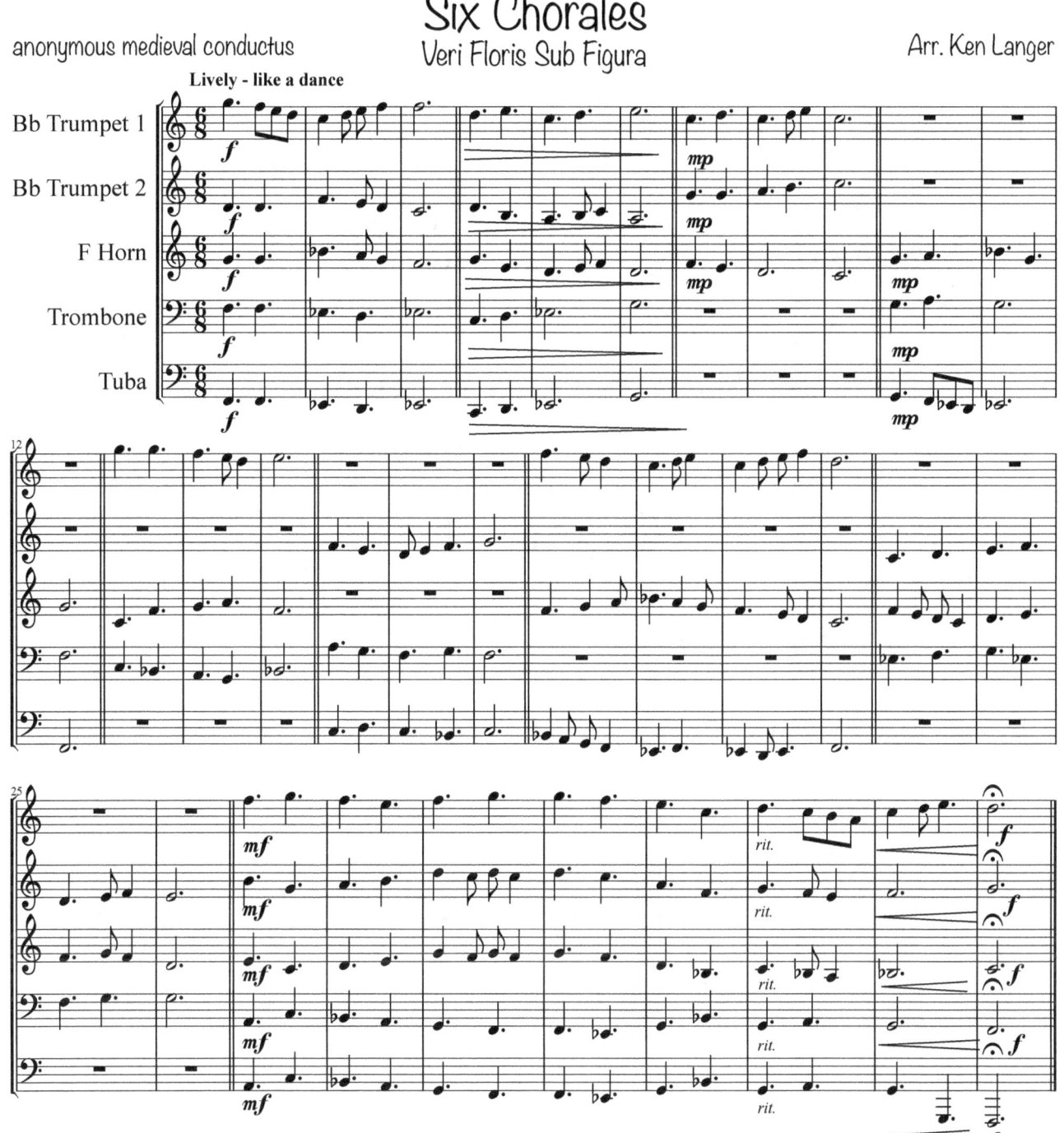

83

Six Chorales
Adoramus Te

Palestrina
arr. Ken Langer

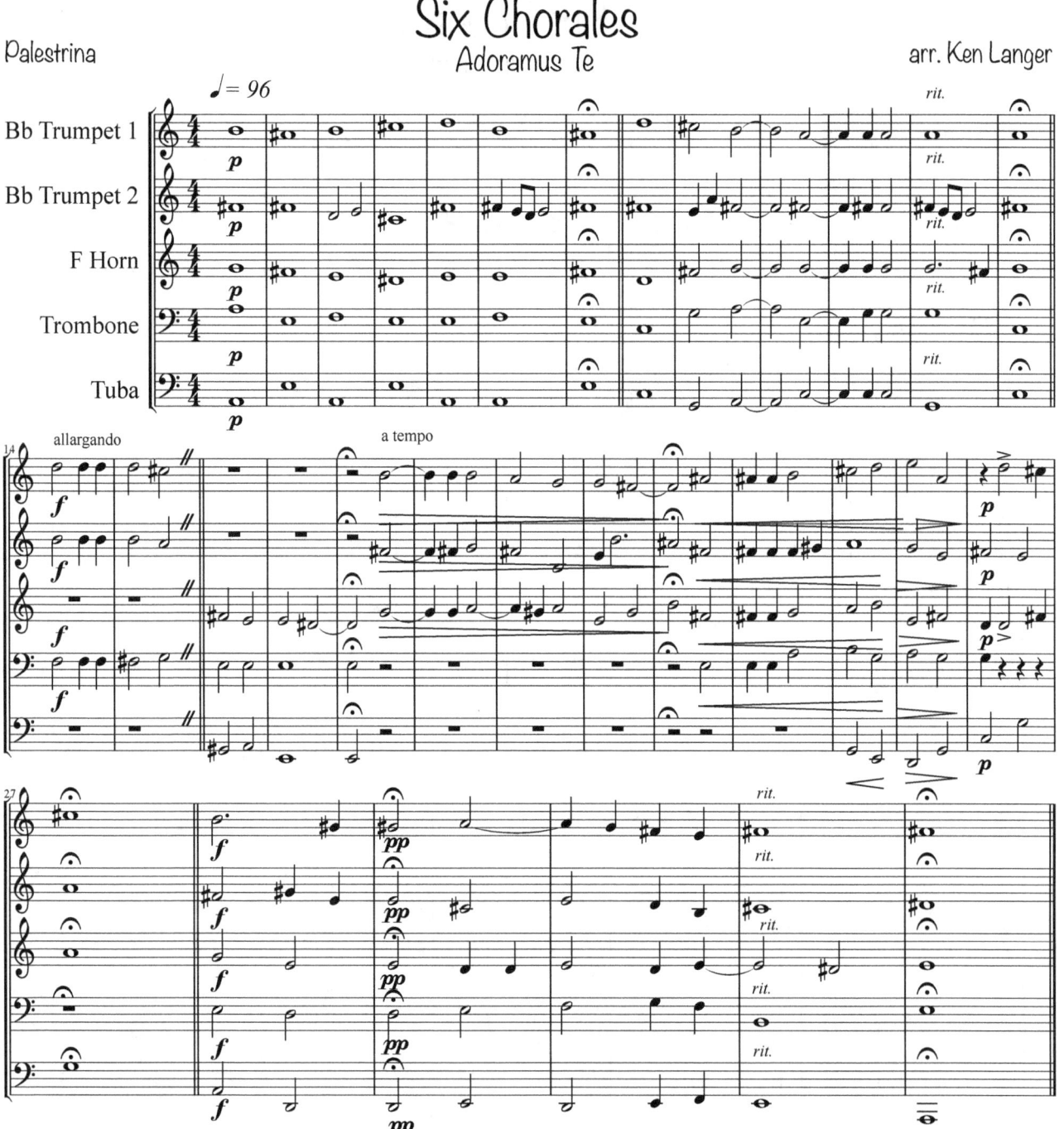

Six Chorales
Hilf, Gott, daß mir's gelinge

J. S. Bach

arr. Ken Langer

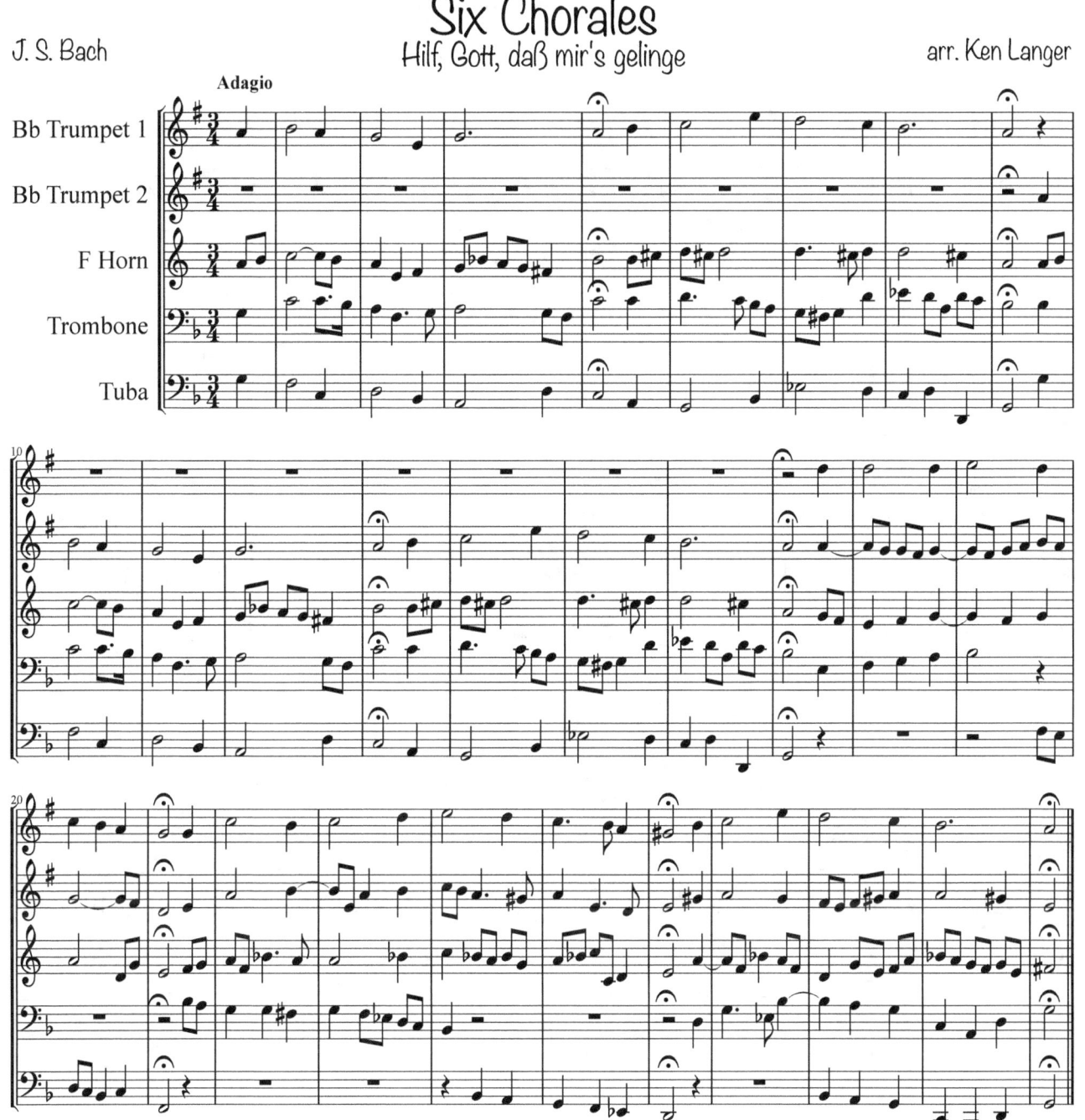

Six Chorales
Adoramus Te, Christe

W. A. Mozart

Ken Langer

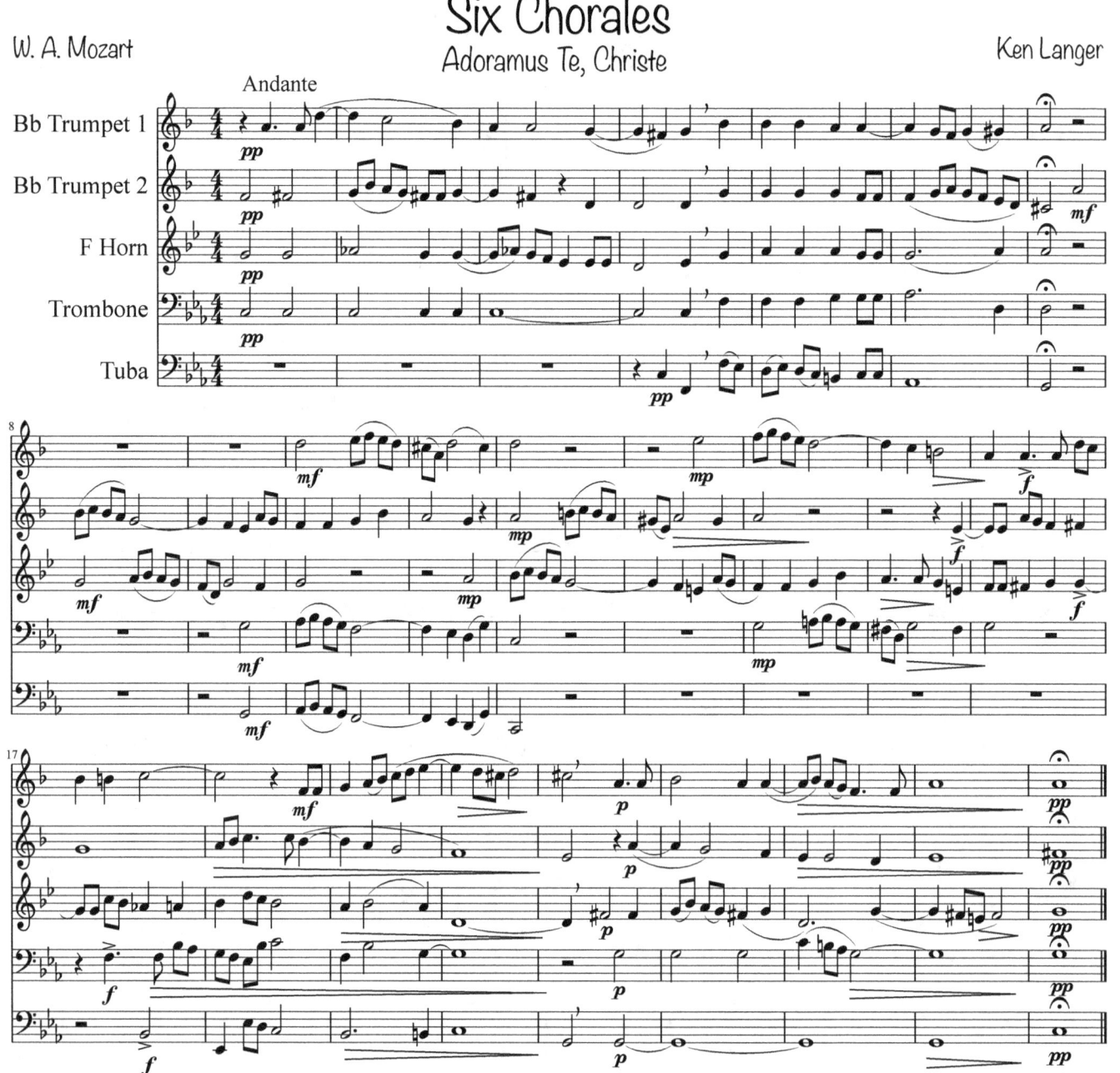

86

Six Chorales
Salve Regina

Franz Schubert

arr. Ken Langer

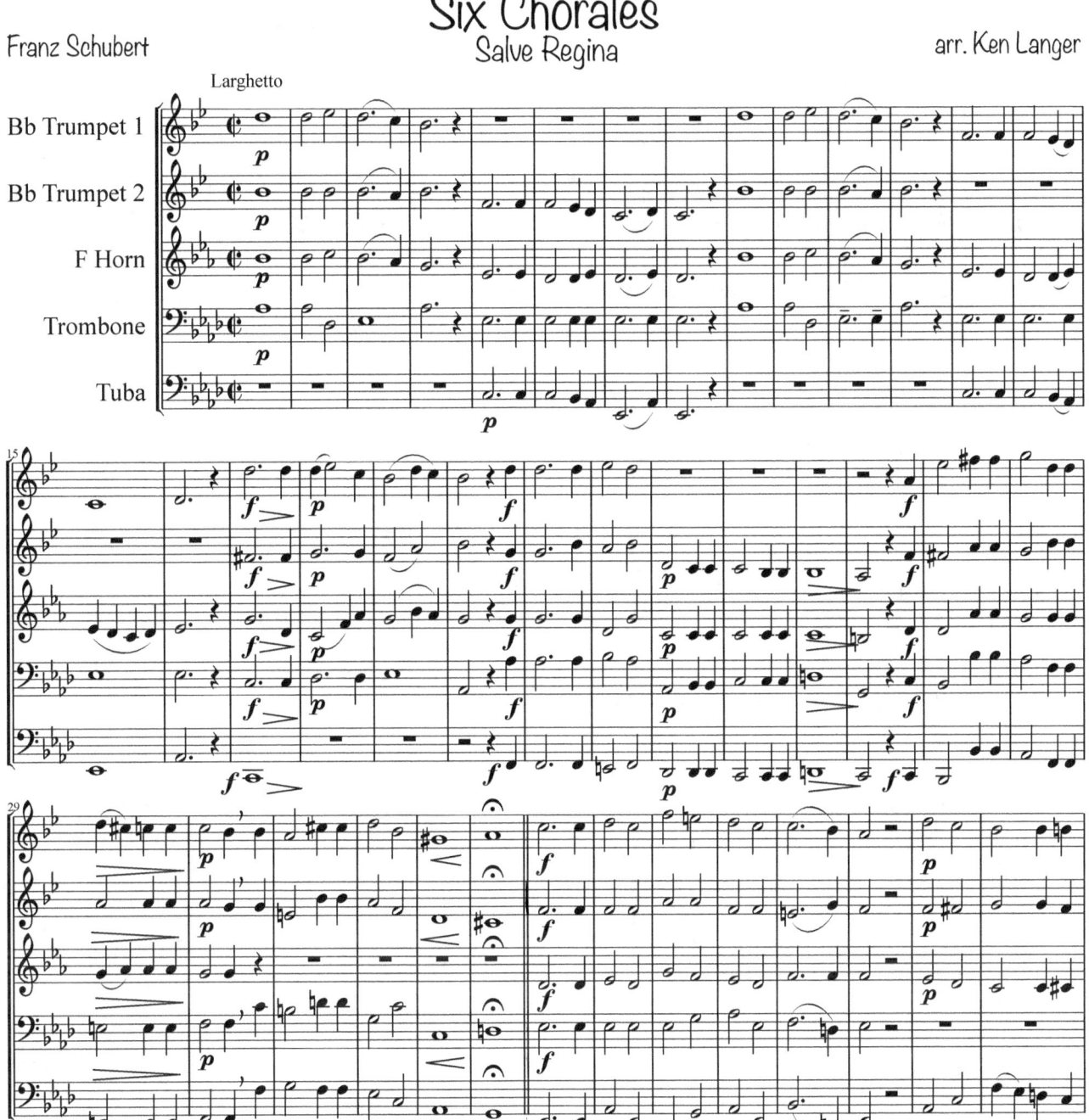

87

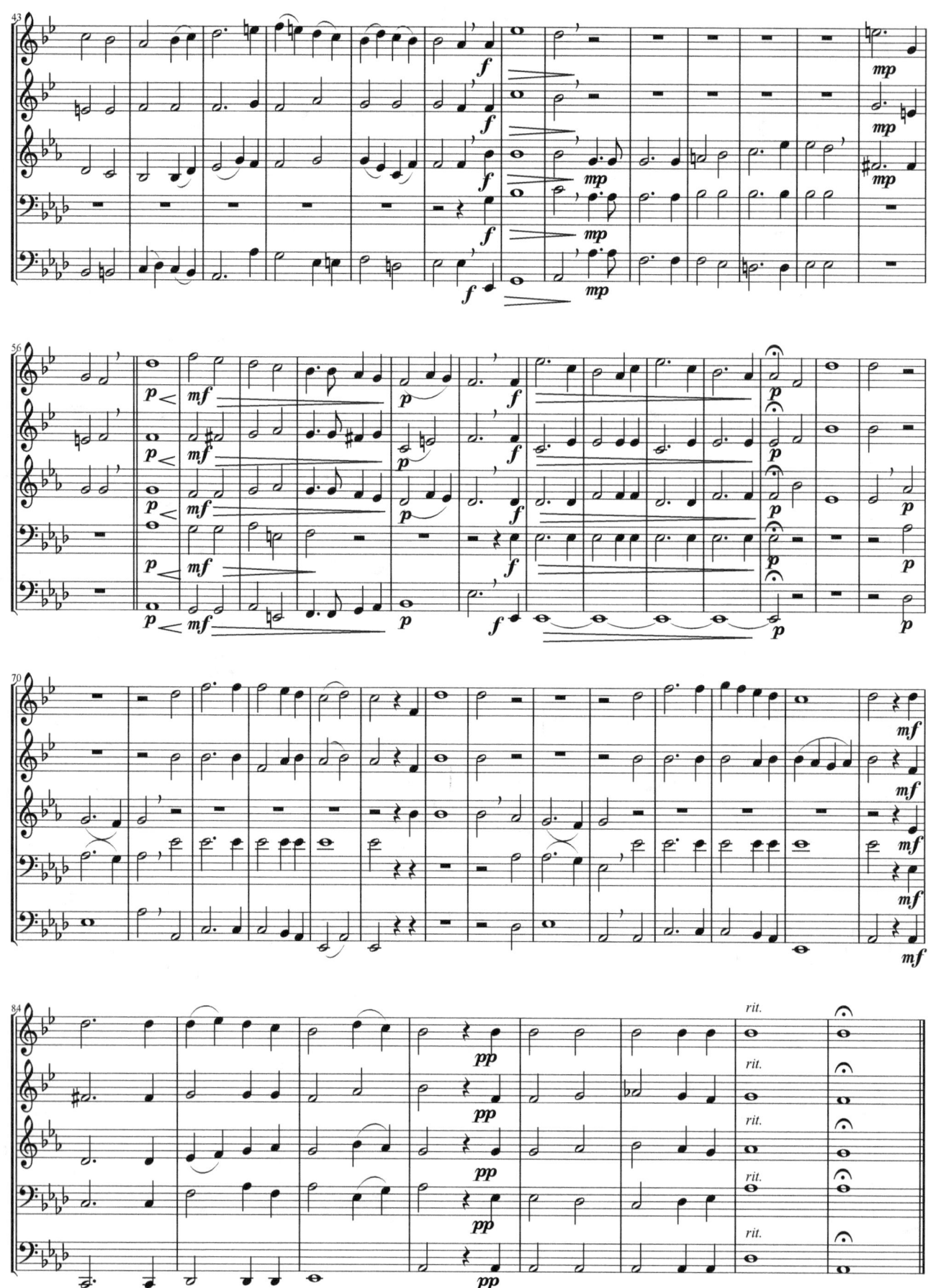

Six Chorales
Mother Earth

Ken Langer

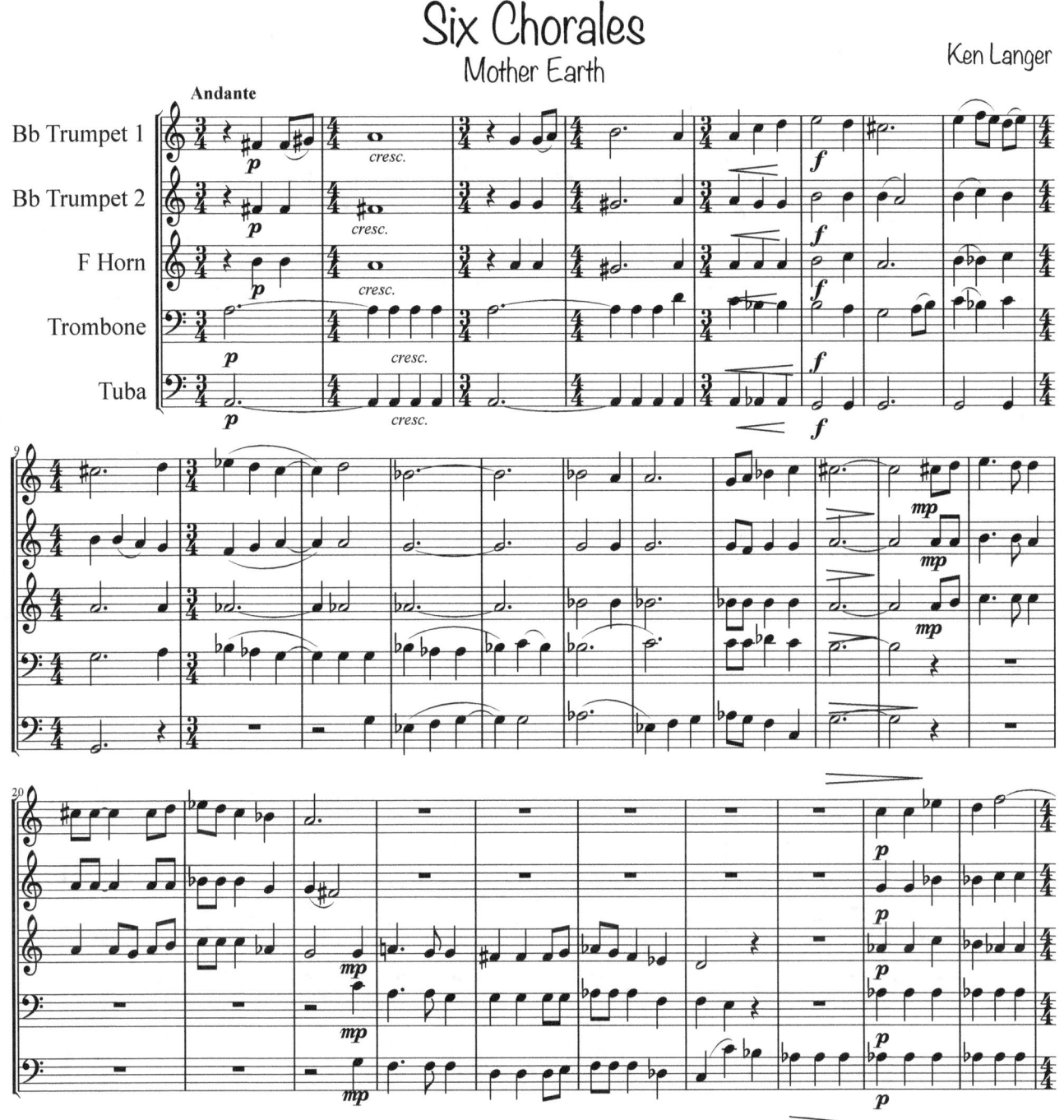

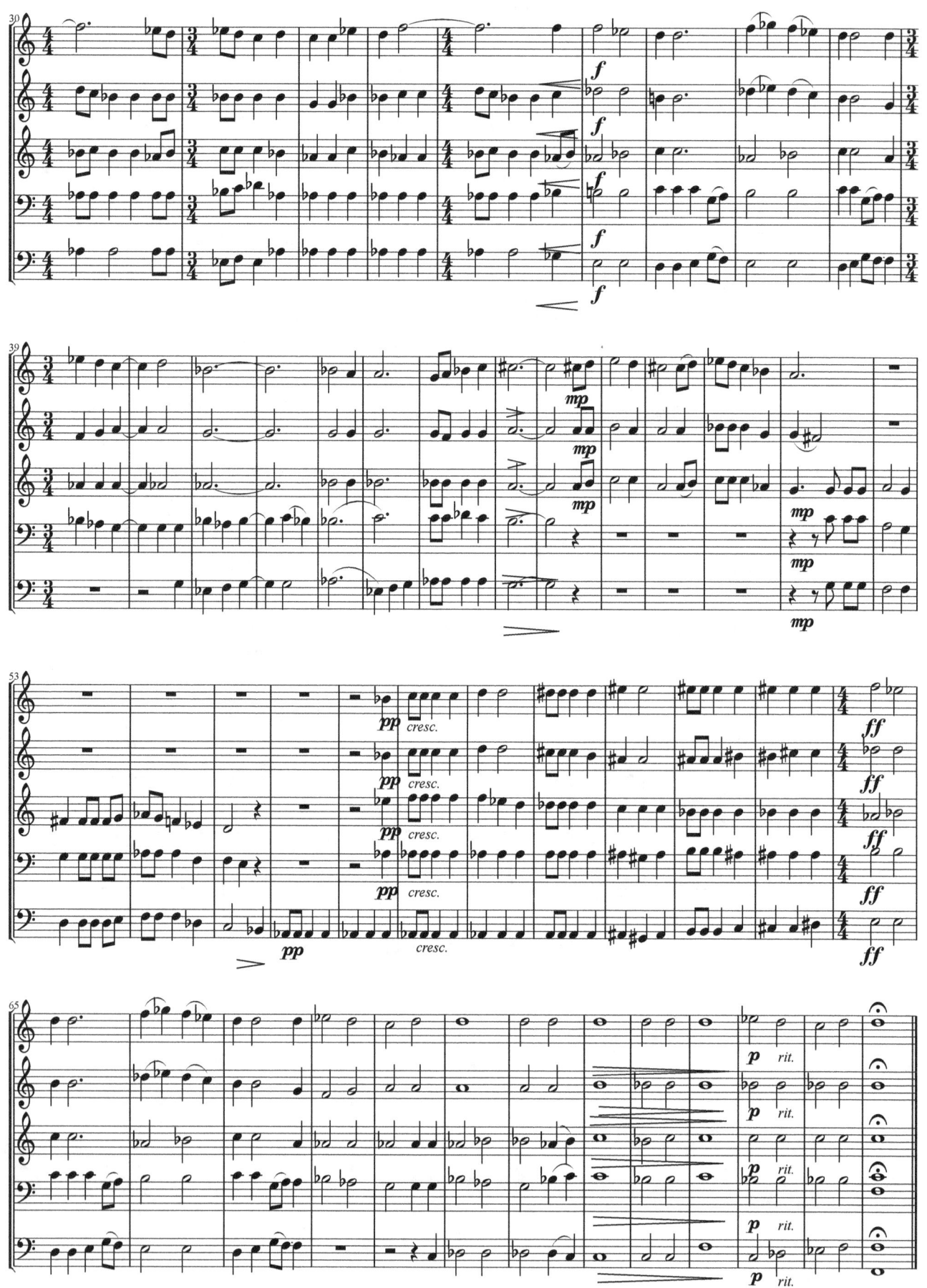

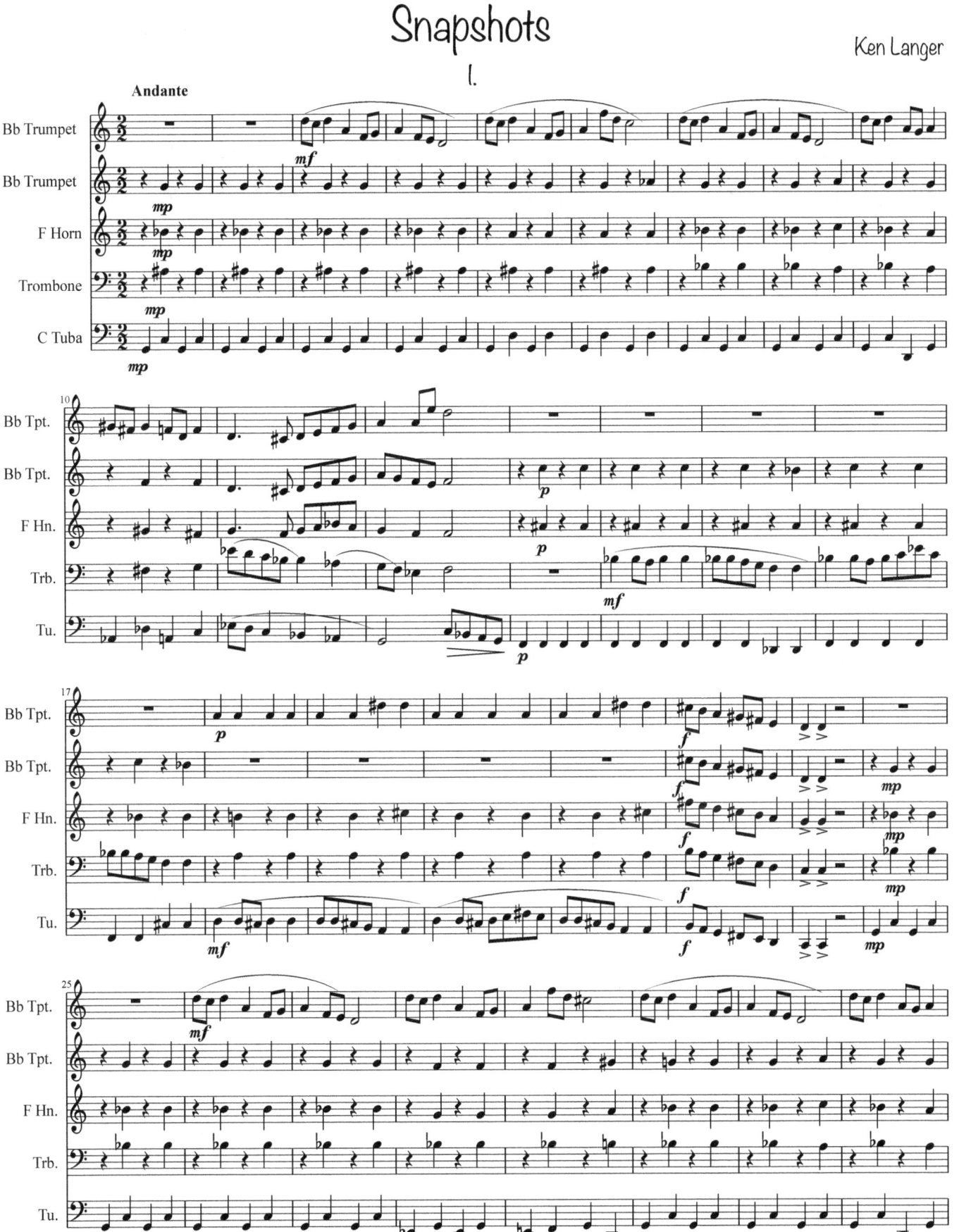

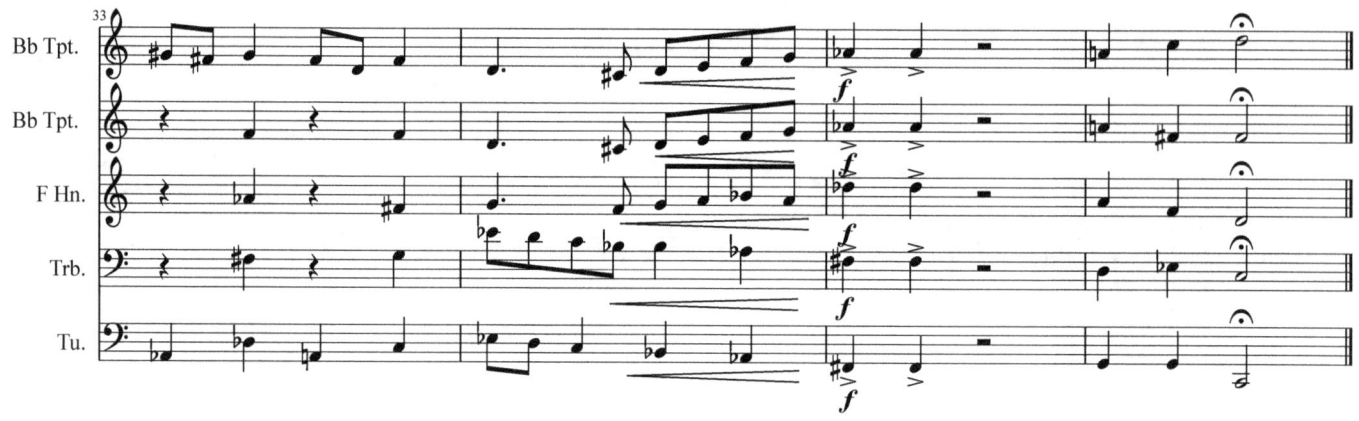

Snapshots
II. Window Shopping

Ken Langer

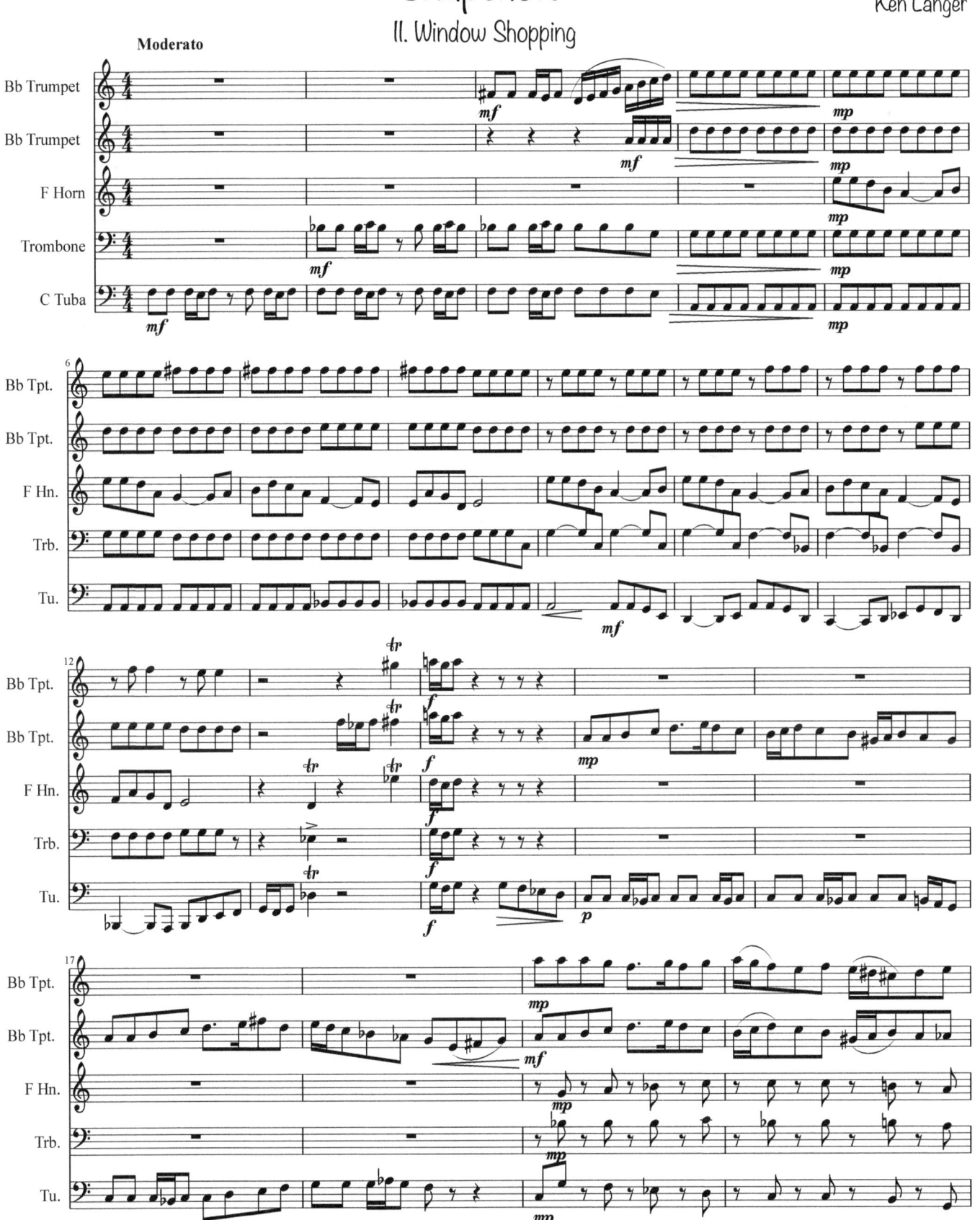

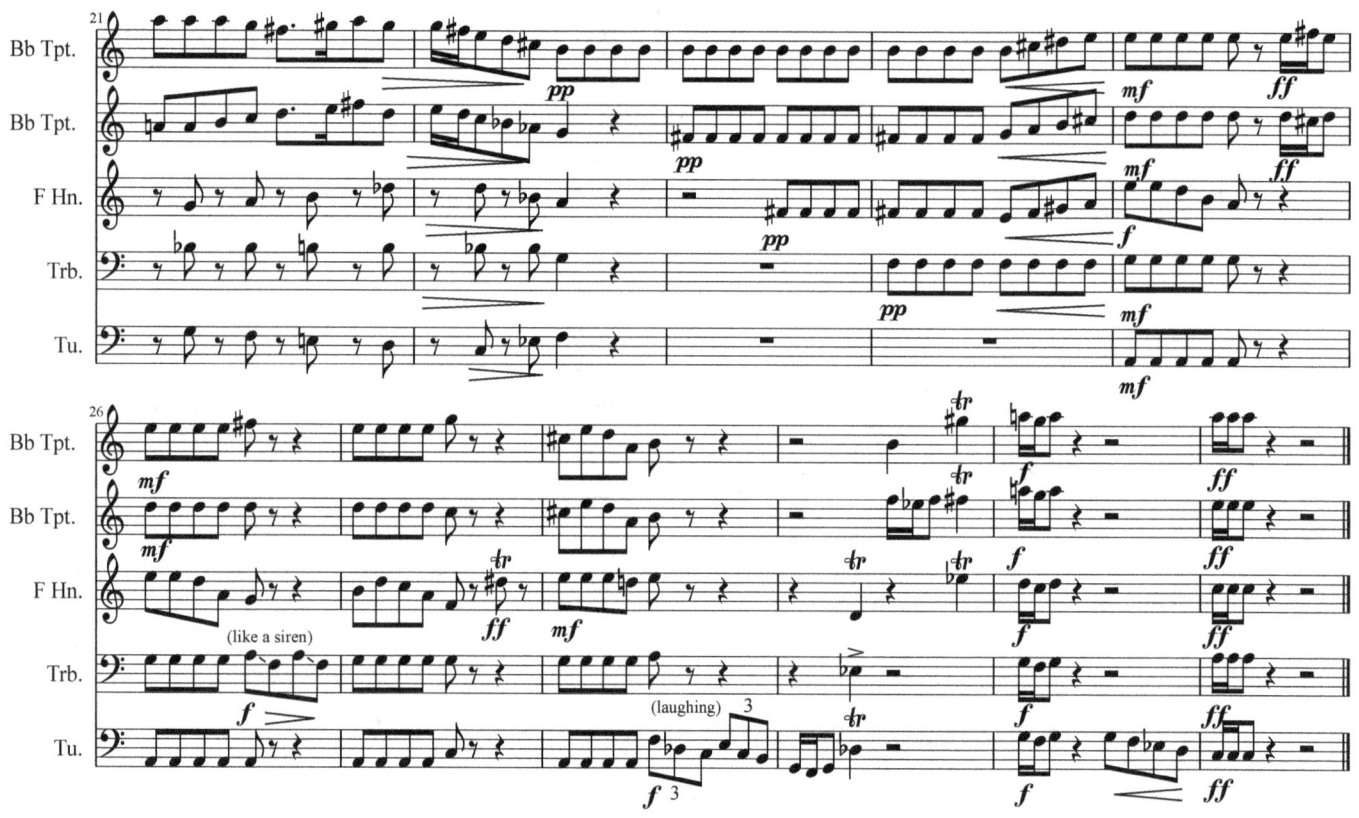

Snapshots
III. The Golden Maples

Ken Langer

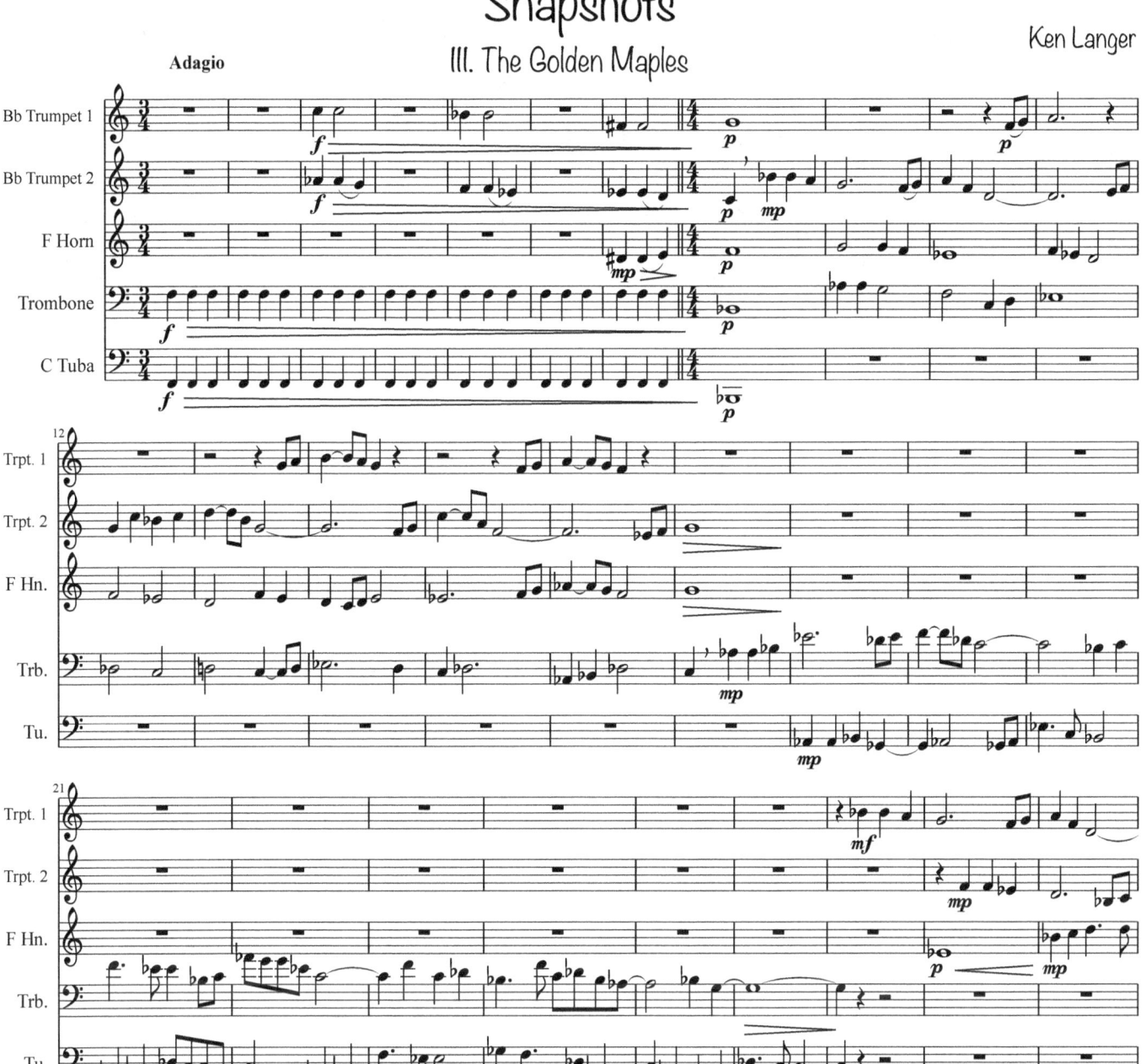

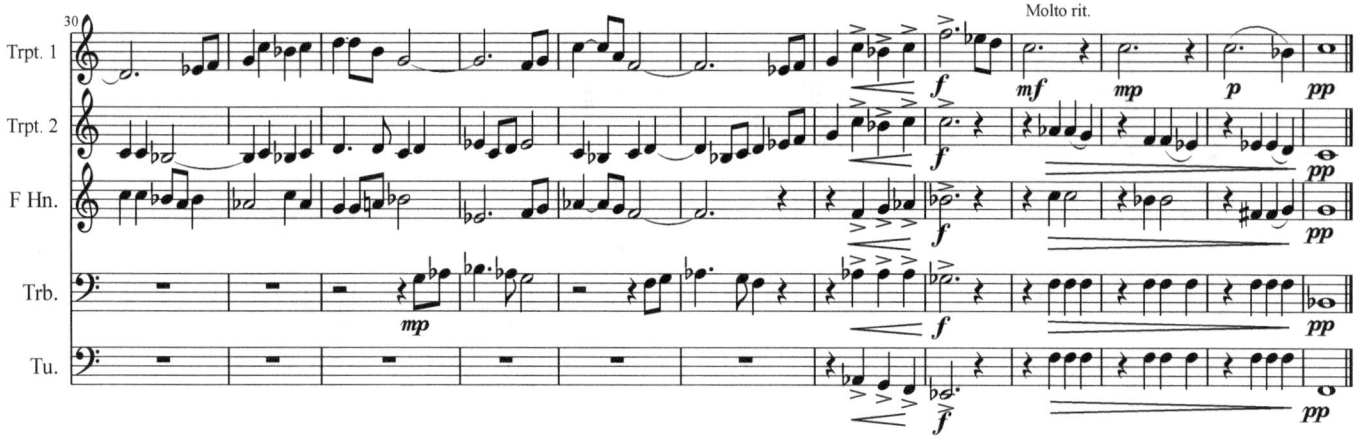

Snapshots
IV. Playing For The Camera

Ken Langer

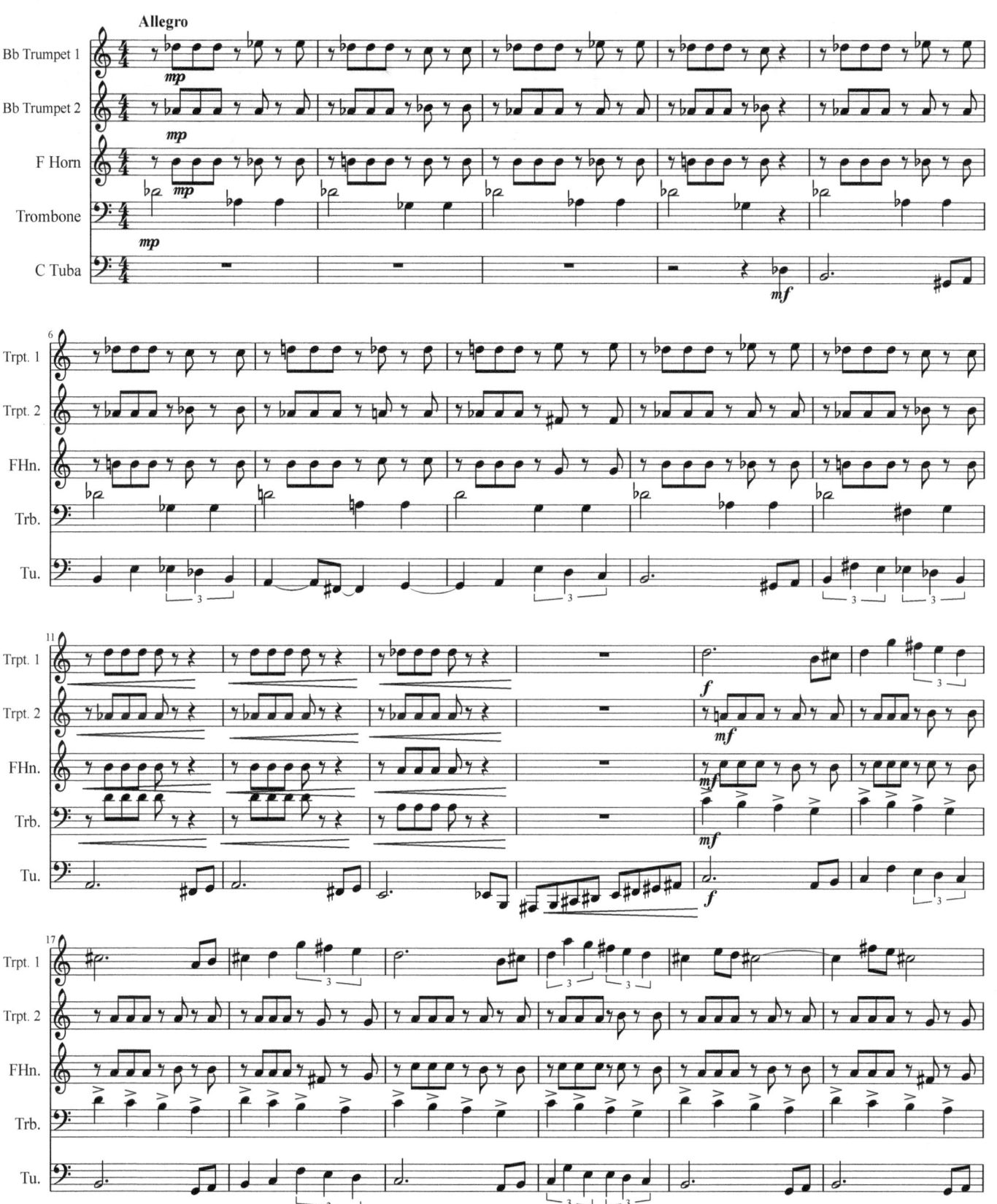

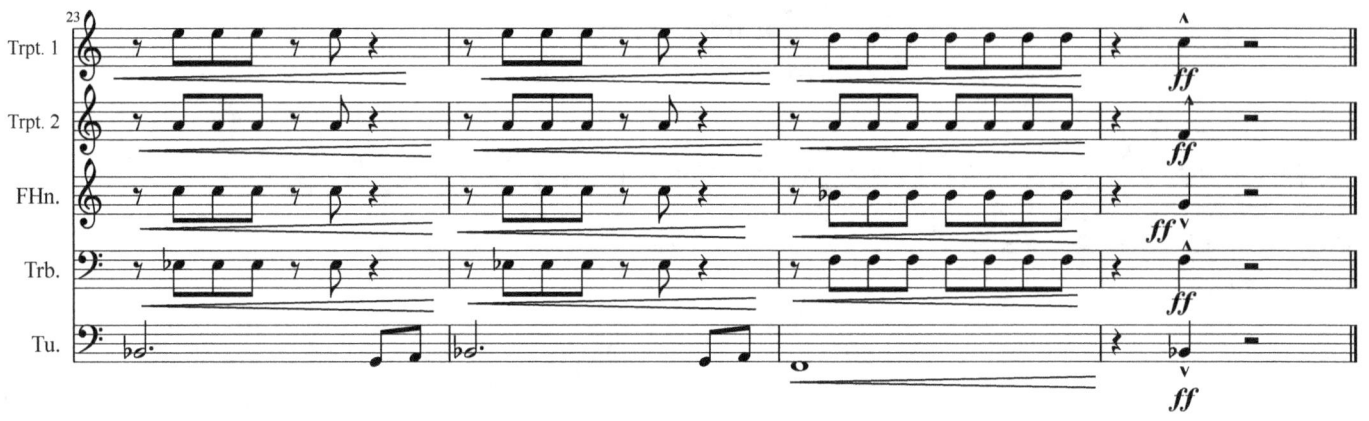

Snapshots
V. The Proud Grandmother

Ken Langer

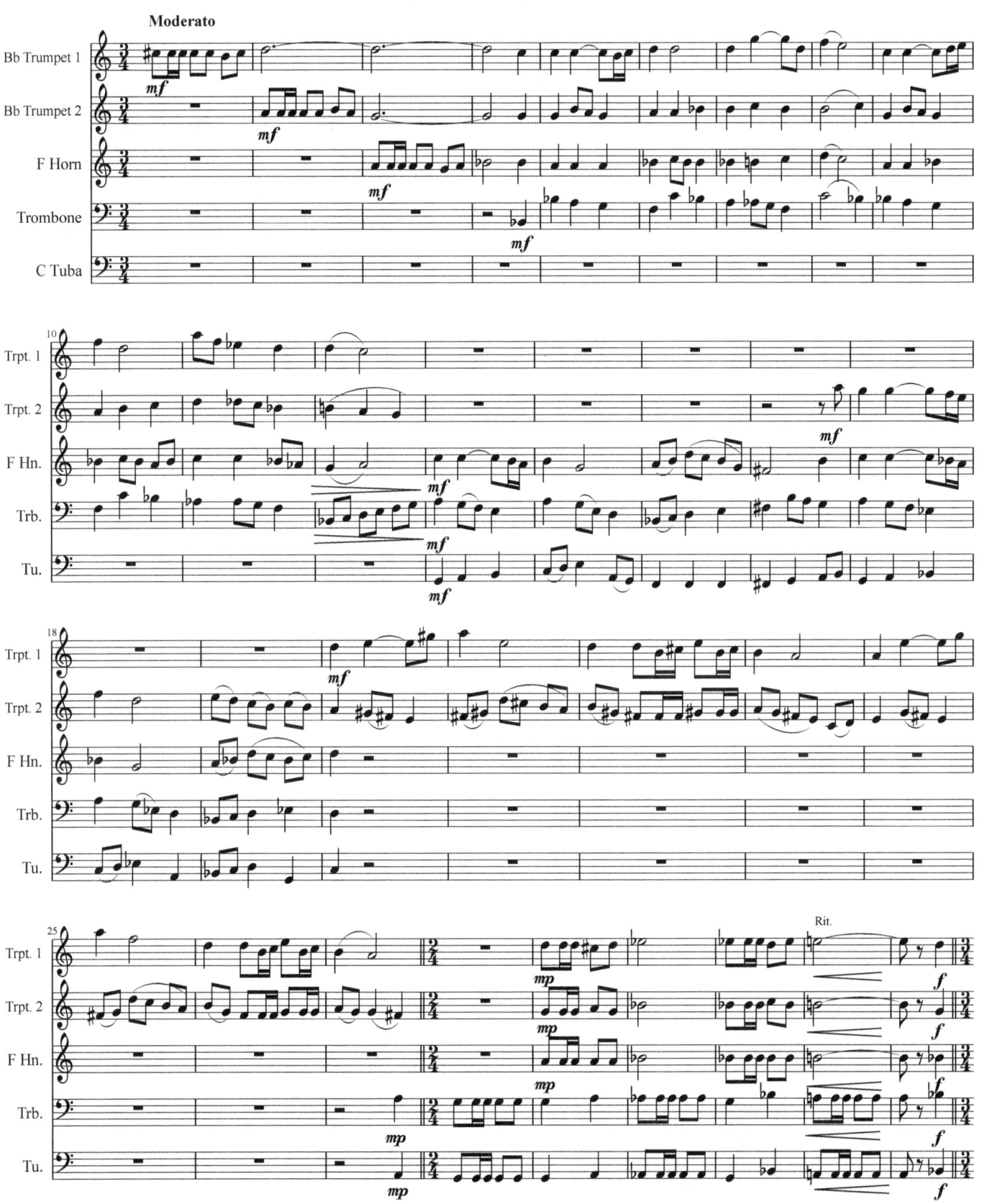

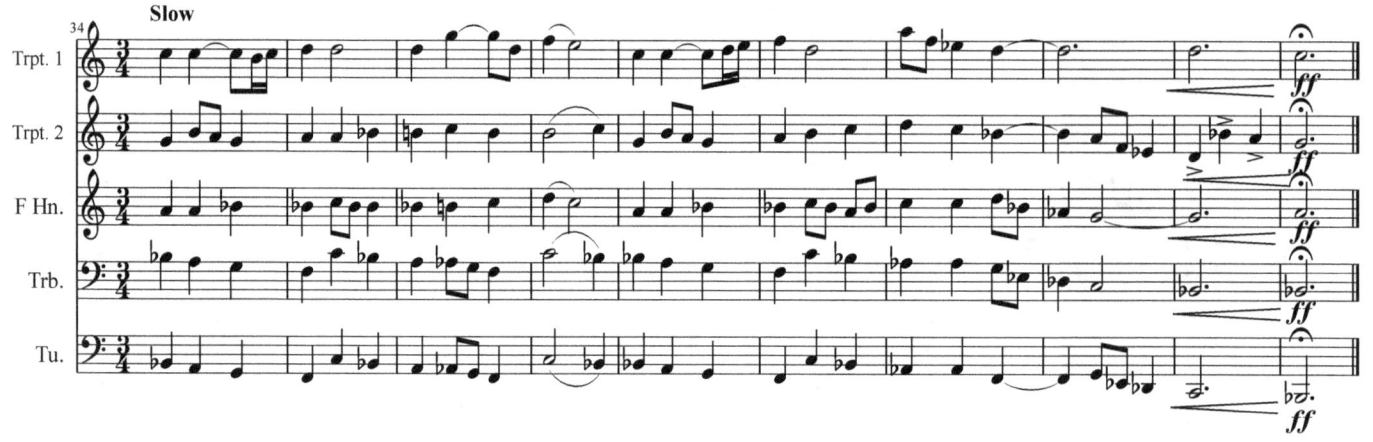

Two Chromatic Madrigals
Belta, poi t'assenti

Carlo Gesualdo

arr. Ken Langer

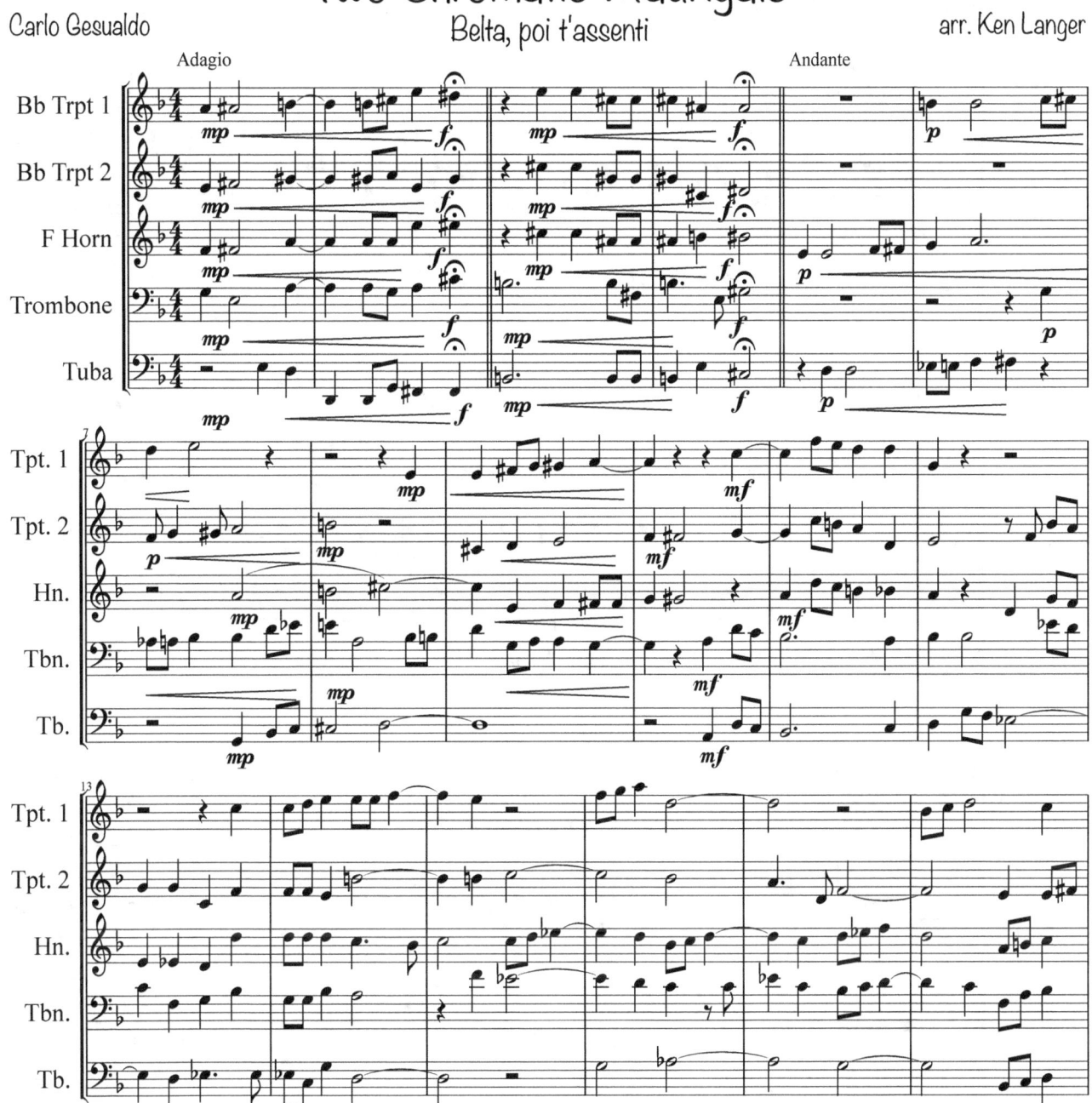

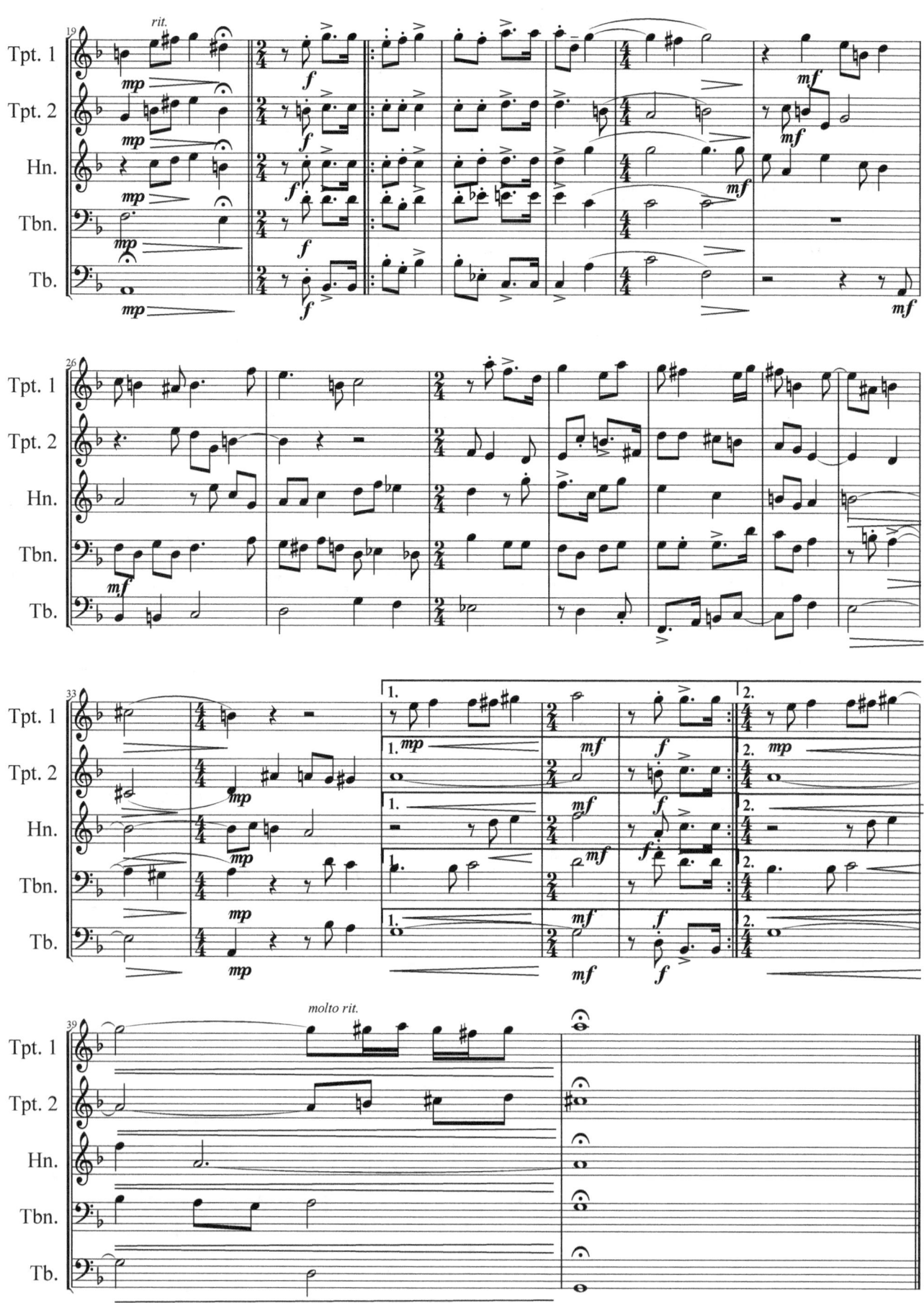

Two Chromatic Madrigals

Carlo Gesualdo

arr. Ken Langer

Morro Lasso

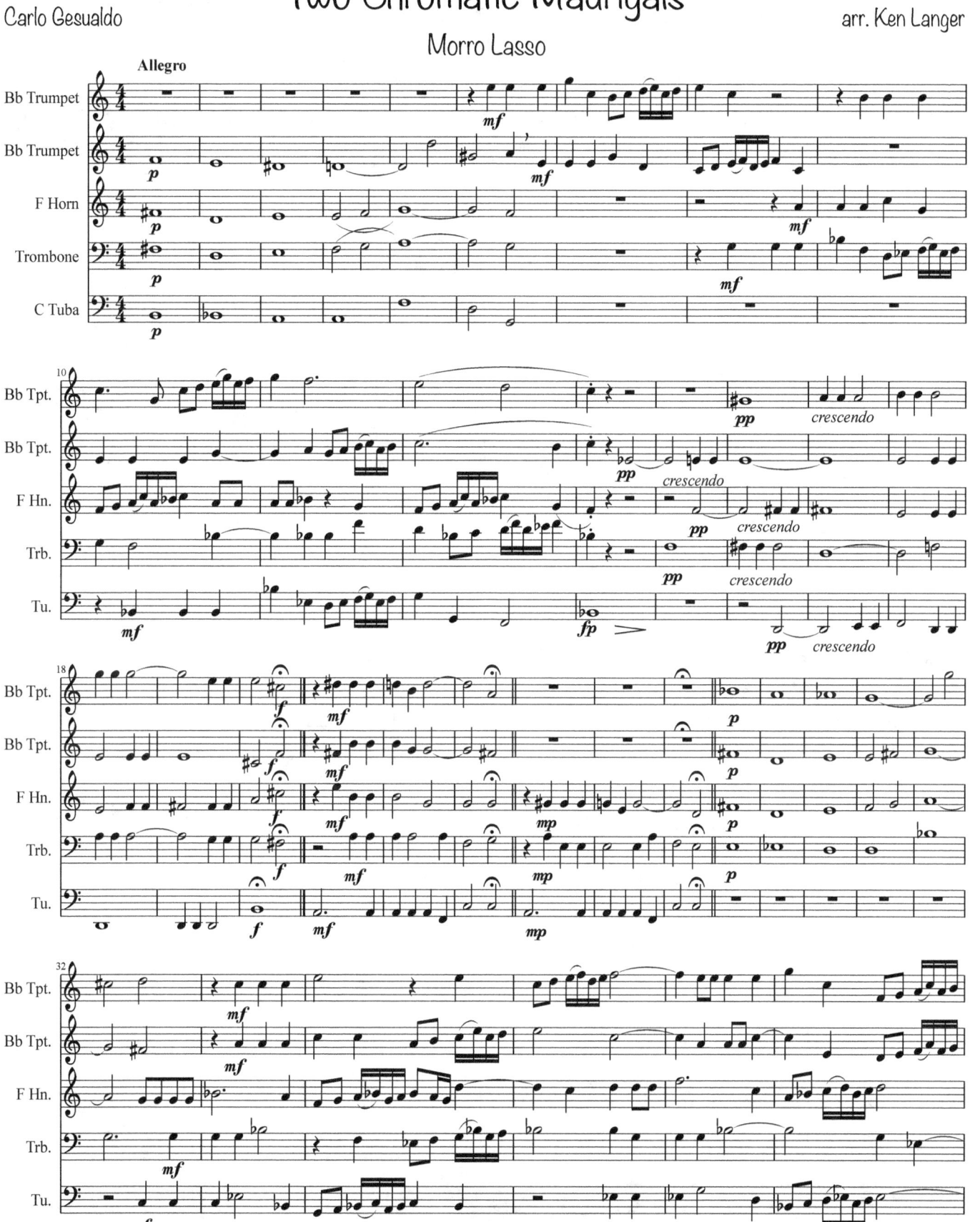

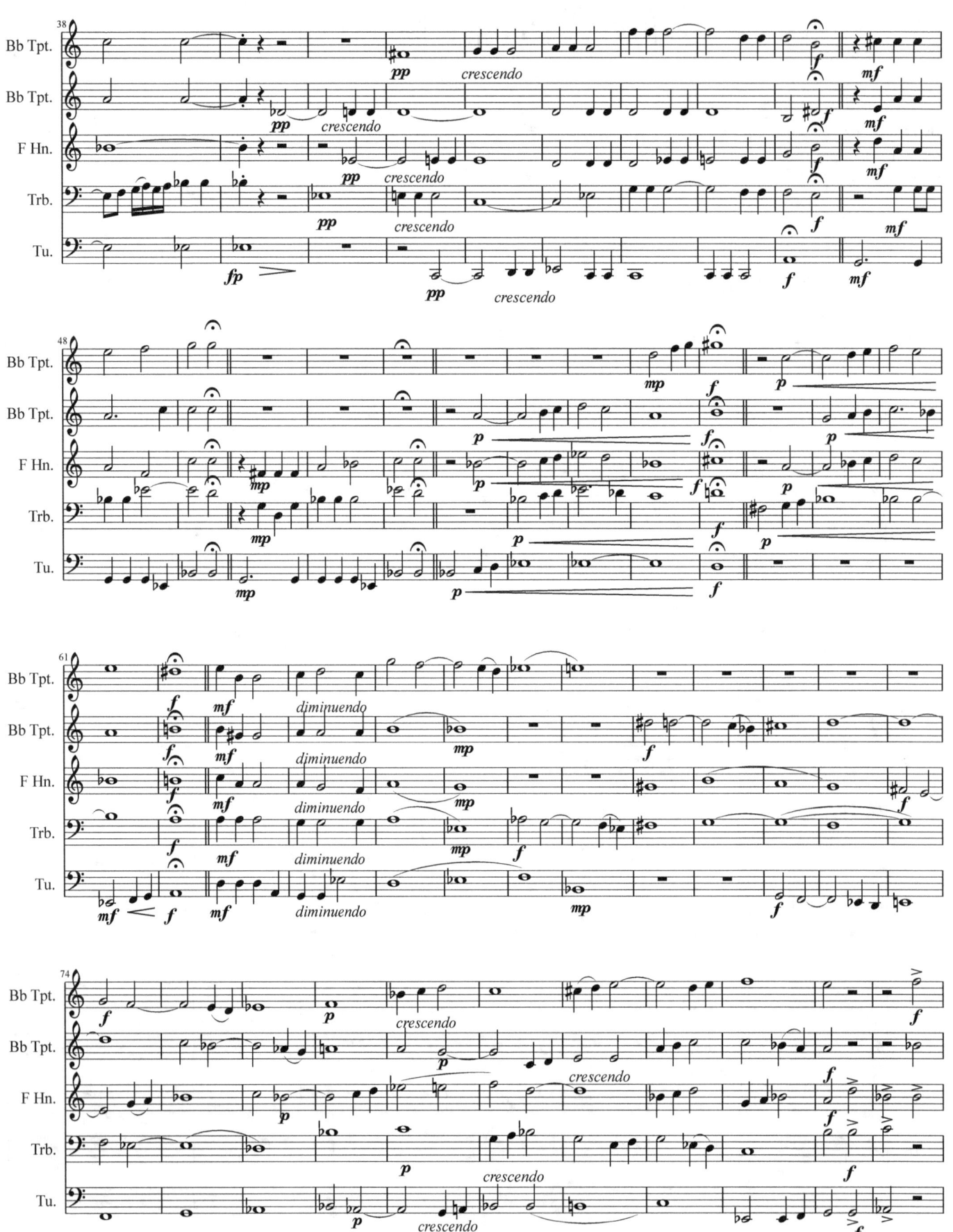

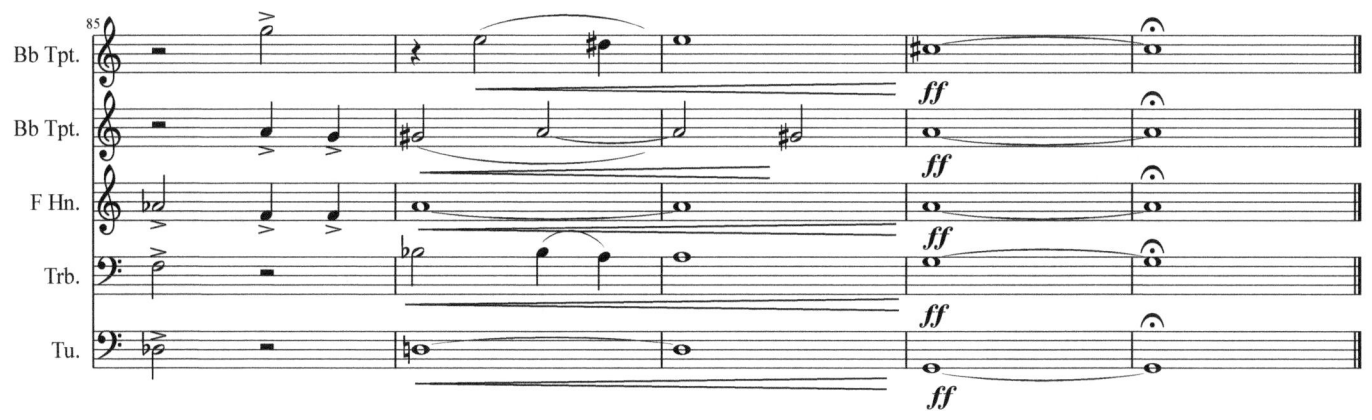

105

Wedding Music
Fanfare

Ken Langer

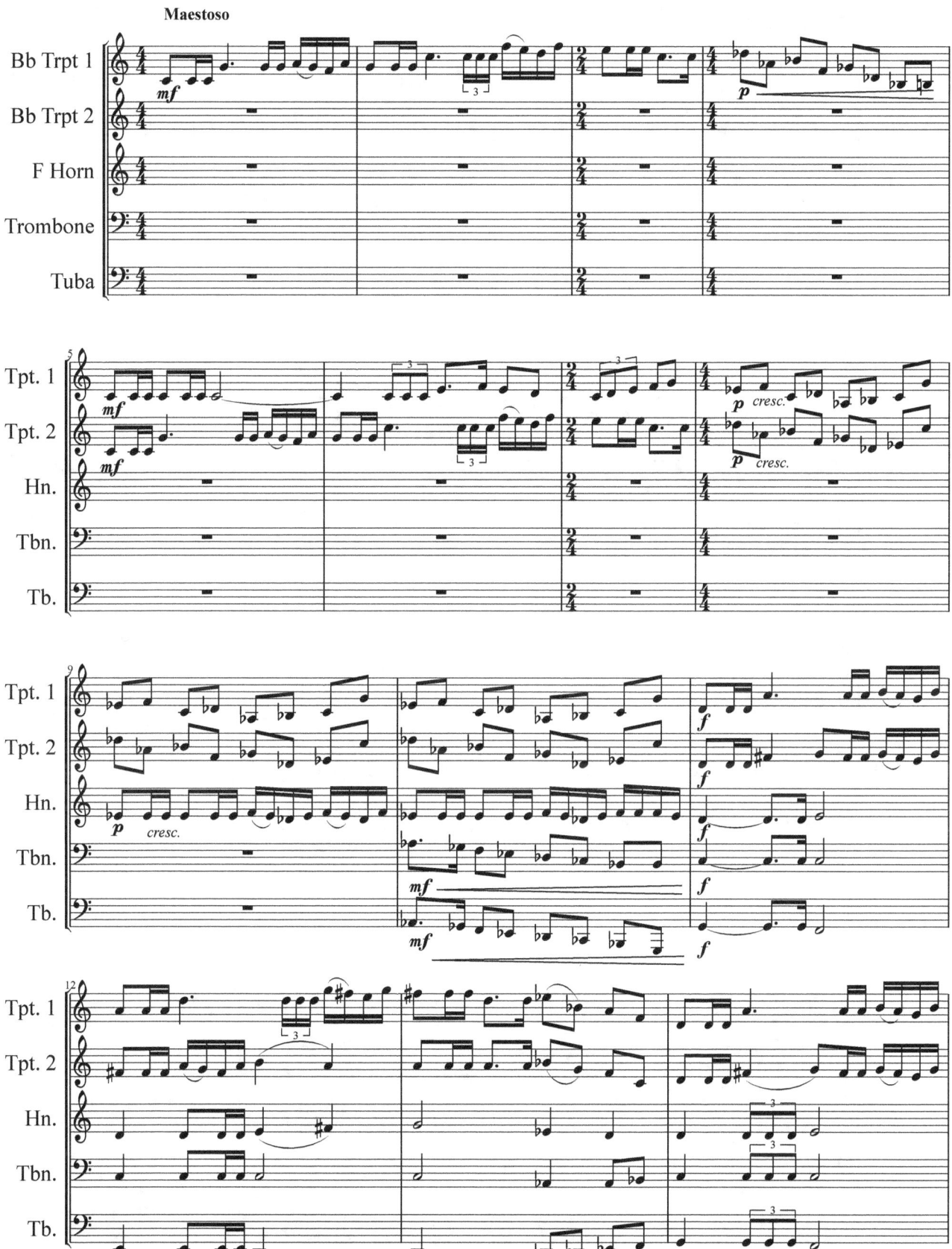

107

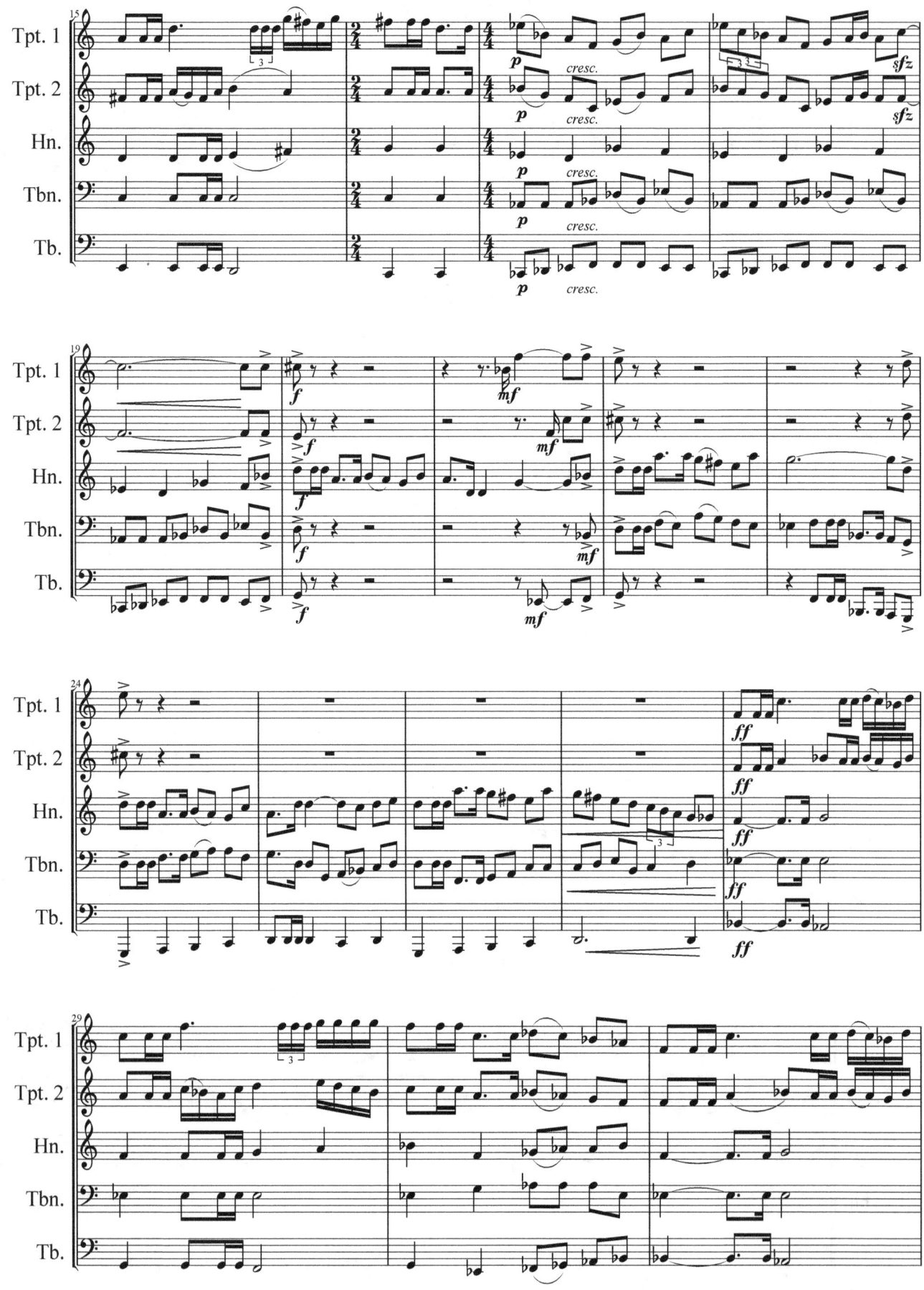

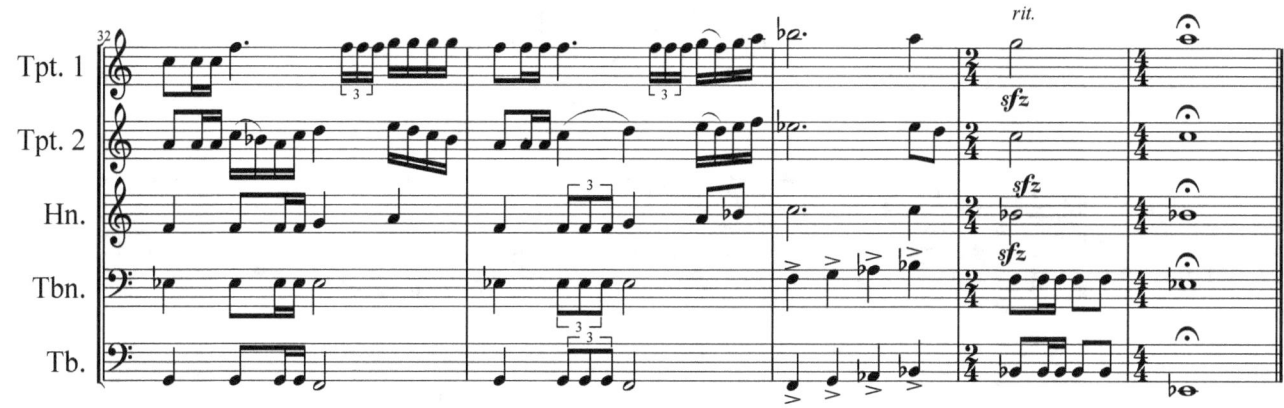

109

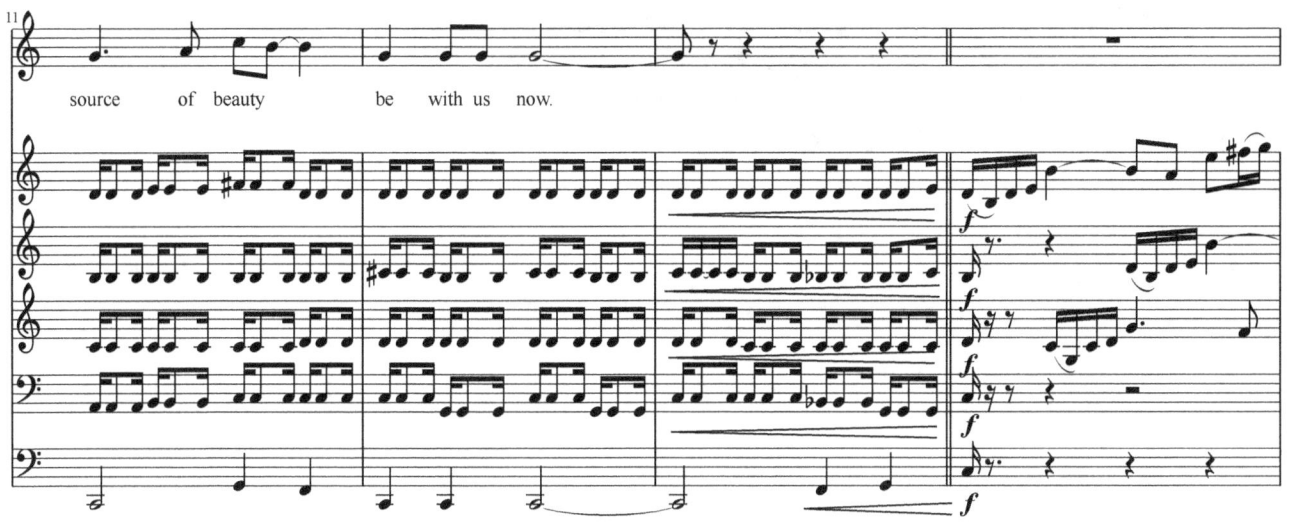
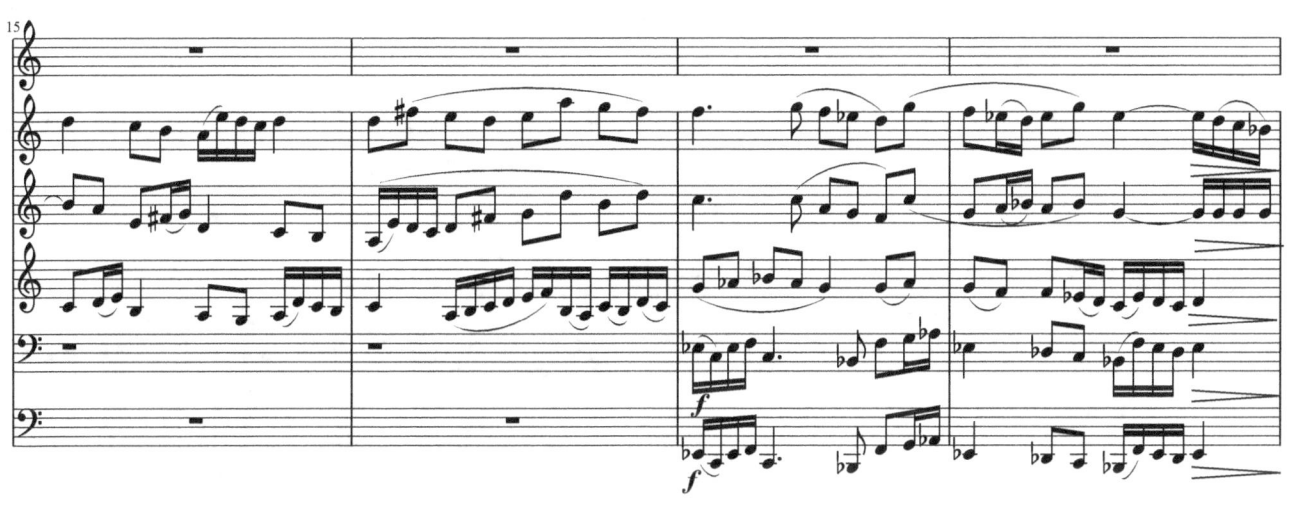
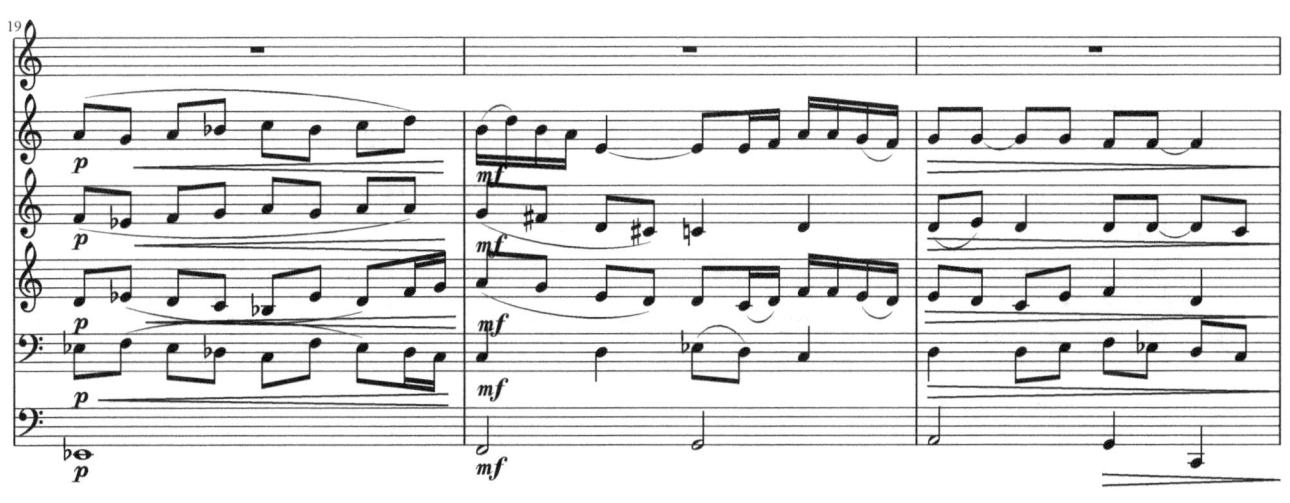

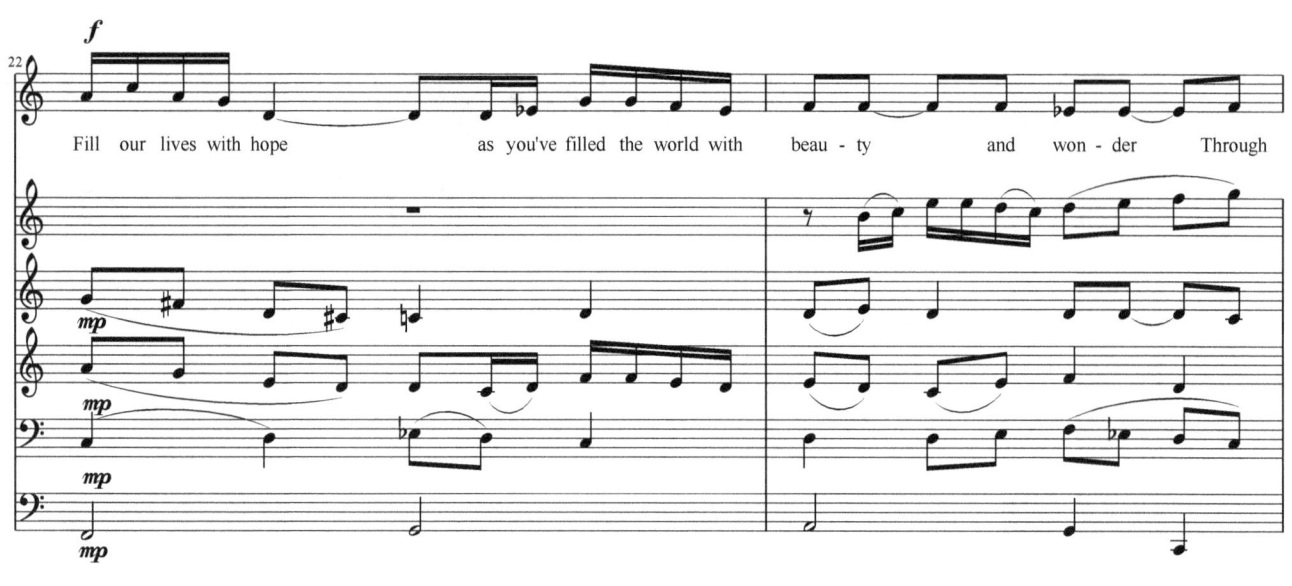
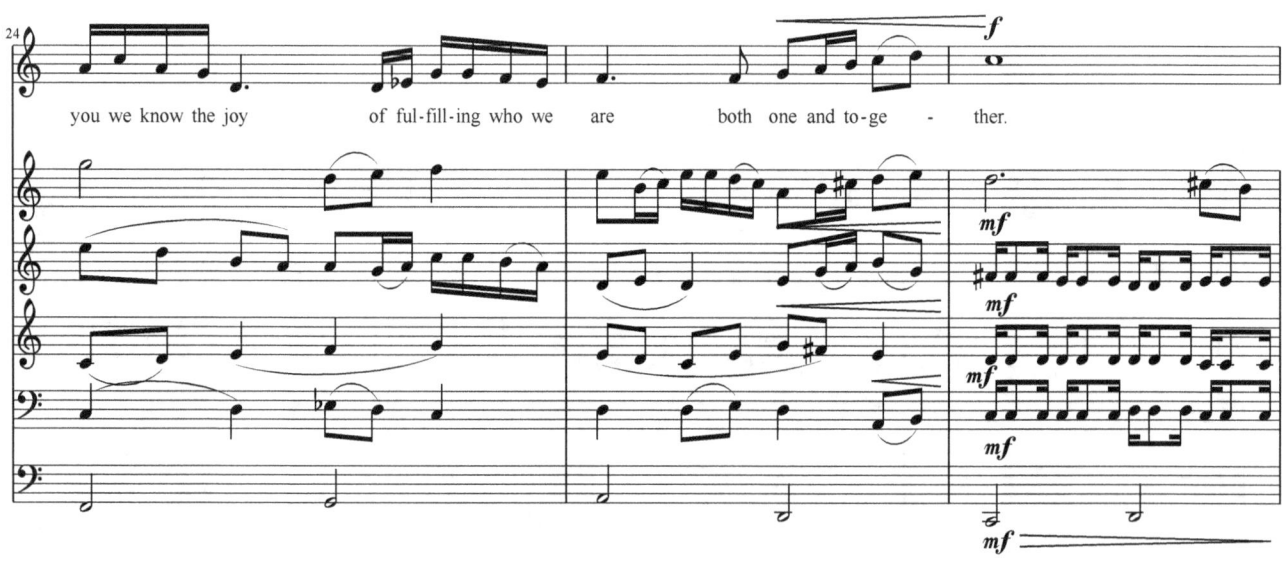
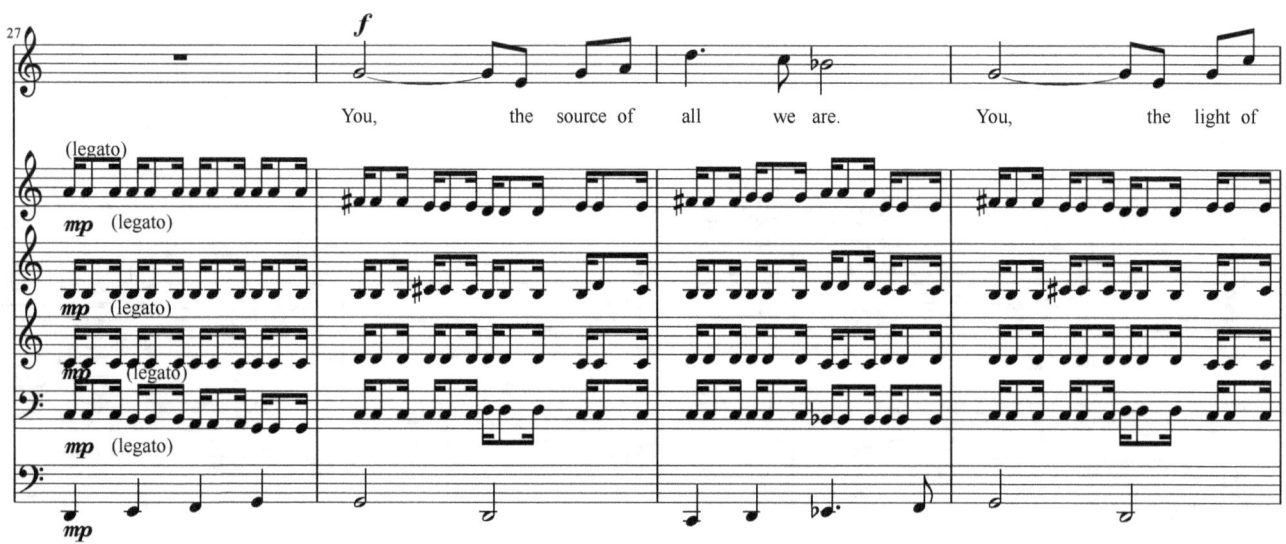

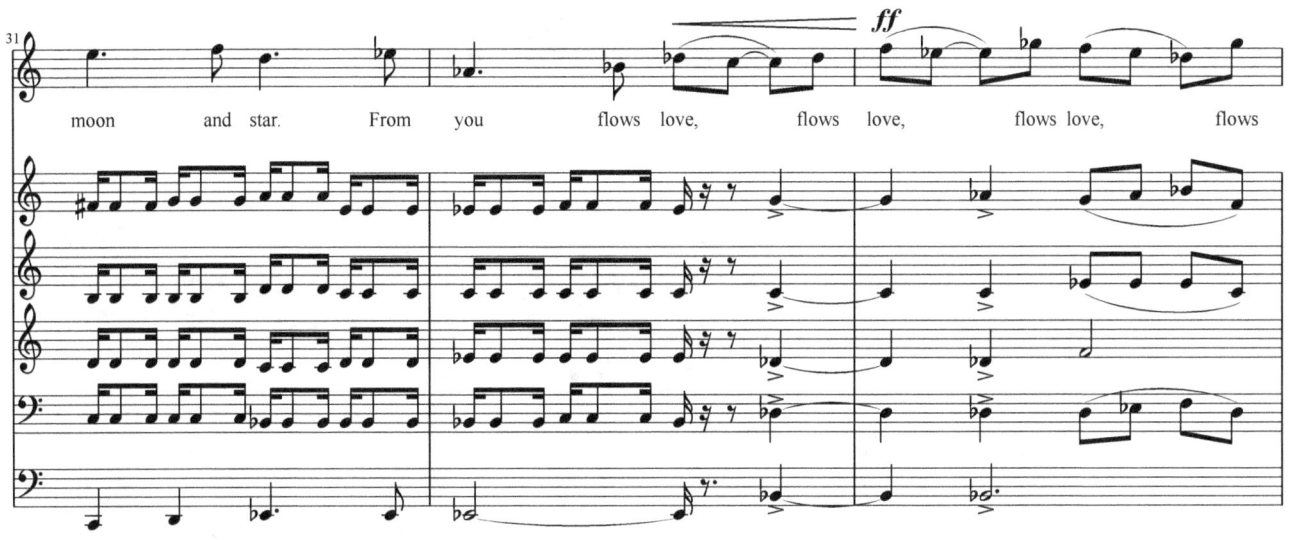
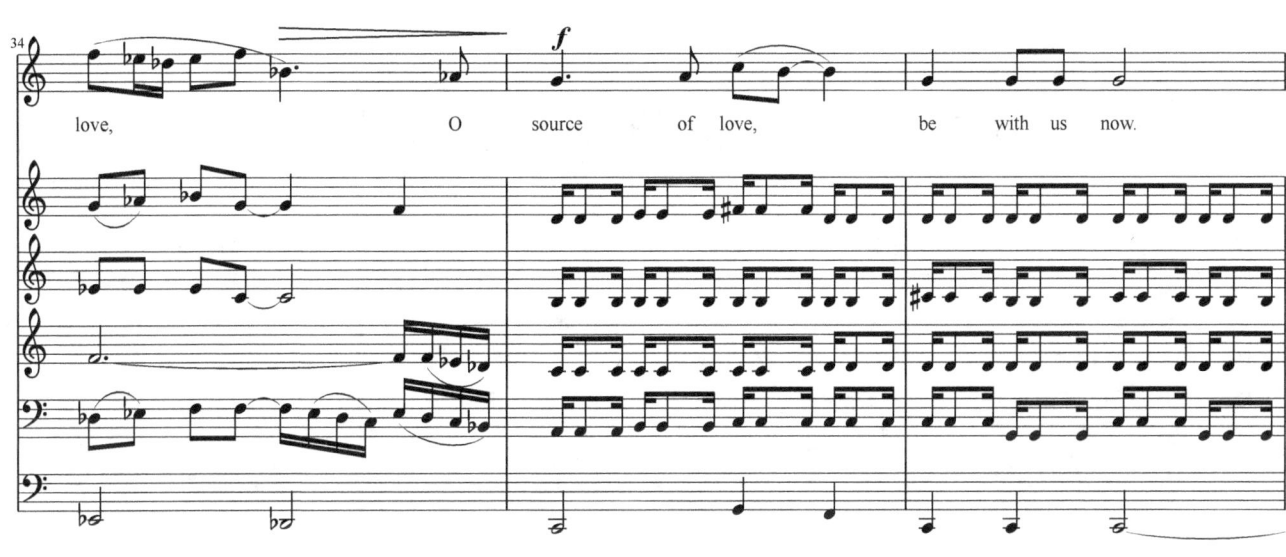
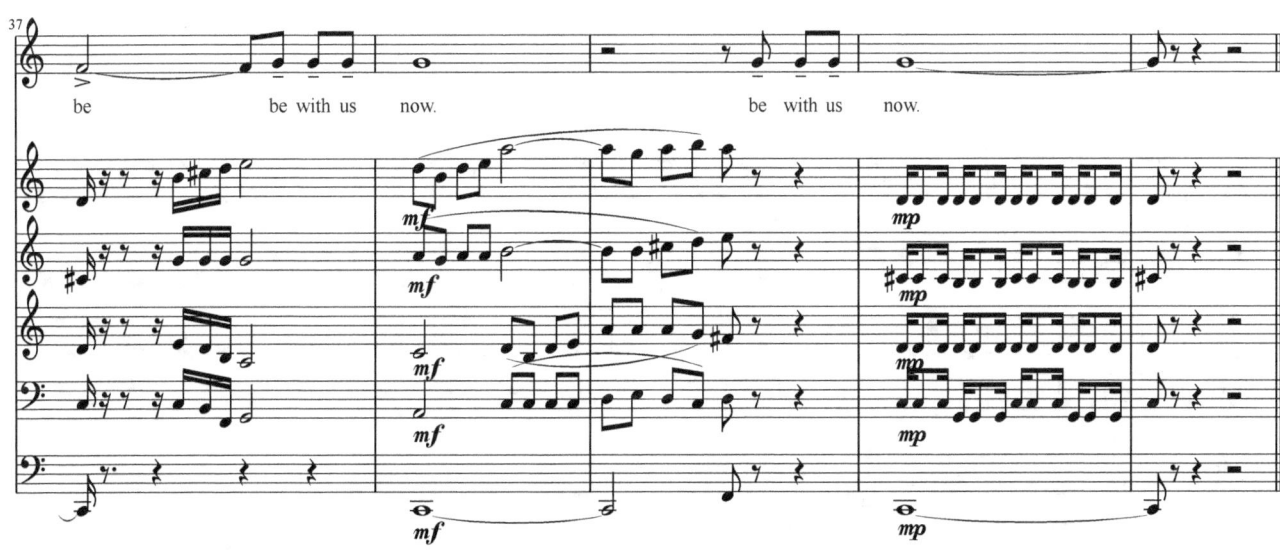

Wedding Music
Invocation

Ken Langer

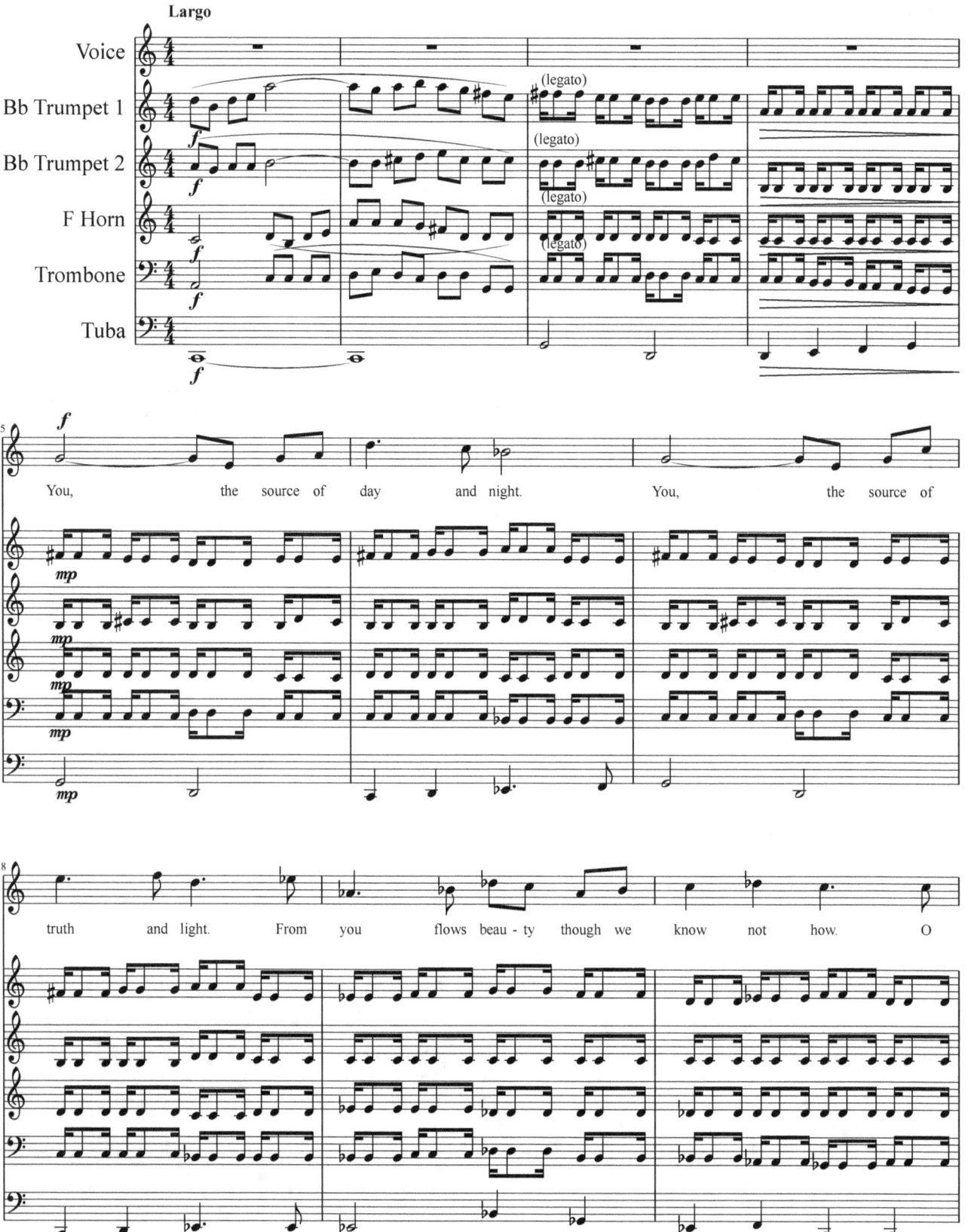

114

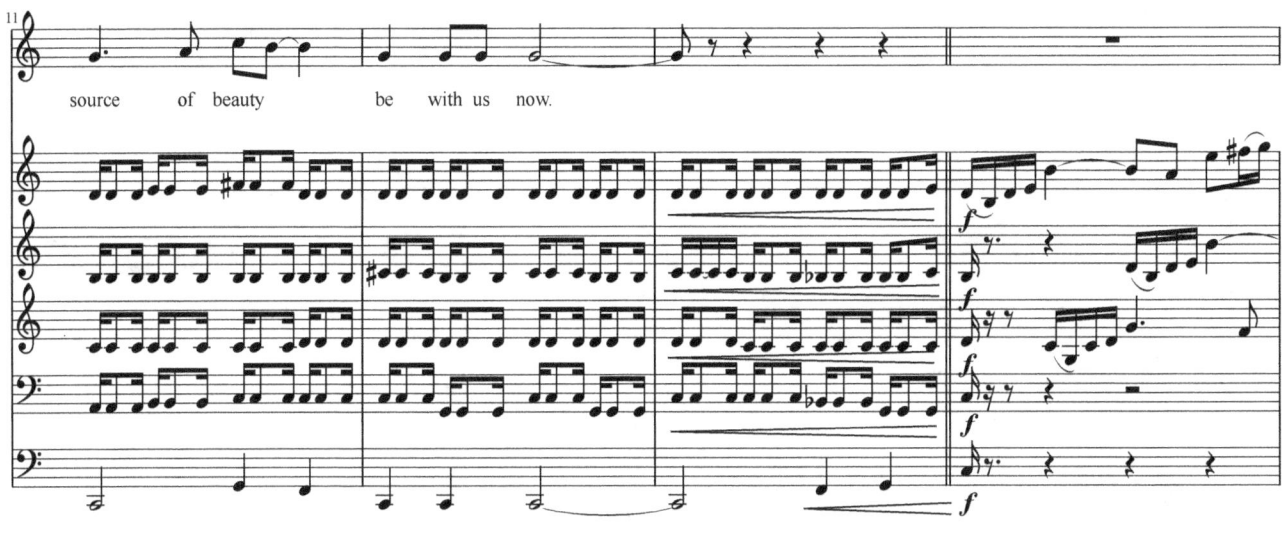
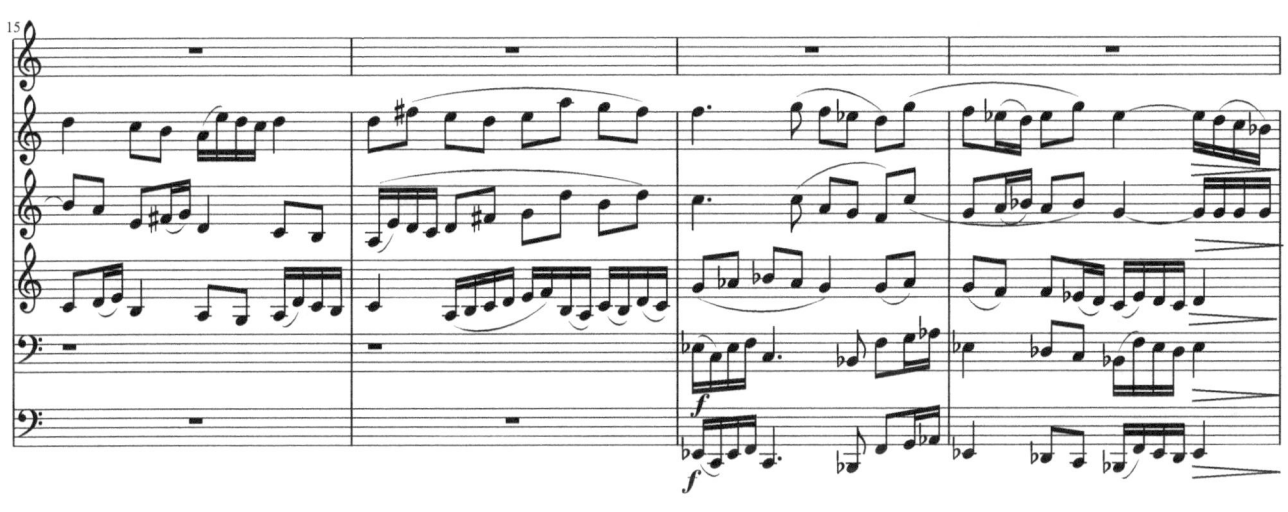
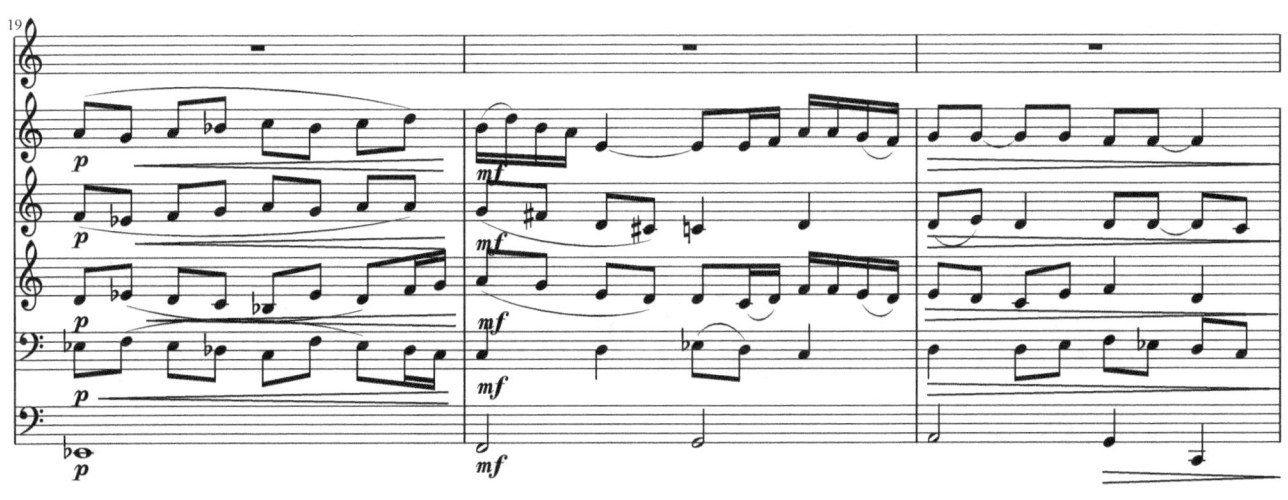

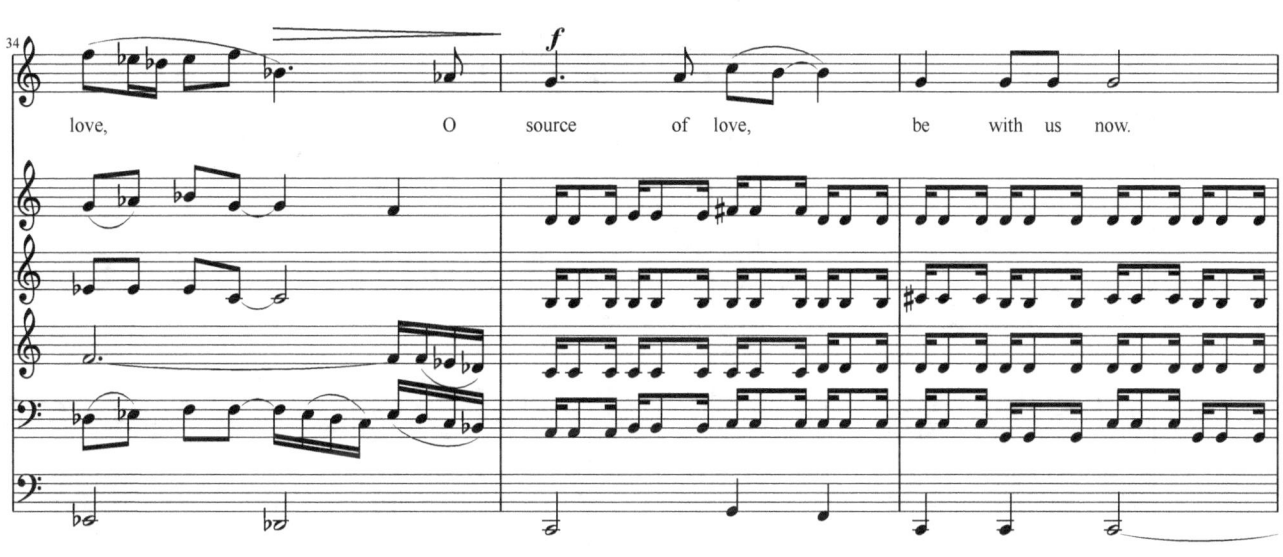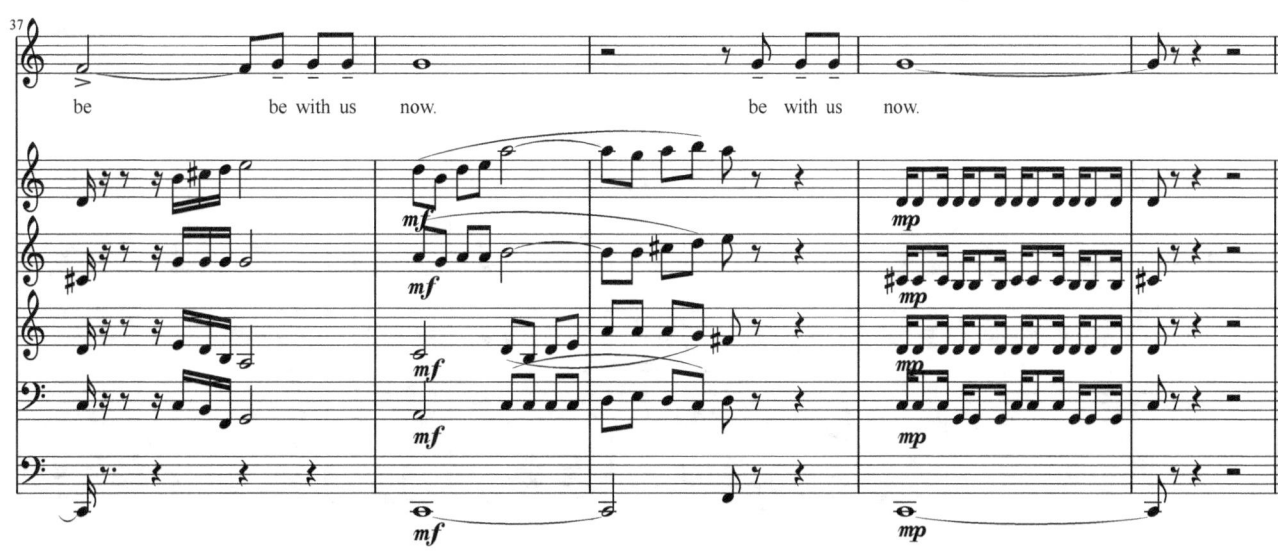

Wedding Music
A Sweet Perfume

Ken Langer

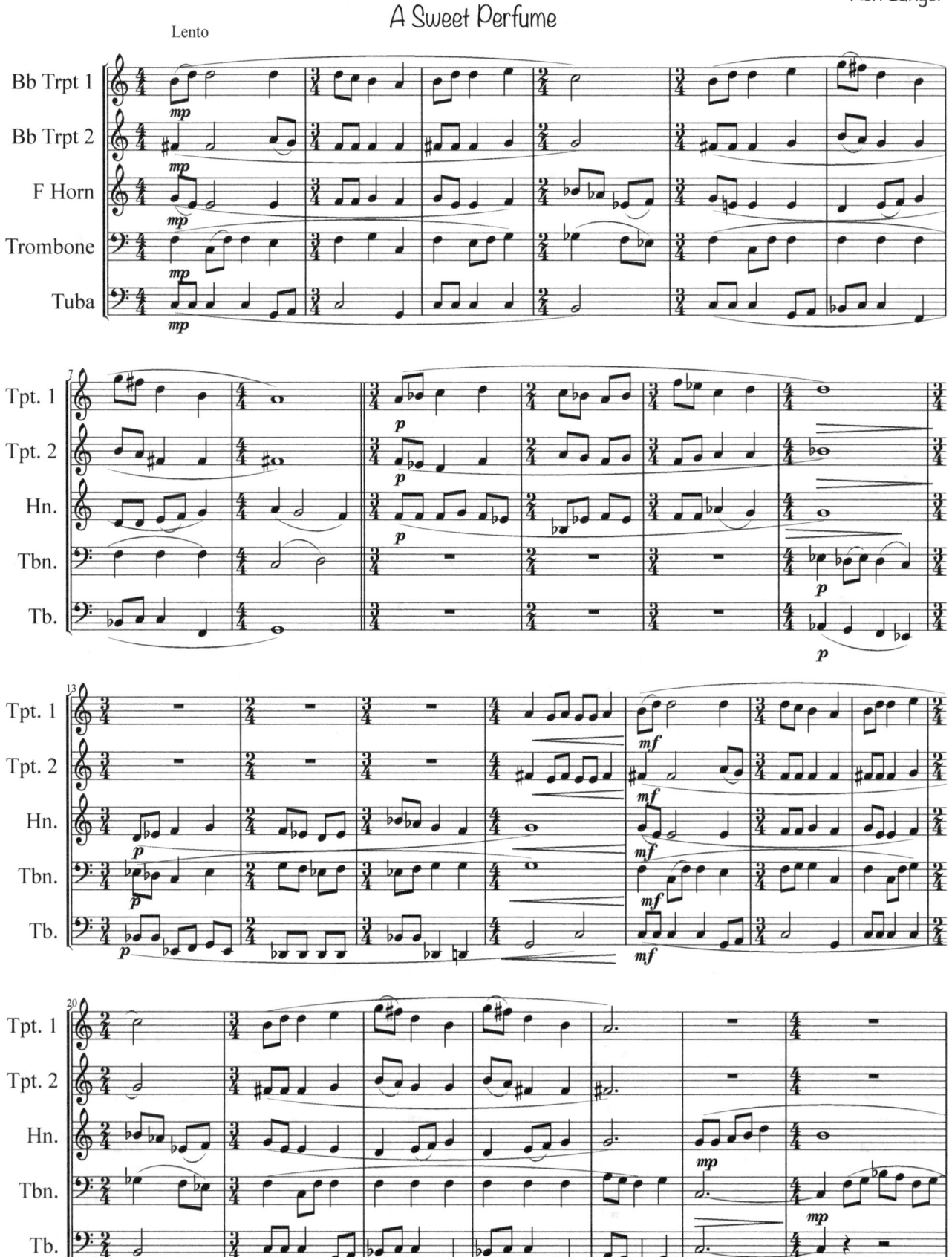

118

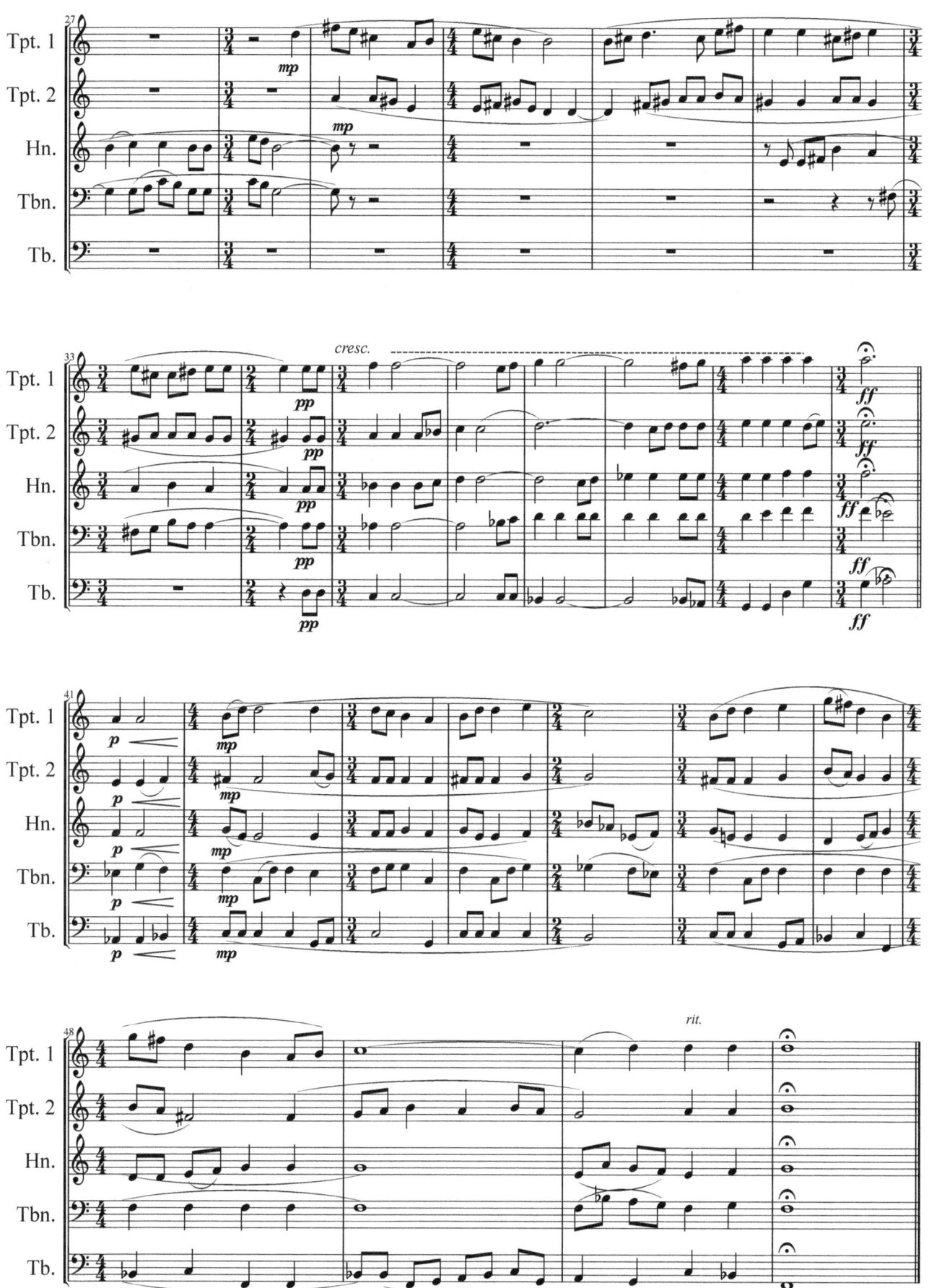

Wedding Music
Love's Philosophy

Percy Bysshe Shelley

Ken Langer

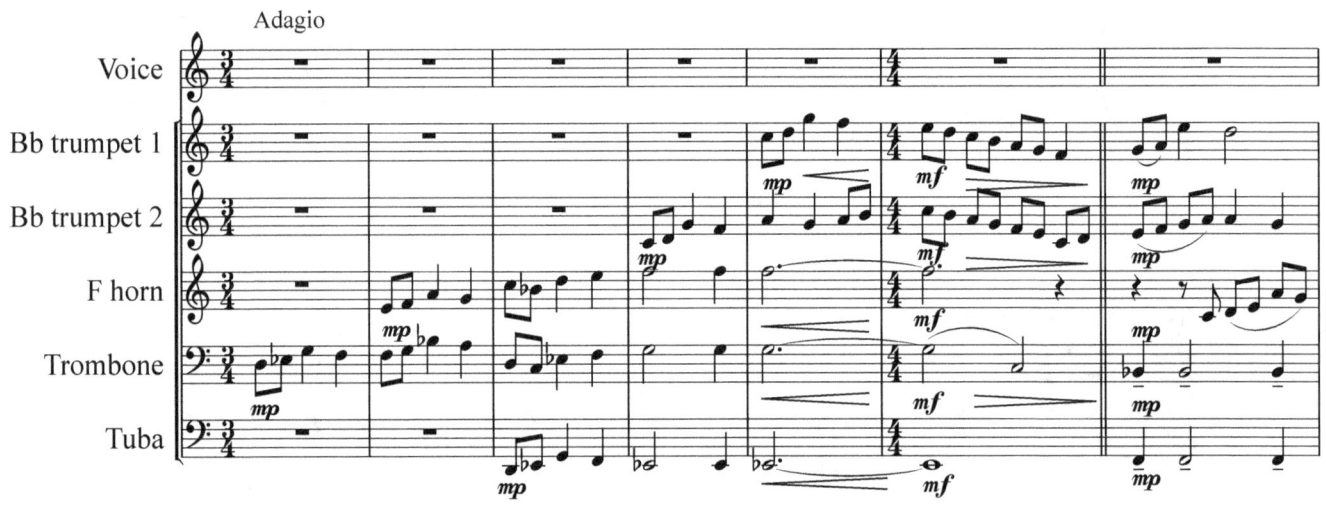
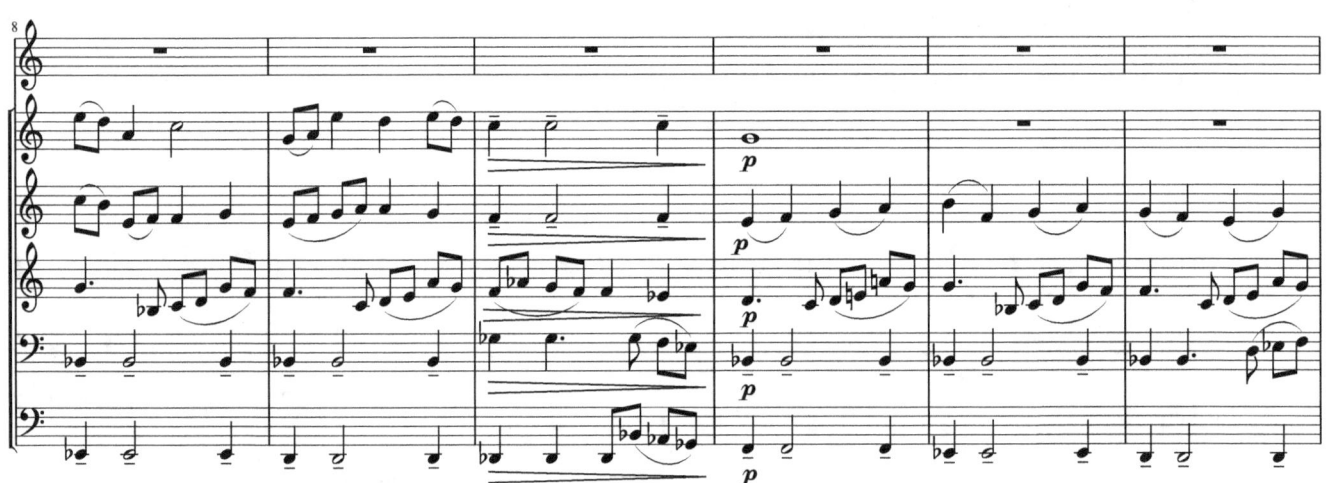
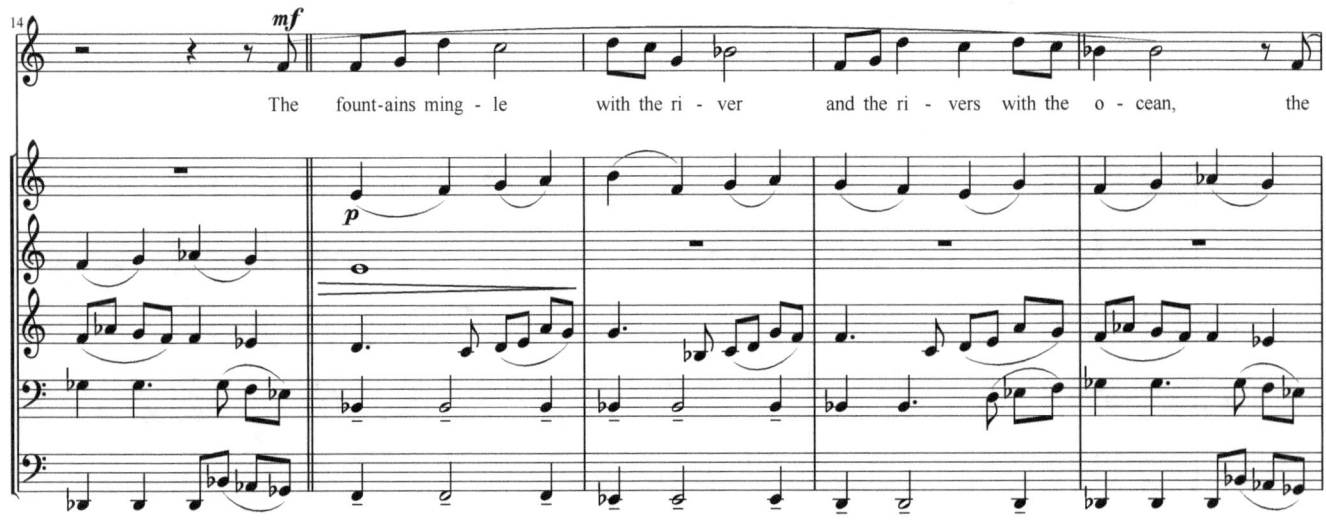

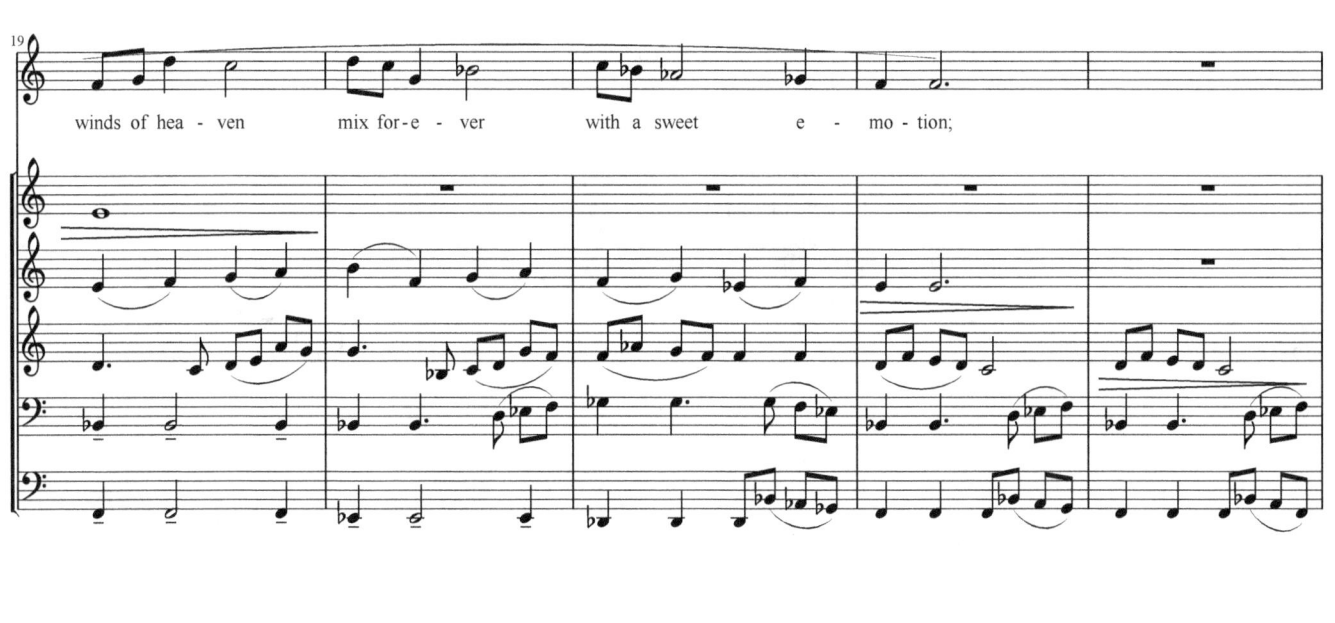
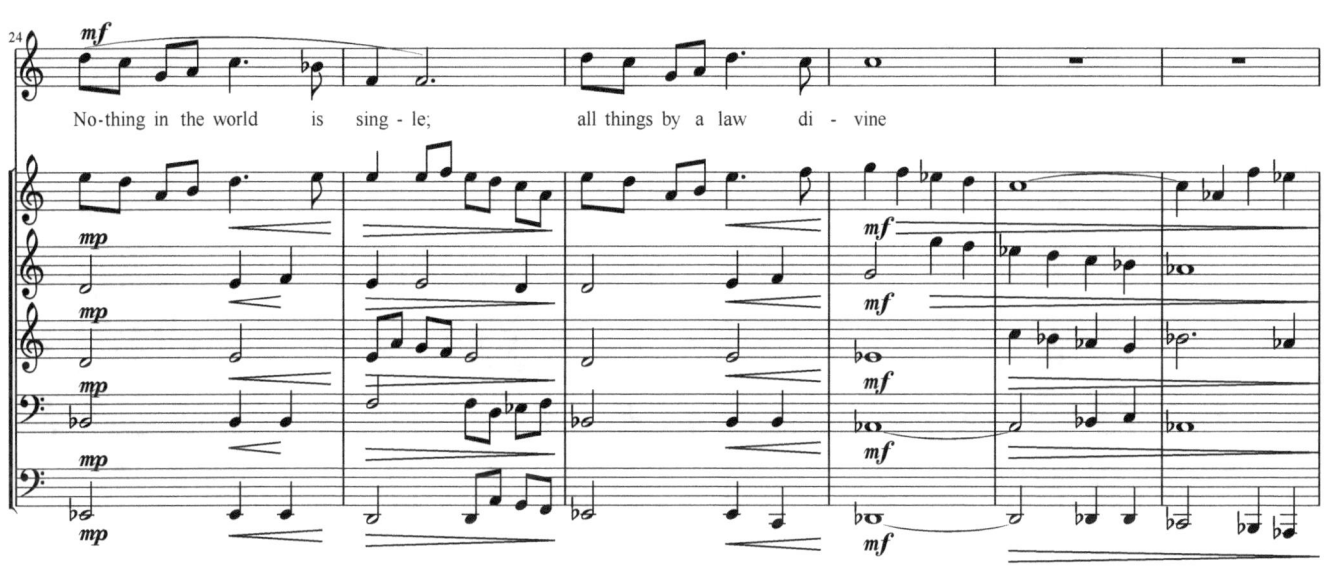
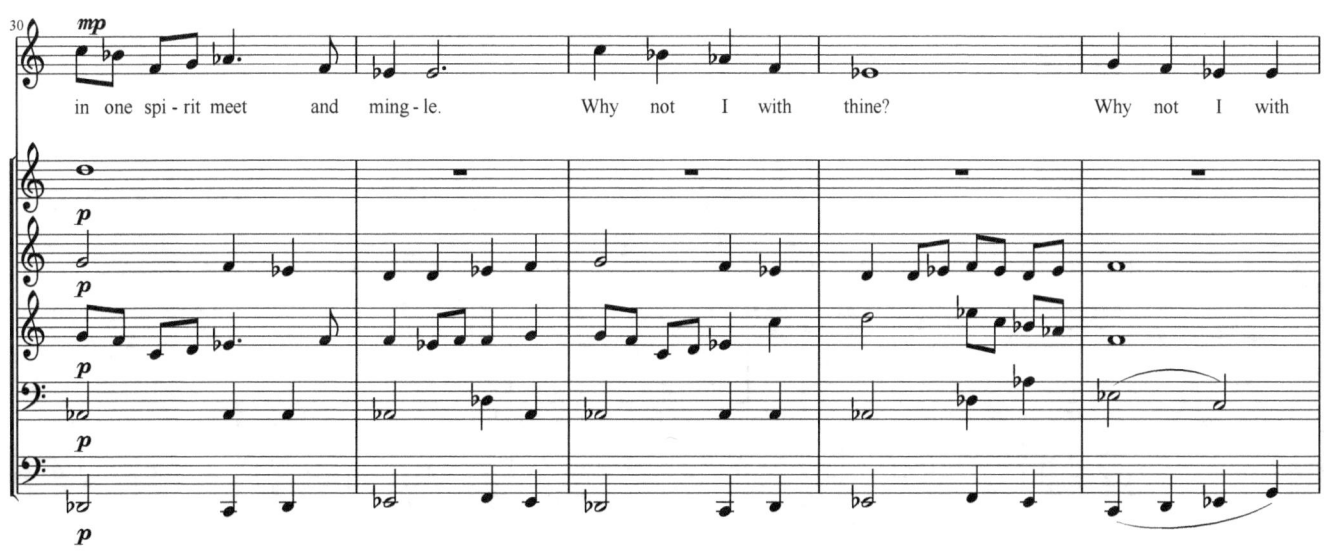

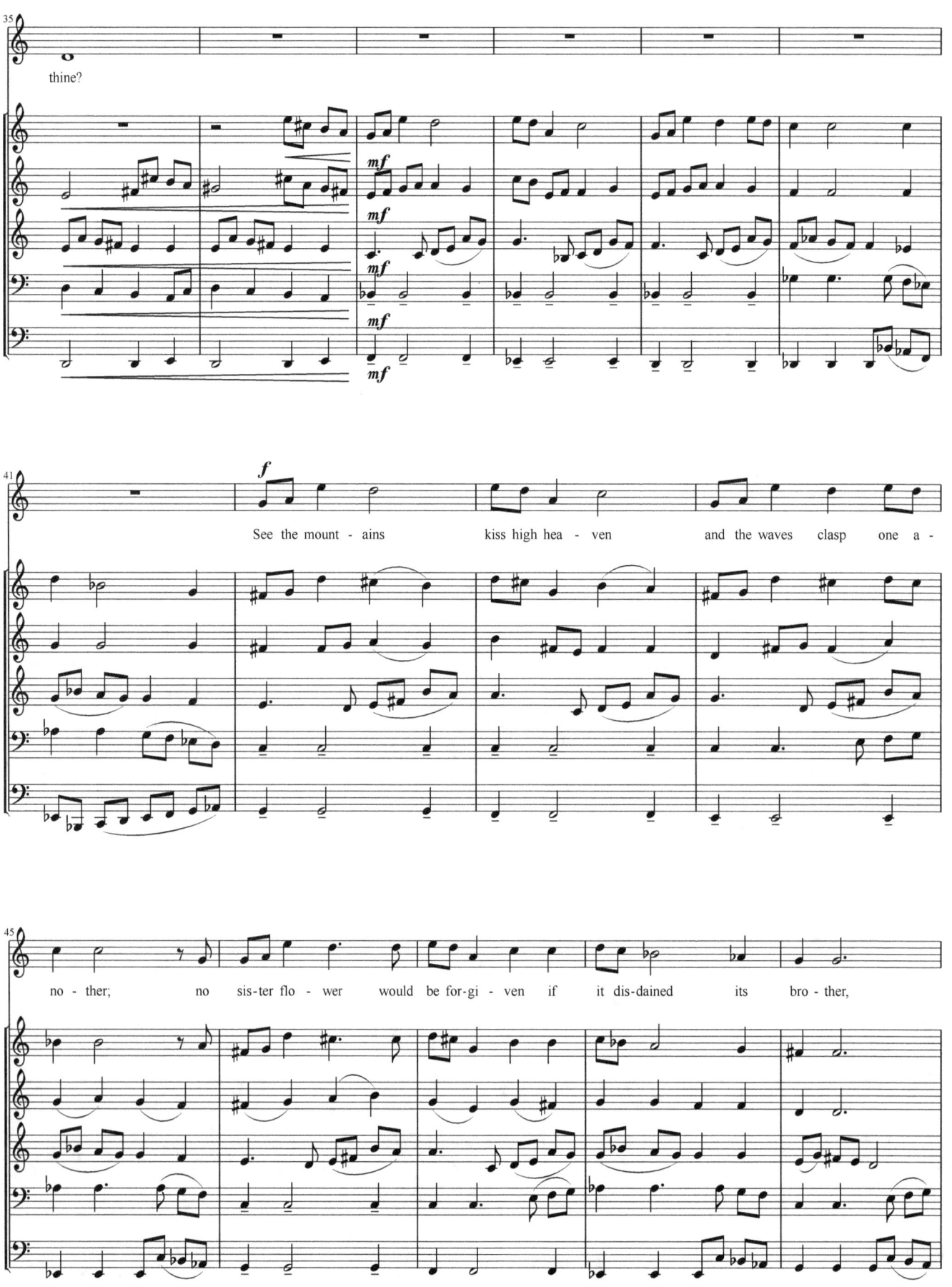

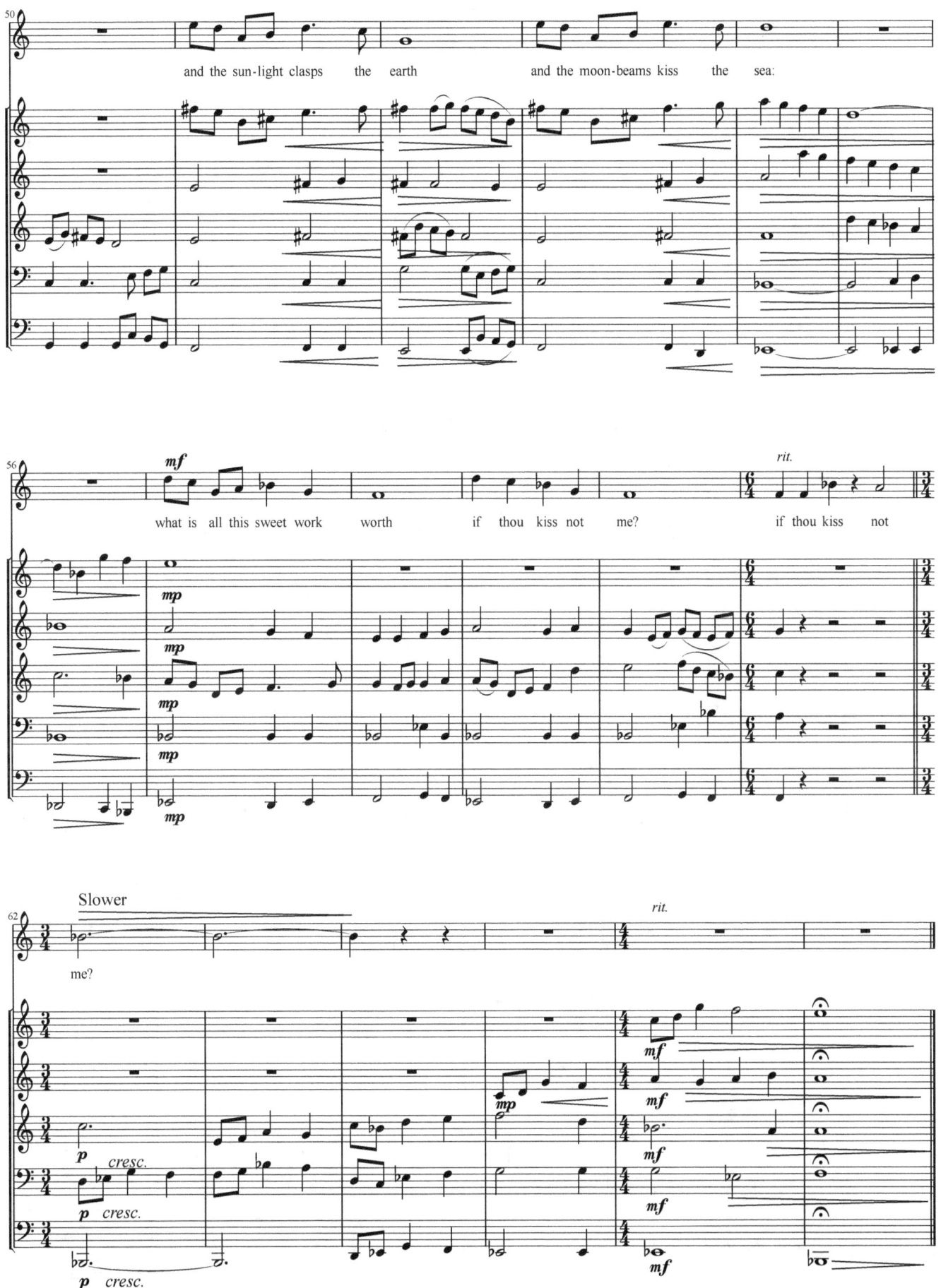

Wedding Music
Recessional

Ken Langer

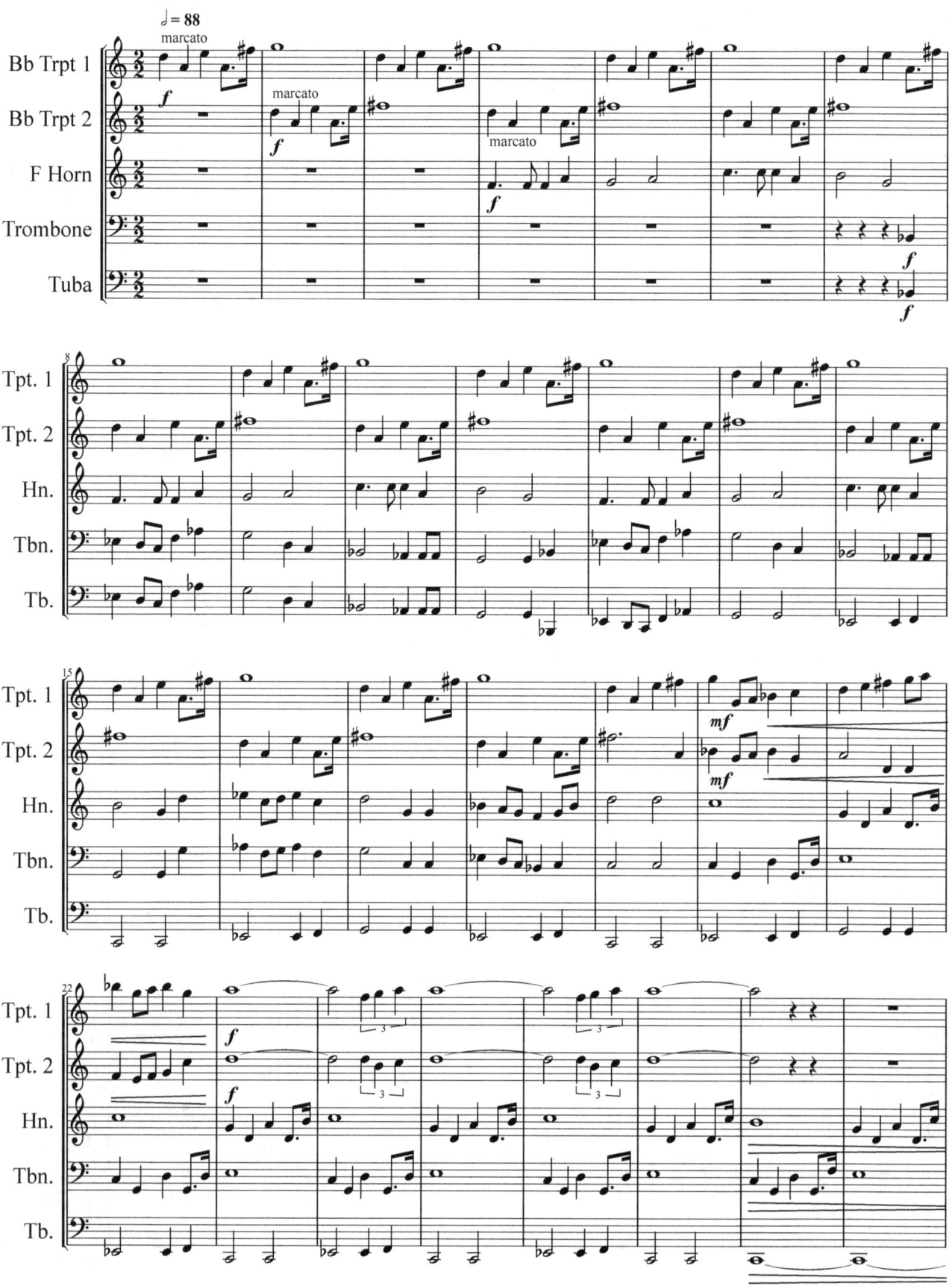

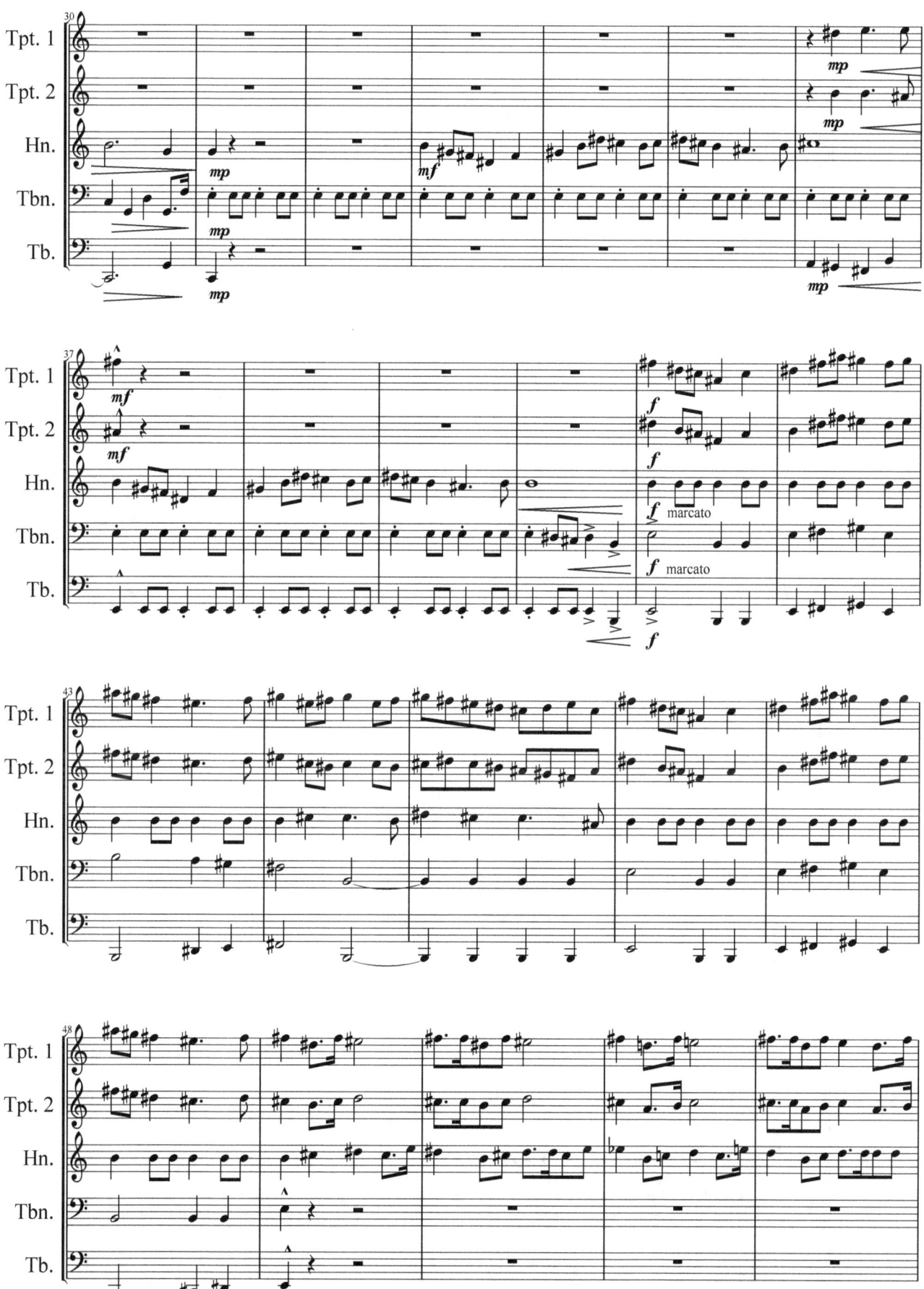

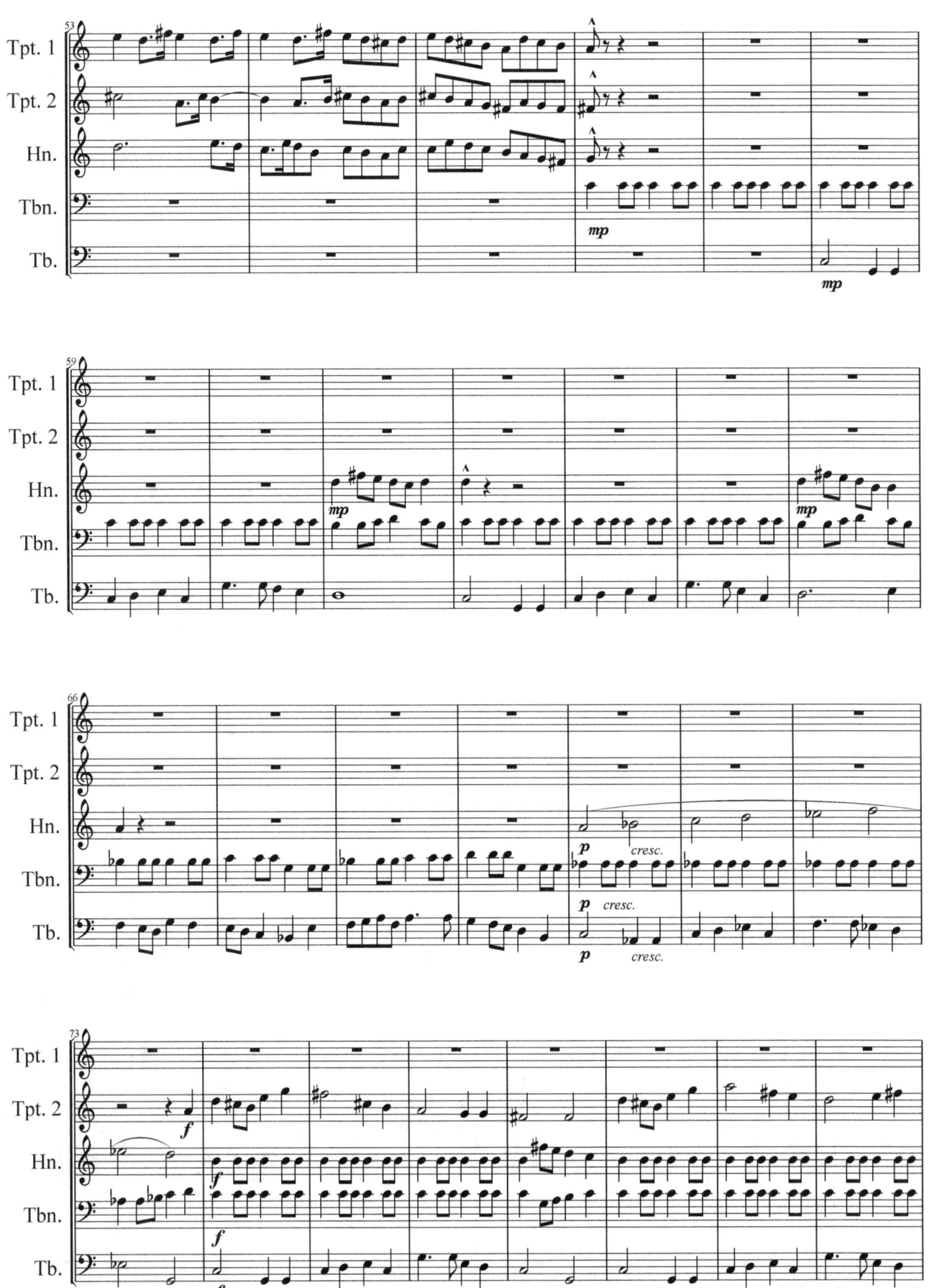

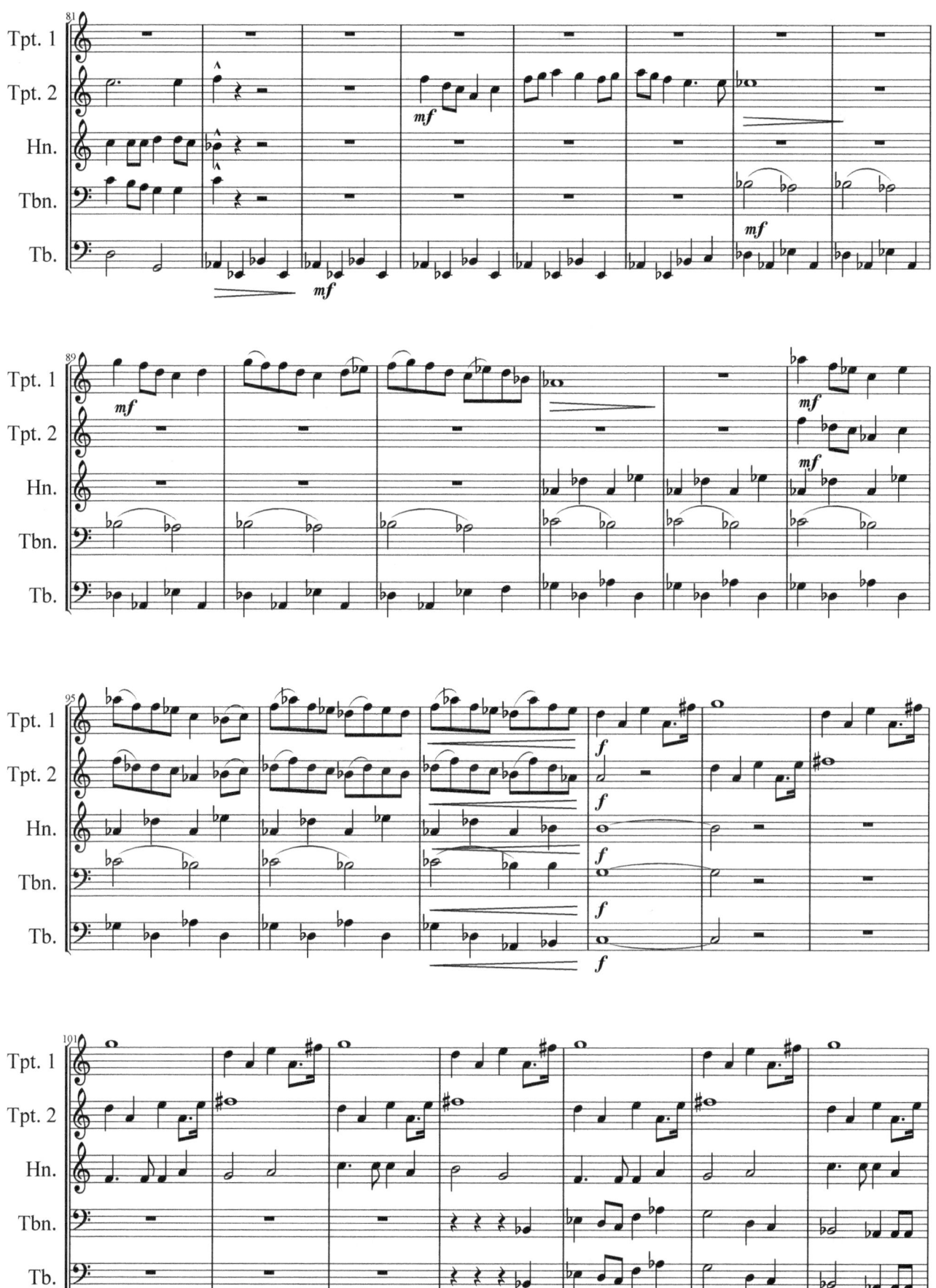

Christmas Bells For Brass

Ken Langer

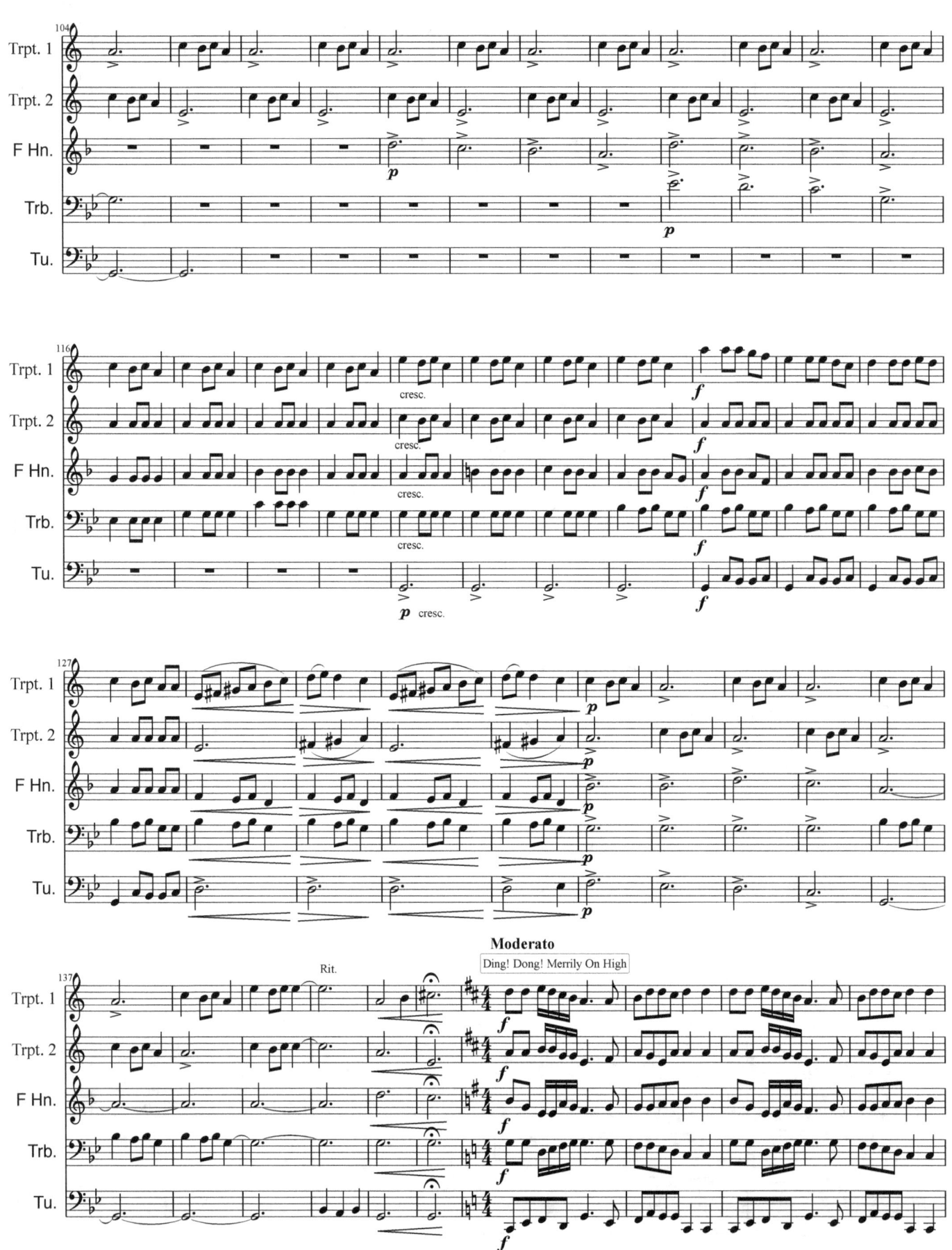

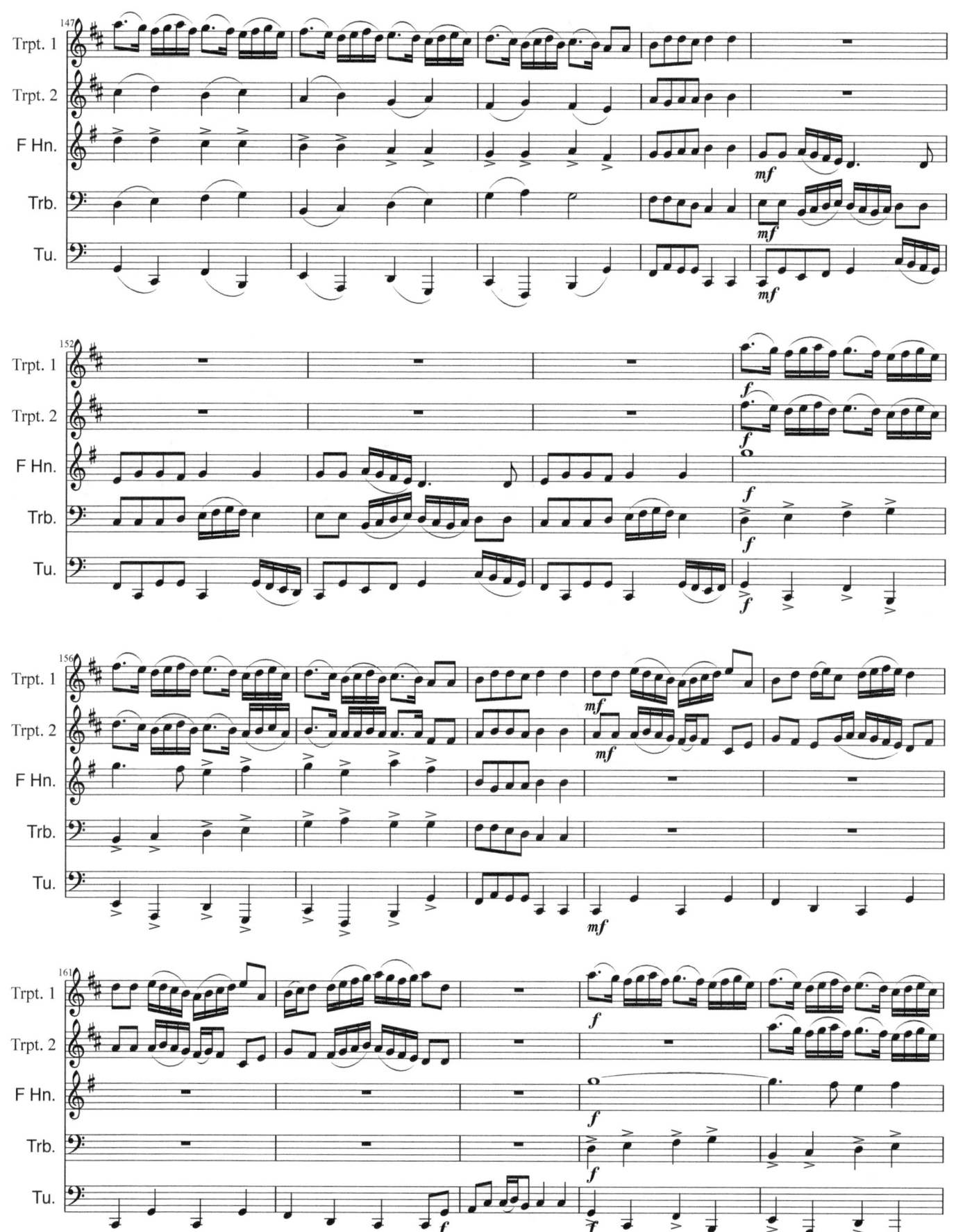

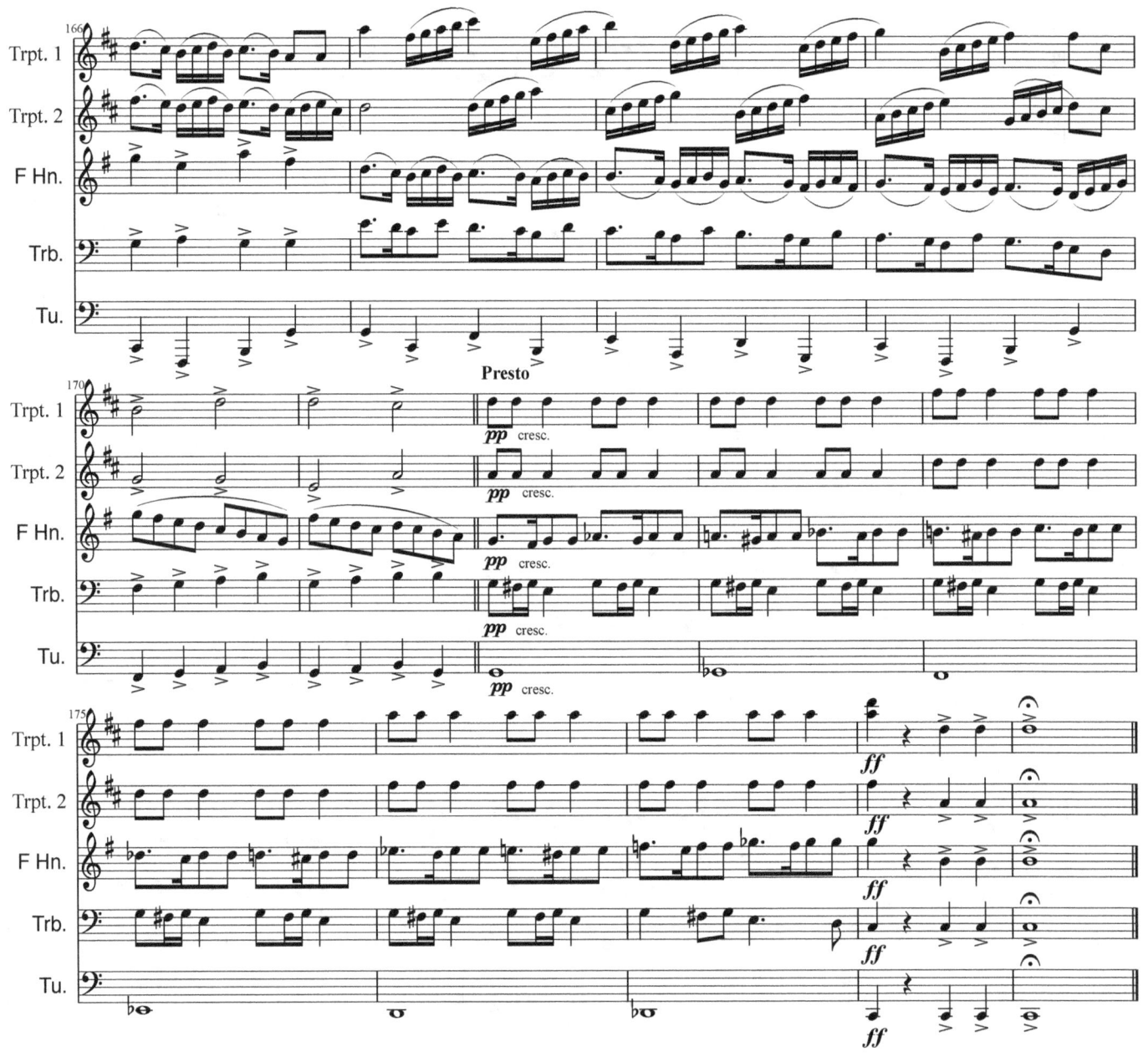

Three For Christmas

arr. Ken Langer

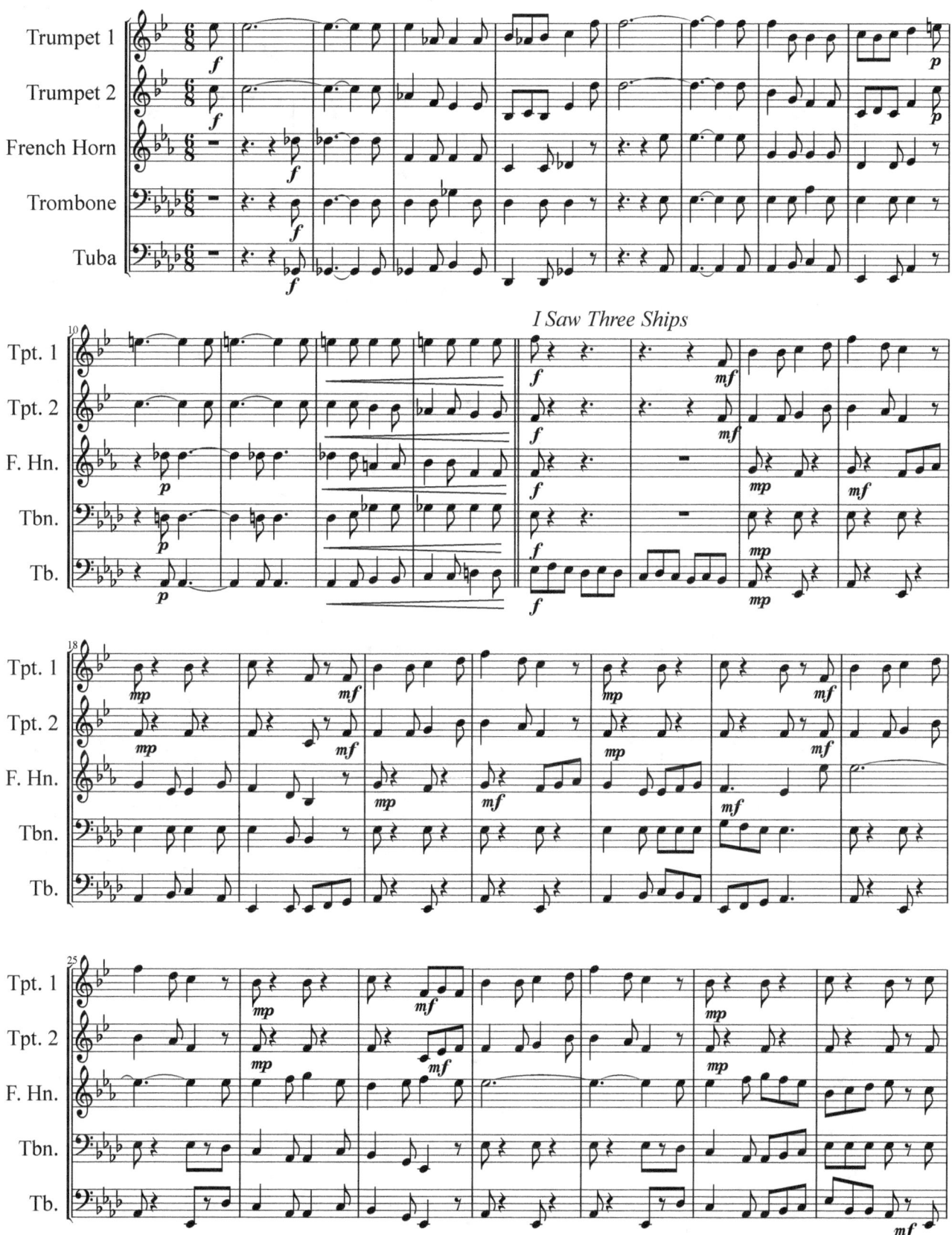

135

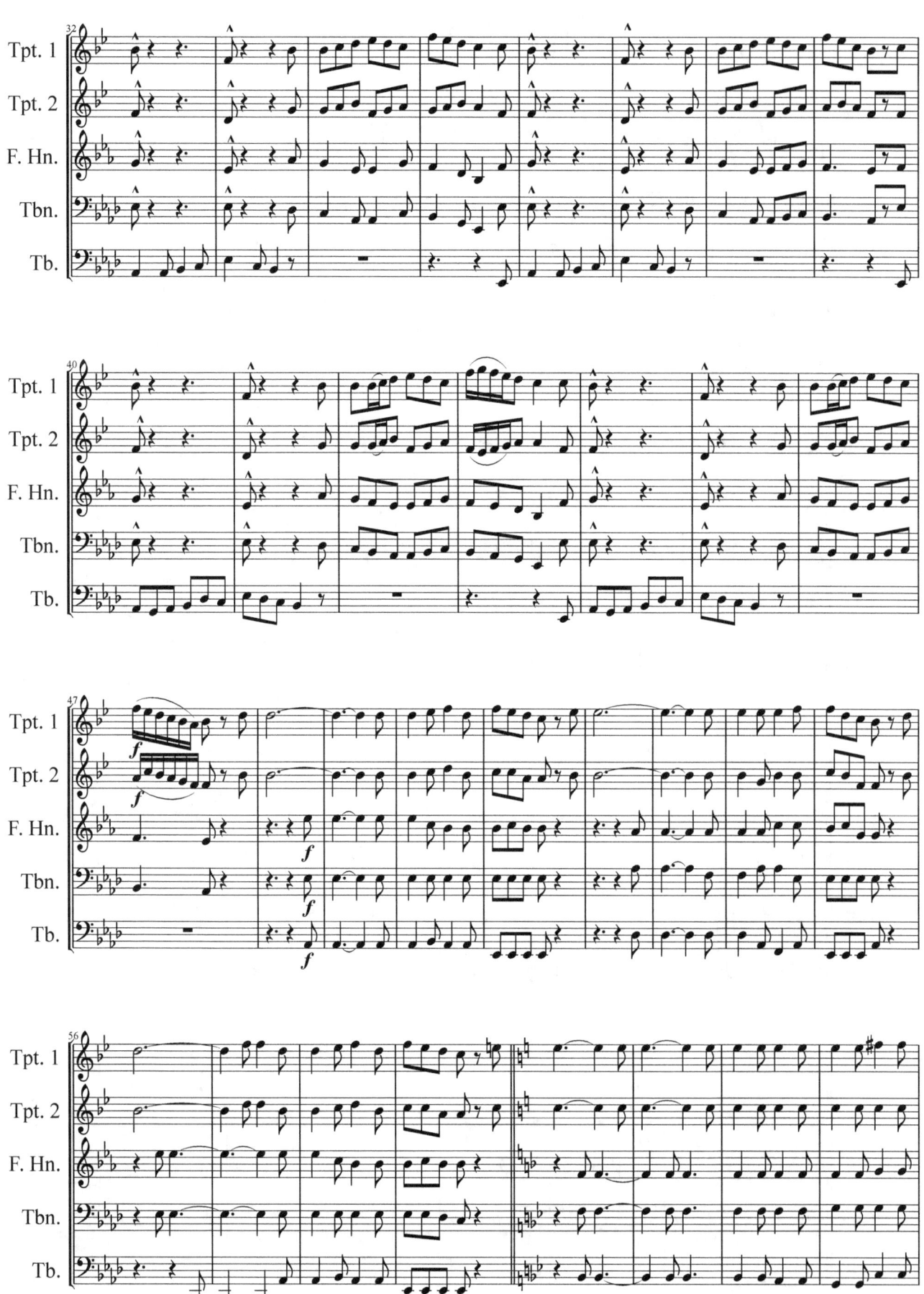

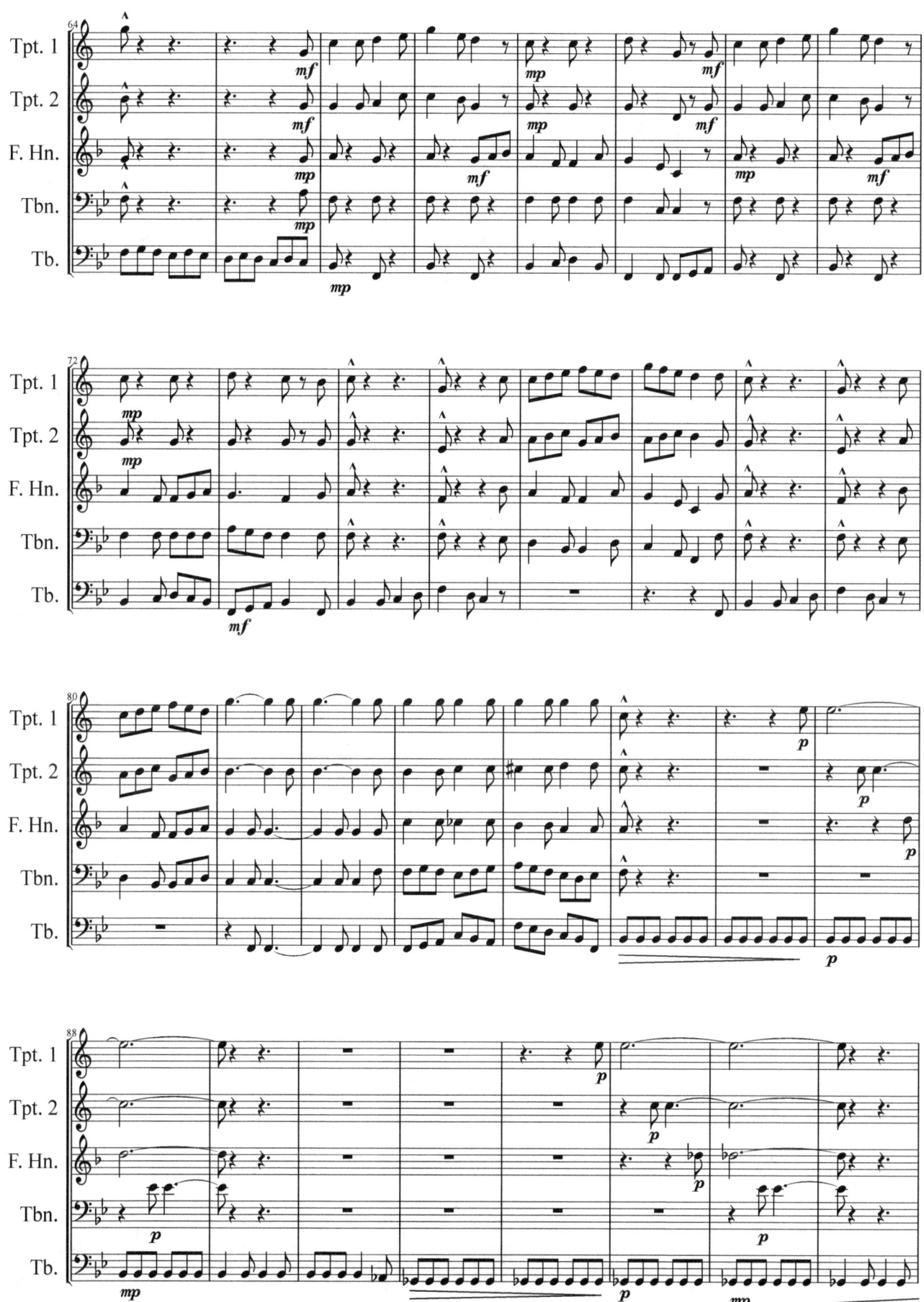

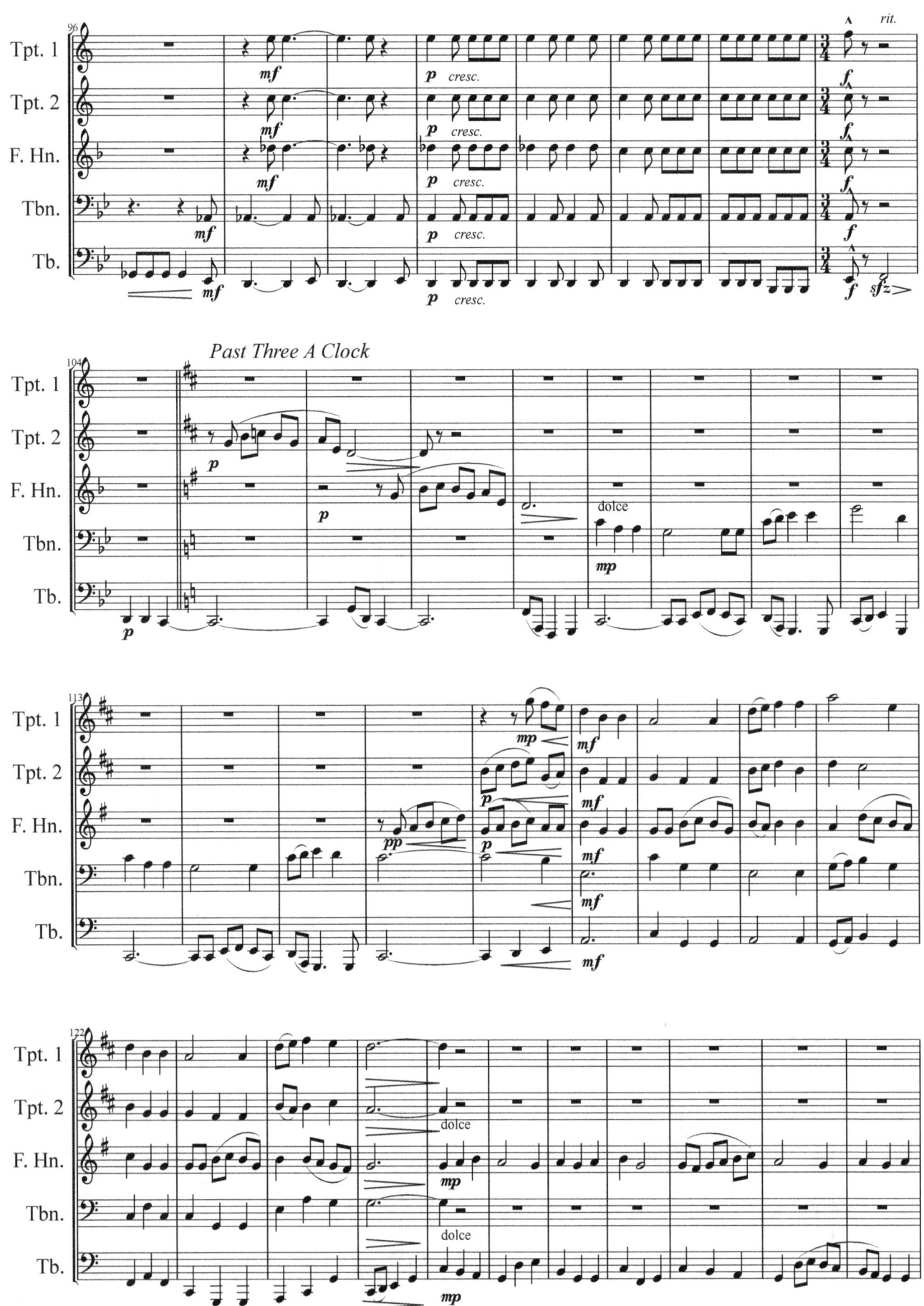

Past Three A Clock

138

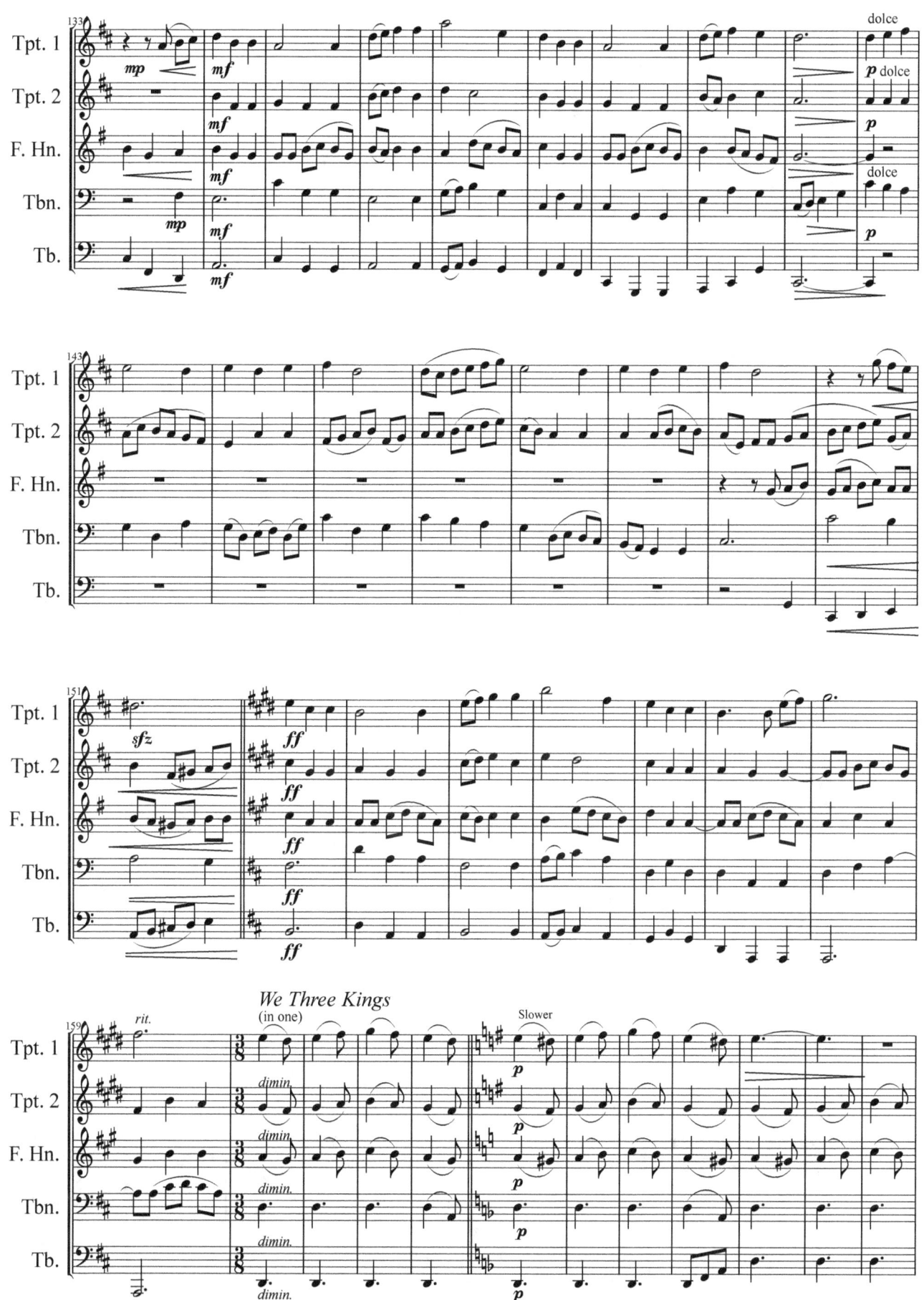

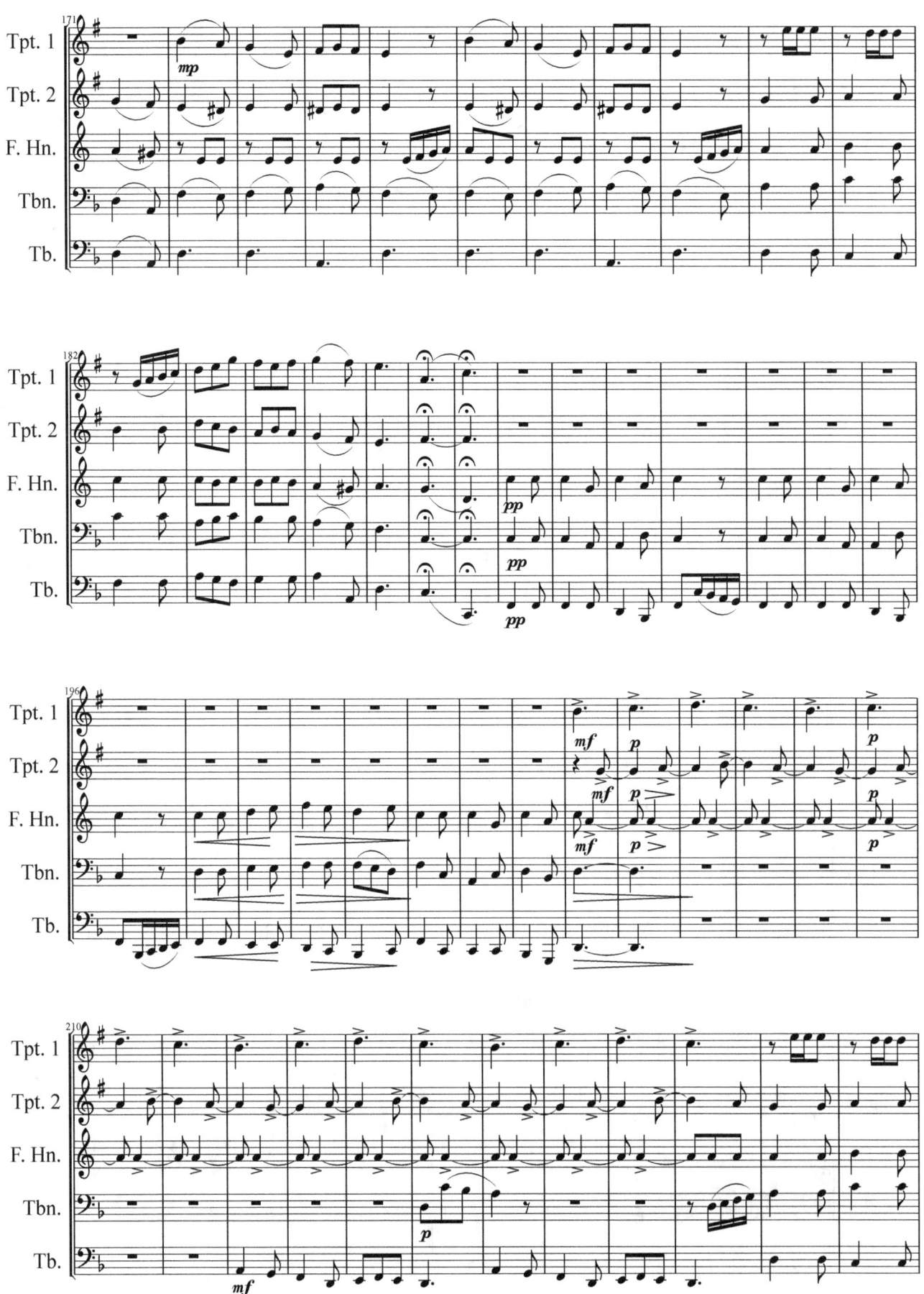

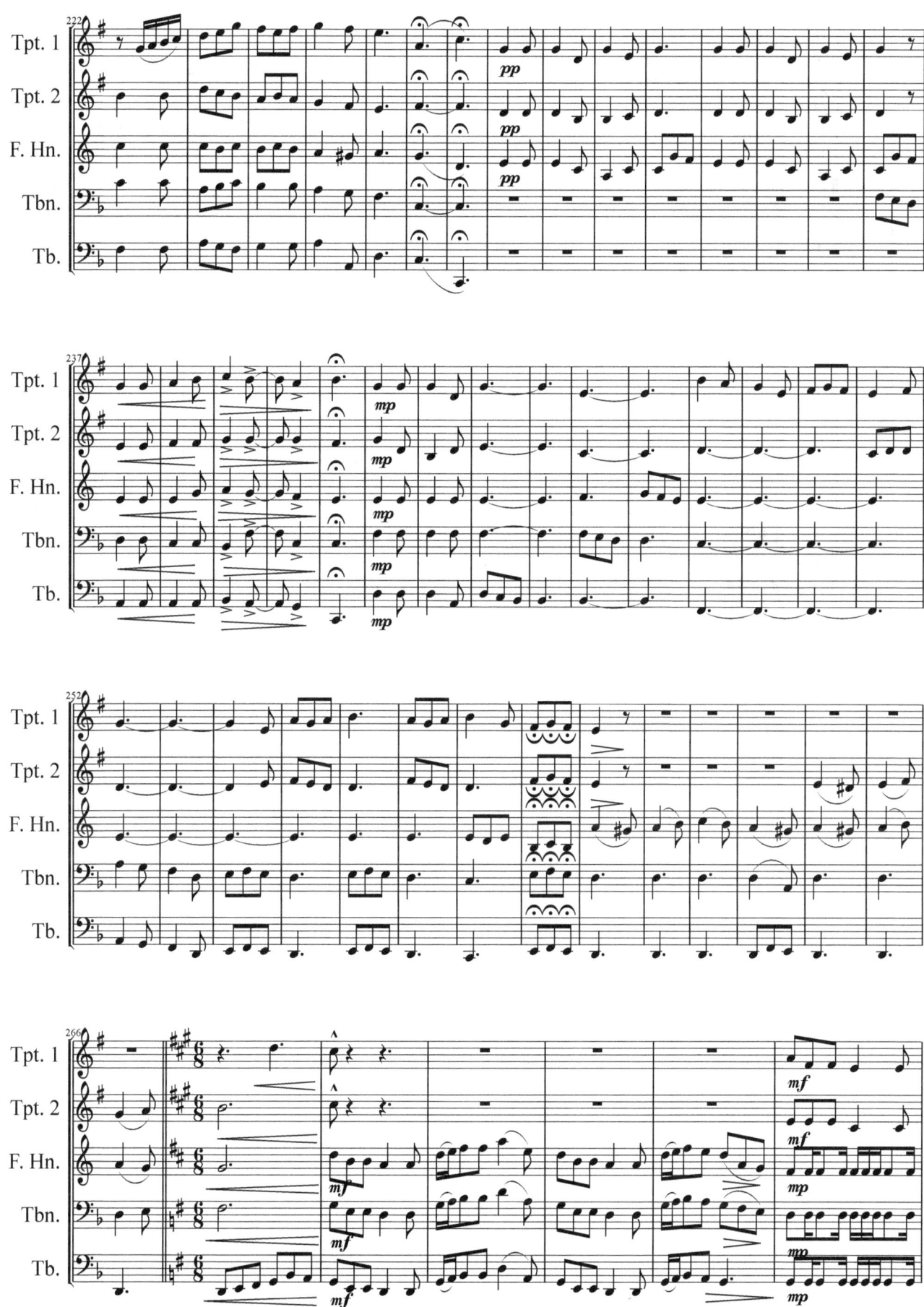

141

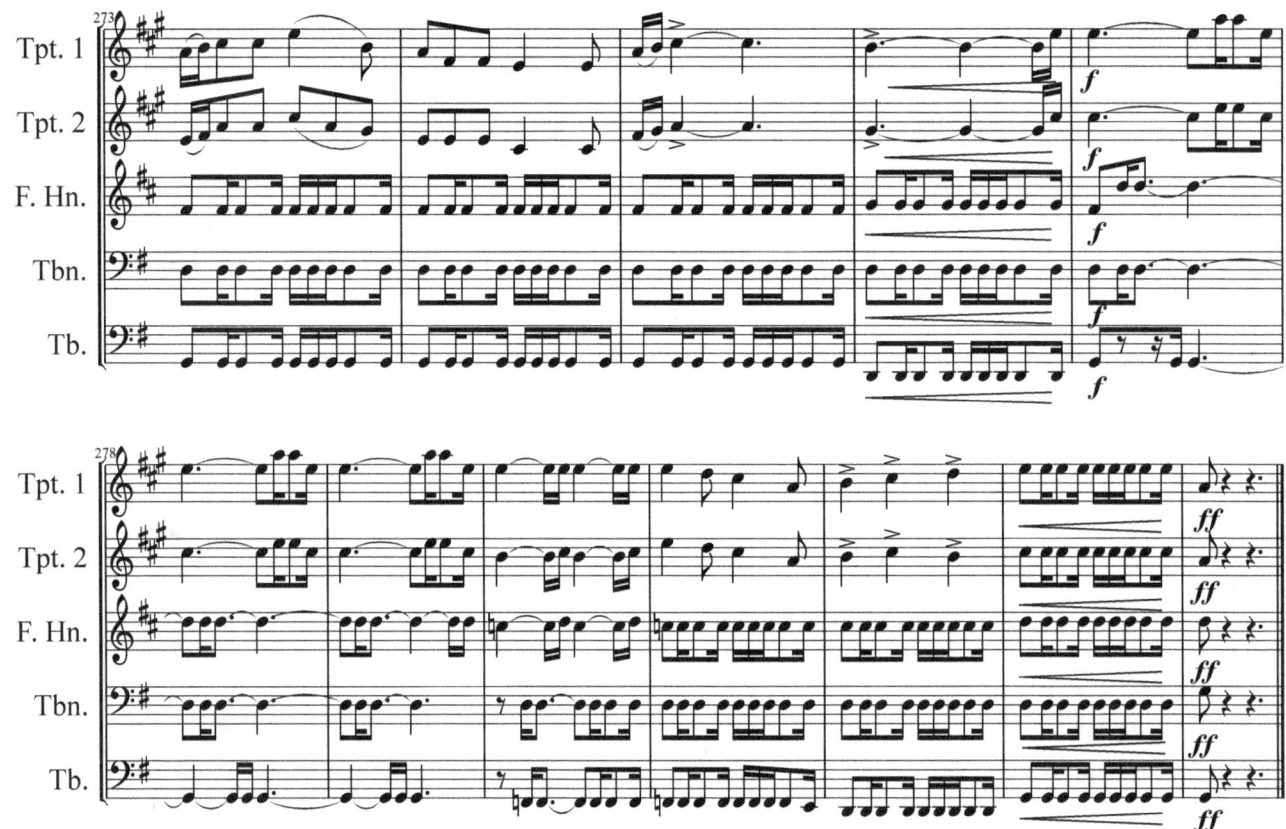

Dialogues for The Insulting Quintet

Dialogue no. 1
Trombone: (To Trumpet 1) What are you doing, you numbskull?
Trumpet 1: What do you mean? I am playing this piece.
Trombone: But you're playing it wrong.
Trumpet 1: No I'm not.
Trombone: Yes you are.
Trumpet 1: No I'm…. oh wait! (turns music over) That's better!

Dialogue no. 2
Horn: This is the dumbest piece of music we've ever played.
Trumpet: No it's not. You just haven't given it a chance.
Horn: I haven't given it a chance? It's not worth our status as a professional performing organization.
Trumpet: Getting paid by your mother to play at a party does not make us professional.
Horn: Whatever! Can we just get on with this silly piece so we can play some real music? I want to play Jingle Bells!

Dialogue no. 3
Trombone: (to Tuba) You lunkhead!
Tuba: What?
Trombone: You missed a note in measure 26!
Tuba: No I didn't!
Trumpet 2: (looking at Trumpet 1) Umm… guys?
Trombone: Yes you did. It's right there in the music.
Tuba: I do not have anything at measure 26!
Trombone: (looks at music then flicks something off the page) You're right!
(Trumpet 1 is starting to pass out)
Trumpet 2: Uh… guys!! (pointing to Trumpet 1)
Trombone: (ignoring Trumpet 2) Can we please just finish this silly piece?
Tuba: Good idea!

Dialogue no. 4
Horn: (to Trumpet 1) Why did you get this ridiculous piece of music?
Trumpet 1: How do you know I got it?
Horn: You get all the stupid pieces of music.
Trumpet 1: I don't know what you mean.
Horn: What about that piece with the kitchen appliances?
Trumpet 1: Umm, well….
Horn: Can we just get this thing over with?

Dialogue no. 5

Tuba: (to Horn) What in the world was that?

Horn: I told you I didn't want to play this dumb piece any more. I prefer to play more refined music!

Trumpet 2: Like Jingle Bells?

Trombone: It's better than this silly thing.

Trumpet 1: Well if you people would actually play the right notes it might sound half-way decent.

Tuba: If you would actually get some real music?

Horn: Is this thing over yet?

Trumpet 1: No!

Dialogue no. 6

Trumpet 1: (to Trumpet 2) You're playing it all wrong!

Trumpet 2: What do you mean?

Trumpet 1: You're playing it all slow and sweet! (makes awful face)

Trumpet 2: Well, excuse me for…

Trumpet 1: It's supposed to be fast and aggressive.

Trumpet 2: Well you play it your way and I'll play it mine.

Trumpet 1: Fine!

(Trombone and Tuba begin to nod off as the trumpets play)

Dialogue no. 7

Horn: Hey! Wake up!

Trombone: (to Tuba) Sleeping during rehearsal? What's wrong with you?

Tuba (to Trombone) Me? What about you? Your snoring sounds like your playing!

(Tuba and Trombone begin arguing)

Horn: (to Trumpets) Can't you two ever just get along? t we just be nice? Can'The world is already too full of discord. We need peace, love, and harmony. Can't we have a little peace, love, and harmony for once?

(Trombone and Tuba settle down) Yea, OK.

Horn: (shouting) OK you clowns! Now let's get this piece of garbage over with!

Dialogue no. 8

Horn: Can we play Jingle Bells now?

All: No!

About The Composer

Dr. Kenneth Langer was born in the Pittsburgh area in 1959. He began playing trumpet in the 5th grade and decided in high school to make music his career.

Dr. Langer earned a Bachelor's Degree in Music Education at James Madison University in Harrisonburg, Virginia; a Master's of Music Degree at Radford University in Radford, Virginia; and a Ph.D. In Music Theory and Composition at Kent State University in Kent, Ohio. Since that time, he has taught music at several small colleges.

He has also been the full-time Director of Music and Arts at the Eno River Unitarian-Universalist Fellowship in Durham, North Carolina and the Assistant Conductor and Resident Composer at the Montpelier Unitarian-Universalist Church in Montpelier, Vermont.

During his twenty years of writing over 150 original works of music for various genres including brass, chorus, strings, orchestra, wind ensemble, and woodwinds; he has received numerous awards for his compositions including being named Vermont's Composer of the Year in the year 2000 and winning placement in several international composition contests. He has commercially published well over 30 compositions.

Dr. Langer currently lives in the Boston area with his family where he works as the Head of the Music Program at Northern Essex Community College in Haverhill, Massachusetts.

Publishers

Music For Brass

Nichols Music Company (Ensemble Publications)
P.O. Box 32 Ithaca, NY 14851-0032
www.enspub.com

Solid Brass Music
P.O. Box 2277 Rome GA, 30164
www.solidbrassmusic.com

Cimarron Music Press
15 Corrina Lane Salem CT 06420s
www.cimarronmusic.com

Wehr's Music House
www.wehrs-music-house.com

Music For Chorus

Yelton Rhodes Music
1236 N. Sweetzer Avenue #5 West Hollywood CA 90069
www.yrmusic.com

www.ingramcontent.com/pod-product-compliance
Lightning Source LLC
Chambersburg PA
CBHW080916170526
45158CB00008B/2133